ROOKWOOD IV & KERAMICS 1994

Featuring important museum quality pieces from
the collection of Dr. Gerald Loetterle and other fine
consignments including eight important examples from
Rookwood Pottery The Glorious Gamble

Auction

June 11th from 9:00 AM until Done

Preview

June 10th from 9:00 AM until 8:00 PM
June 11th from 8:00 AM until 9:00 AM

Sale Coordinator

Riley Humler

Auctioneer

J. Louis Karp

Associate Auctioneer

Brad Karoleff

Sale Consultant

Louis Aronoff

Cincinnati Art Galleries

Michele and Randy Sandler
635 Main Street
Cincinnati, OH 45202
(513) 381-2128
Fax (513) 381-7527

ISBN: 0-943633-07-9
Library of Congress Catalog Card Number: 94-071388

Terms of Sale

The buyer is the person making the final and highest bid. In the event of a disputed bid, the auctioneer shall determine who is the successful bidder, or the auctioneer may resell the lot in dispute, but in all instances the judgment of the auctioneer shall be final.

Sales Tax

A 5.5% Ohio Sales Tax applies to all retail purchases. Ohio Sales Tax exemption forms must be executed and filed with the auction clerk at the time of auction registration.

Withdrawal

The auctioneer reserves the right to withdraw any lot before or at the time of the sale.

Credit, Methods of Payment

Cash, Visa, Mastercard, certified check and bank letters of credit are acceptable methods of payment. If you are known to us, your credit, and your credit only, can be established. Please check with the sale clerk. No company or personal references are accepted. We would appreciate credit arrangements being made in advance of the auction date. Persons not making prior credit arrangements can pay by personal check, but no merchandise can be removed until all checks have cleared. Any packing and shipping expenses will be borne by the purchaser. All items must be paid in full within 72 hours of the end of sale or the Auctioneer retains the right to resell the property, either at auction or by private sale. Purchaser will be liable for any deficiencies and all costs incurred, including collection and legal fees.

Bidding

Lots will be sold in the order in which they appear in the catalog. The normal bidding increments are as follows:

Up to $500	Bids will increase in $25 increments
$500-$1000	Bids will increase in $50 increments
$1000-$5000	Bids will increase in $100 increments
$5000-$10000	Bids will increase in $250 increments
$10000 up	Bids will increase in $500 increments

The Auctioneer reserves the right to vary the bidding increments.

The final bid is the price at which the lot is knocked down to the buyer.

This final bid, in all cases, is subject to a 10% buyer premium, the purchase price being the total of the two sums.

If the purchase price is not paid in full, the auctioneer may either cancel the sale, and any partial payment already made shall be there upon forfeited as liquidated damages or the auctioneer may resell the lot, without notice to the buyer.

Absentee, Written and Telephone bids

Absentee bids are welcomed. Absentee bids will be executed as if the bidder were present at the auction with the earliest bid received having preference in case of a tie between absentee bidders. Floor bids will be taken over absentee bids in case of a tie. Absentee, written or telephone bids are subject to the same 10% buyer's premium, and all credit requirements as listed above. The auctioneer, Cincinnati Art Galleries, and their employees are not responsible for absentee, written or telephone bids that are not properly executed. We have a limited number of telephone lines available during the auction. These will be reserved on a first come first served basis for telephone bidding. Due to the limited number of lines, we will not be able to accomodate telephone bidding on lots with low estimates of under $500. We will be happy to accept absentee bids on any lots not eligible for telephone bidding. All packing and shipping cost of items purchased by Absentee, Written or Telephone bids will be borne by the purchaser.

Buyer's Premium

The final bid ("hammer" price) is subject to a 10% premium. The purchase price is the total of these two sums.

Reserves and Estimates

The estimated value of each lot is printed in the catalog, and merely reflects the price range into which a lot might fall. All lots have a reserve price below which they will not be sold. The reserve price is not published in the catalog, but in no case is it higher than the lower amount of the estimated price.

Removal

All lots are to be removed by their buyers not later than 9:00 PM, Saturday, June 11th, 1994. Lots are released to buyers upon presentation of proof of payment.

Packing and Shipping

We have made arrangements to assist in packing and shipping your puchases should you desire. We will pack any item and arrange shipping through U.P.S., Federal Express or other shippers, as long as the items are insured. International shipping is likewise available. Packing and shipping will be done on a "time and material" basis and all cost will be billed directly to the purchaser. We fully expect excellent results and moderate prices from our new packing and shipping arrangement.

Guarantee

All lots in this catalogue are guaranteed as described and are guaranteed to be free of other problems or repairs. Crazing is only mentioned if objectionable. Sizes are approximate. (See Peck Book II for shape number references). We guarantee the authenticity of all lots in this auction.

Advice to Bidders

The Cincinnati Art Galleries staff is available to discuss all lots with potential buyers at all presale exhibitions, or by telephone (513-381-2128) Monday thru Friday 9AM-5PM, Saturday 9AM-4PM.

Prices Realized

The list of prices realized at the auction will be mailed shortly after the sale. Lots that have been withdrawn from the sale or that have failed to reach the reserve price will be excluded from the prices realized.

CONSIGNMENTS WANTED
For Rookwood V and Keramics 1995

Cincinnati Art Galleries is now accepting consignments for Rookwood V and Keramics 1995 which will take place in June of 1995. We have consistently set new levels of excellence in selling Art Pottery and would be pleased to assist you in making decisions about your single piece or collection.

Cincinnati Art Galleries is unique in the world of auctions. We have unmatched expertise in dealing with Rookwood and are quickly establishing our place as a trusted and appreciative seller of all Art Pottery. We operate our sales with the greatest attention to detail, honesty and scholarship and no one can offer consignors and sellers alike, a more friendly and efficient atmosphere in which to buy or sell.

We have established great credibility in dealing with fellow pottery lovers and we encourage anyone interested in learning about us to talk with others who have dealt with Cincinnati Art Galleries. Our reputation is important to us and we believe it should be of importance to you.

If you would like a professional and confidential opportunity to discuss the sale of a single piece or your entire collection, please call Riley Humler at 513-381-2128.

Cincinnati Art Galleries also offers extensive advertising for its sales. We target a number of National and Regional magazines and newspapers, ensuring the best possible exposure of your merchandise to potential buyers.

We purchase Rookwood and American and European Art Pottery.

Cincinnati Art Galleries is also interested in purchasing Rookwood and American and European Art Pottery. If you do not wish to pursue the auction method of selling your pottery, we would like to talk with you about outright purchase. Whether you have a $200 vase or a $2,000,000 collection, Cincinnati Art Galleries is ready and willing to review your needs. If you would like a confidential, no obligation discussion with the experts at Cincinnati Art Galleries, please call Riley Humler or Randy Sandler at 513-381-2128.

THE STAFF OF CINCINNATI ART GALLERIES

Ralph Allalouf	Mark Lario
Edie Buschle	Cal Long
Tracy Daugherty	Michele Sandler
Tom Deaton	Randy Sandler
Jim Fleming	Rick Santa
Riley Humler	Brian Sparks

SELECTED BIBLIOGRAPHY

Altman	Seymour and Violet	The Book of Buffalo Pottery	Bonanza Books	1969	New York
Barr	Margaret Libby et al.	University of North Dakota Pottery The Cable Years	Published by the Authors	1977	Grand Forks, ND
Blasberg	Robert W.	The Unknown Ohr	Peaceable Press	1986	Milford, PA
Burt	S.G.	2,292 Pieces of Early Rookwood Pottery in the Cincinnati Art Museum in 1916 (Reprinted in 1978)	Herbert Pack	1978	Tucson
Buxton	Virginia Hillway	Roseville Pottery for Love or Money	Tymbre Hill Publishing Co.	1977	Nashville
Chipman	Jack	Collector's Encyclopedia of California Pottery	Collector Books	1992	Paducah, KY
Clark	Garth and Margie Hughto	A Century of Ceramics in the United States 1878-1978	E.P. Dutton	1979	New York
Cox	Warren E.	The Book of Pottery and Porcelain Combined Edition	Crown Publishers	1944	New York
Cummins	Virginia Raymond	Rookwood Pottery Potpourri (Reprinted in 1991)	Cincinnati Art Galleries	1991	Cincinnati
Dale	Sharon	Frederick Hurten Rhead: An English Potter in America	Erie Art Museum	1986	Erie, PA
Darling	Sharon	Teco Art Pottery of the Prairie School	Erie Art Museum	1989	Erie, PA
Dietz	Ulysses G.	The Newark Museum Collection of American Art Pottery	Peregrine Smith Books	1984	Salt Lake City
Eidelberg	Martin, Editor	From Our Native Clay Art Pottery from the Collections of the American Ceramic Arts Society	Turn of the Century Editions	1987	New York
Ellis	Anita J.	Rookwood Pottery The Glorious Gamble	Rizzoli	1992	New York
Evans	Paul	Art Pottery of the United States Second Edition	Feingold & Lewis	1987	New York
Goodman	Marcia and William	American Art Pottery	Cooper-Hewitt Museum	1987	New York
Henzke	Lucile	Art Pottery of America	Schiffer Publishing Ltd.	1982	Exton, PA
Humler	Riley, Editor	Rookwood II	Cincinnati Art Galleries	1992	Cincinnati
Humler	Riley, Editor	Keramics 1993	Cincinnati Art Galleries	1993	Cincinnati
Humler	Riley, Editor	The Glover Collection: Rookwood Pottery	Cincinnati Art Galleries	1991	Cincinnati
Humler	Riley, Editor	Rookwood III	Cincinnati Art Galleries	1993	Cincinnati
Huxford	Sharon and Bob	Early Roseville	Collector Books	1977	Paducah, KY
Huxford	Sharon and Bob	The Collectors Encyclopedia of Weller Pottery	Collector Books	1979	Paducah, KY
Huxford	Sharon and Bob	The Collectors Encyclopedia of Roseville Pottery Second Series	Collector Books	1980	Paducah, KY
Huxford	Sharon and Bob	The Collectors Encyclopedia of Roseville Pottery First Series	Collector Books	1976	Paducah, KY
King	Lyndel	American Studio Ceramics 1920-1950	University of Minnesota	1988	Minneapolis
Kircher	Edwin J.	Rookwood Pottery, An Explanation of Its Marks and Symbols	Published by the Author	1984	Cincinnati
Kircher	Edwin J. et.al.	Rookwood: Its Golden Era of Art Pottery 1880-1929	Published by the Authors	1969	Cincinnati
Kovel	Ralph and Terry	The Kovels' Collector's Guide to American Art Pottery	Crown Publishers, Inc.	1974	New York
Lehner	Lois	Lehner's Encyclopedia of U.S. Marks on Pottery, Porcelain & Clay	Collector Books	1988	Paducah, KY
McDonald	Ann Gilbert	All About Weller	Antique Publications	1989	Marietta, OH
Meinig	Laurel	Rookwood Pottery	The Yuma Art Center	1978	Yuma
Nelson	Scott, et al.	A Collector's Guide to Van Briggle	A.G. Halldin Publishing	1986	Indiana, PA
Pear	Lillian Myers	The Pewabic Pottery	Wallace-Homestead Book Co.	1976	Des Moines, IA
Peck	Herbert	The Second Book of Rookwood Pottery	Cincinnati Art Galleries	1985	Cincinnati
Peck	Herbert	The Book of Rookwood Pottery	Cincinnati Art Galleries	1968	Cincinnati
Perry	Barbara, Editor	American Ceramics The Collection of Everson Museum of Art	Rizzoli	1989	New York
Poesch	Jessie	Newcomb Pottery	Schiffer Publishing Ltd.	1984	Exton, PA
Postle	Kathleen R.	The Chronicle of the Overbeck Pottery	Indiana Historical Society	1978	Indianapolis
Purviance	Louise et al.	Zanesville Art Pottery in Color	Mid-America Book Company	1968	Leon, IA
Sasicki	Richard and Josie Fania	The Collector's Encyclopedia of Van Briggle Art Pottery	Collector Books	1993	Paducah, KY
Schneider	Norris F. Editor	Rozane Ware Catalog (Reprint)	The Roseville Pottery Company	1906	Zanesville, OH

ROOKWOOD POTTERY
An Explanation of Its Marks and Symbols
by Edwin J. Kircher

HISTORY

The Rookwood Pottery was founded in 1880 at Cincinnati, Ohio by Mrs. Maria Longworth Storer. The establishment was named for the Longworth Estate in the nearby countryside. The family home had large numbers of crows roosting in the trees on its grounds, and acquired its name from their presence.

The first plant was an abandoned schoolhouse at 207 Eastern Avenue. This address has been changed due to street renumbering, and the building has been razed, but the location was near the present intersection of Kemper Lane and Eastern Avenue. The factory remained in this location until construction of its Mount Adams site in 1893.

Mrs. Storer was the granddaughter of Nicholas Longworth, a wealthy pillar of the early Cincinnati community, and daughter of Joseph Longworth who endowed the Cincinnati Art School. Her husband, Bellamy Storer, was the son of a prominent judge, and himself a barrister. He served two terms as Congressional Representative before being appointed in 1887 by President McKinley to the post of Ambassador to Belgium. He later became Minister to Spain.

Mrs. Storer had been an active participant in the development of artistic interest in Cincinnati in the decade preceding the founding of Rookwood. She had worked at the Frederick Dallas Pottery as did members of the Cincinnati Women's "Pottery Club" of which Mrs. Storer was not a member, but from which she later drew heavily for artists with which to stock her company.

Admiration of the Japanese ceramics exhibit at the 1876 Centennial Exposition in Philadelphia crystallized Mrs. Storer's intention to manufacture "Art Pottery" in Cincinnati. Her experience made her realize that the existing local equipment and potteries were not adequately designed to fulfill this objective. She then set about assembling her plant and equipment, and Rookwood Pottery was born.

Mrs. Storer gathered around her the finest chemists, potters and decorators available in the local area. She also brought in the Japanese artist, Kataro Shirayamadani, to inject the influence of an advanced pottery technique which she had admired so much.

At the Paris Exposition of 1889 Rookwood Pottery received a gold medal and "the world awakened" to Rookwood. The Pottery began to pay its own way by 1890 and monetary support by the Longworth family was no longer necessary. In 1891 Mrs. Storer turned over management of the Pottery to the capable direction of W. W. Taylor. It was under the leadership of Mr. Taylor that the Pottery attained its greatest significance in pursuit of a unique American contribution to western culture.

During the years 1890-1925 Rookwood probably realized its greatest profit both in money and talent. At this time the Vellum finish was developed; the Iris glaze and Rookwood Porcelain came into being. It was also at this time that the Rookwood Faience architectural tiles and ornaments were fully developed. Such talents as Carl Schmidt, E. T. Hurley, Fred Rothenbusch, Ed. Diers, and Sturgis Lawrence were at their zenith. Kataro Shirayamadani, Matt Daly, and A. R. Valentien enjoyed international reputations. An extraordinary array of experience and talent underpinned by the many years of technical development had built the finest Art Pottery the world has ever known.

FACTORY MARKS

The factory mark identifies the manufacturer of the ware. Rookwood has used a number of factory marks. It has employed both its name, in various forms, as well as the picture-symbol type of representation associated with most European furnaces. The symbol that comes quickly to mind is the world famous monogram mark of the reversed R and P, with its wreath of flames.

This unique factory mark was used longer than any other, and was in use at the time the pottery enjoyed its greatest prestige. As a result it is this mark that is most often found on the finest of Rookwood productions. Prior to its institution the factory marks were widely varied in design and survived but a short time. They are herein explained and illustrated in the order of their occurrence, beginning with the earliest.

The most common marks prior to 1882 were the name of the pottery and the date of manufacture, either painted or incised on the base of the piece by perhaps the decorators or potters. A variation of this consisted of the initials of the Pottery, and of the founder: R.P.C.O.M.L.N. (Rookwood Pottery, Cincinnati, Ohio, Maria Longworth Nichols. Mrs. Nichols remarried in 1886 and became Mrs. Storer.) Illustrations of two of these marks are below:

From 1880 to 1882 another design used was that prepared by the famous Cincinnati artist, H. F. Farny. This factory mark was printed in black beneath the glaze, and represents a kiln with two Rooks.

The following oval mark bearing the name and address of the factory was also used for a short time.

In 1882 the following two types of marks were used. Both were impressed in a raised ribbon, and the upper one appeared on a commercial project - a large beer tankard made for the Cincinnati Cooperage Company.

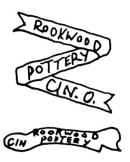

Prior to 1883 an anchor was sometimes impressed or placed in relief. It occasionally occurred in connection with an impressed date, and often in conjunction with a decorator's mark. (The illustration to the left is impressed; the one to the right appears in relief.)

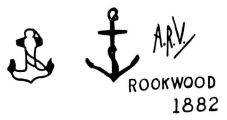

The regular mark adopted in 1882 was the word ROOKWOOD and the date in arabic numerals, impressed. This mark was in continuous use until 1886, the date being changed each year.

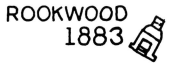

In the year 1883 a small kiln mark was impressed in the ware, and may or may not appear with the word ROOKWOOD and the date, also impressed.

ROOKWOOD 1883

The monogram mark of the reversed R, and P was adopted in 1886, although it has been found upon ware dated as early as 1882. The monogram mark and the "ROOKWOOD 1886" both exist denoting the year 1886, the ROOKWOOD mark having been used in the earlier part of the year. In 1887 a flame point was placed above the RP monogram, and one point was added each year until 1900, at which time the monogram mark was encircled by 14 flame points.

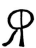
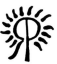

In 1901 the same mark used to indicate 1900 was continued, and the Roman numeral I was added below, to indicate the first year of the new century. The Roman numeral was subsequently changed to denote the correct year.

SHAPE NUMBERS AND SIZE SYMBOLS

Shape numbers are impressed in the clay just below the factory mark, and are usually followed by the size symbol if applicable. These numbers were assigned consecutively, and bear no direct relationship to year of manufacture or quantity produced. On early pieces the size symbol sometimes precedes the pattern number. It is also known to have appeared immediately below the pattern number, particularly on items upon which the area available for marking is limited. An example of each arrangement is shown on the following page:

568B A7 9 0 1
 C

There are three categories of shapes. 1.) The regular series which comprise the majority of the pieces produced. 2.) The "Trial" series, in which the pattern number is preceded by a "T". ("E" for experimental could not be used — "E" is a size symbol.) 3.) Those items bearing no pattern numbers at all. (These were often the result of gifts for friends, etc., and in these cases were singular items.) Each of the categories excepting #3 were numbered consecutively.

2191 T1250

Clarence Cook, in "The Studio," said "Rookwood Pottery shows good taste in adhering to the principles which are the foundation of the system of forms called classical." In later years some patterns were duplicated, (same shape different pattern number) but despite exceptions, the patterns over the years have been generally quite artistic and tastefully executed.

Size symbols are impressed in the clay next to the pattern number and are represented by six letters. The sizes of the patterns were always lettered with A representing the largest, diminishing through F. If no size letter is shown, only the one size of the pattern exists. If an A exists, at least a B must have been constructed. However, there is no basis for assuming a C existed. Likewise, if an E is encountered, an A, B, C, and D were created, but not necessarily an F. Occasionally another was created at a later date, necessitating an insertion of a new size, such as "BB". An example of each single letter is shown:

A B C D E F

Different pattern numbers having the same size letters bear no relation to each other. That is, a 907C and a 6308C have no relation in size, the former being a 14" high vase, and the latter a 7" high vase. Size ratio exists only within the category of a particular pattern or shape and is of no defined scale.

CLAY SYMBOLS

Rookwood Pottery employed a series of letter-symbols to indicate the clay used in the manufacture of the body. The clays were classified only in regard to color. The symbols were six in number and were impressed. The following letters were employed:

G O R S W Y

These indicate Ginger, Olive, Red, Sage Green, White, and Yellow. The Ginger colored clay is one that would be termed a "Buff" clay. The letter "G" and the title Ginger" were employed to avoid confusion with the size symbol "B". The letter "S" is also used in another category, that of a special symbol.

The symbols refer only to the color of the various bodies, and as such do not take into consideration the possible chemical variations within a color. The White body was the most popular and undoubtedly the one most frequently used by the potters. This color was developed and compounded in at least seven chemically different varieties to fit glazes in use at the Pottery. Often no distinction was made in them when marking the ware. In later years the clay symbol "W" was sometimes omitted.

Rookwood experimented with artificially tinted bodies as have most of the world's leading potteries, but their existence in relation to the total production is quite small. Tinted grey, blue and black bodies were utilized for the most part after 1920.

Rookwood also experimented with foreign clays to some extent; but domestic clays, and particularly those from the Ohio Valley, were most popular. The Ohio region is rich in fine clays. These are naturally colored, having been stained by the mineral deposits of the area. The Red clay was from Buena Vista, Ohio and the Yellow from Hanging Rock, Ohio.

A Yellow clay was obtained from Georgia, and a Cream colored one from Chattanooga, Tennessee; still another clay came from Florida. The existence of a Cream colored clay, as well as examples of Cream colored ware, creates speculation that there may have been a symbol for "Cream" clay in use at one time, for relatively early pieces have been found marked with a double "C".

PROCESS MARKS

At Rookwood all experiments or changes in clay, decorative materials, and glaze were carefully recorded and studied. To do so, it was necessary to identify the items after their return from the fire. Therefore the chemists, and sometimes the potters, placed identifying symbols on the pieces. They did this by incising or impressing impromptu, but recognizable designs, much as Westerners brand cattle. The precise meaning of these symbols could only be known through access to the notebooks kept by these men. For the benefit of those who may come across such symbols a few are illustrated:

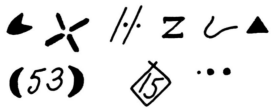

SPECIAL MARKS AND SYMBOLS

In the following paragraphs are collected and defined those marks and symbols which do not fit precisely into a prior category. These marks are not to be considered of any lesser importance than those comprising the other categories, because they also contribute invaluably to the understanding of the history and significance of the piece of Rookwood Pottery in question. Some are old. Others are of more recent composition. None are without precise meaning and purpose, though that be temporarily unknown.

The first mark to be considered, is the one that will be encountered most frequently. This is the "X" mark used to indicate a piece of secondary quality. Rookwood ware from its inception was graded into three classifications. These are: (1.) Those items of the best quality, that is, most nearly flawless. (No critisism of art work was involved, according to my friend Virginia Cummins, who was employed in the salesroom.) (2.) Those items displaying obvious technical faults, such as glaze bubbles, minor discolorations, kiln cracks, warp, and other manufacturing defects. It was this category of ware which was so designated by the "X" mark. (3.) Those items defective to the point of ruination of either their utility, decoration, or both. These were destroyed.

The "X" mark indicating secondary quality was usually cut into the underside of the piece, by means of a grinding wheel, much the same as that used to remove excess glaze from the resting surface of an item. The mark was also known to have been cut into the decorated surface of some pieces, and in these cases, undoubtedly contributes additionally to the undesirableness of the piece. The mark was not generally accurately cut, and as a result may appear as a "V" like score in the body, however, there is no reason to confuse this with the Vellum "V" mark, which is explained later in this same category. The "X" mark is generally large, and appears as a deeply ground score in the body, as follows:

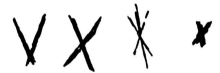

The category of second quality was usually determined in the showroom, by those in charge. The sales personnel had access to a grinding wheel, and cut the second mark themselves. It is presumed that the decorators could also request that an item of their work be adjudged as secondary quality. The extent to which this was done, if any, is not known. The third example from the left is a wheel ground "X" with an additional cut through the center which was used for items to be given away. "Give away" recipients ranged from visitors of note to unsold pieces "raffled" at company sponsored parties for employees. In later examples (circa 1940) a single wheel ground line has been found, which may have been the equivalent of an "X".

As any collector can attest, the judgment of secondary items over a period of years as represented by pieces of varying age, appears rather whimsical. Many items so marked contain only flaws of a very minor nature. In contrast, items are known with kiln cracks of several inches or more, and are not marked seconds. Regardless of the apparent overlapping of categories, and inconsistent application of standards, a second is less valuable. The second quality items were placed on a separate table at the Pottery, and marked down, in relation to items of first quality.

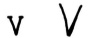

The examples above show the two varieties of the "V" mark which was used to designate the Vellum line. This particular glaze was first introduced in 1904 and is credited to the efforts of the plant chemist Stanley G. Burt.

The Vellum mark always appears on the bottom of the item, apart from the factory mark, so that it can never, be confused with the date 1905 (V). It is either impressed, in which case it is in the form of a printed "V", or incised. It is believed the impressed "V" refers to a "vellum" body, and the hand incised "V" refers to the decorators desire to have the piece "vellum" glazed. This explanation is based upon empirical evidence, and the double "V" occurs mostly within the mid-range years of vellum production. The possibility of mismarked items is rather remote, and although this has undoubtedly occurred, the Pottery was rather well organized at the time Vellum was manufactured, and an error of this type would be unusual. After seeing several Vellum pieces and examining them closely, it becomes increasingly easier to identify, and reference to the "V" mark serves only as a verification of one's knowledge.

The Vellums are one of the most beautiful and unusual of all the Rookwood creations. To describe Vellum in its simplest terms Rookwood's master potter, Earl Menzel, said, "It is merely a transparent mat, developed in the fire." The implication of this, is that Rookwood was the first pottery to develop this glaze without the aid of chemical or mechanical means. The Vellum glaze won a Gold Medal at the St. Louis World's Fair in 1904.

S

The above letter "S" was impressed in the clay of Rookwood as an indication that the particular item had been created as a "special" shape (perhaps at the request of a decorator) and was not assigned a normal sequential shape number. However, one must be careful to distinguish between the "S" indicating the Sage Green clay (see: clay marks) and the "S" indicating the potter's handiwork. This is a relatively easy distinction to make, for the Sage Green clay is a pale olive color, and is easily recognized on the unglazed portions of the under surface. In addition, Sage Green bodies usually lent themselves to decoration in tones of green, brown, and yellow.

In the case of a Sage Green clay piece which was thrown by hand, the piece would bear two "S's". Examples of this nature do in fact exist, as do all the other combinations of clay marks and the potter's "S".

P

The above letter, impressed in the paste, represents the term, "Porcelain." It was introduced at Easter, 1915, after Rookwood had developed a "porcelainized" body, and accompanying high gloss glaze. The body is not a true porcelain, but should be more correctly termed a "soft-porcelain" or "semi-porcelain."

These pieces were generally decorated in light colors. This was probably due to the high glaze maturity and body vitrification temperatures, conditions which tend to "burn out" deeper colors. This body has a slightly irridescent appearance, and in the thinner pieces a translucence will be evident when exposed to a strong light. The colors and manner of decoration surpassed those of the Copenhagen furnaces, and magnificent blues had been developed. The ware was quite costly to produce, and was subsequently abandoned for a ware referred to as "Jewel Porcelain."

Jewel Porcelain was also a "porcelainized" or vitreous body, but employed a distinctively different glaze, which was characterized by a running of the colors. This ware was manufactured for quite some time. It bore no body or glaze mark of its own, nor did it bear the "P" mark.

The "L" mark, as illustrated above, is found incised into older pieces of Rookwood in conjunction with the "Standard" glaze. The items are decorated, and the "L" is often under the decorator's mark, as shown in the second example, having been incised by the decorator himself. There is no apparent relationship between this mark and that of a specific decorator. It is found with the marks of all decorators of the period.

The letter refers to the decorator's choice of glaze to be employed. "L" refers to a lightly colored standard glaze and an M (not illustrated) refers to a Mahogany tinted standard glaze, The "D" for a dark standard glaze, was also used, and the script "G" (example 3) refers to the sea green glaze. The sea green glaze "G" is also found impressed as a capital G.

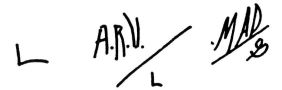

The above examples of the printed name "CINCINNATI" were used in an effort to identify the name of Rookwood with the city in which it was founded and had prospered. The impressions were always used in addition to the other standard symbols, factory marks, etc. This practice was originated circa 1920, and the symbol used from time to time on various productions. The mark on the extreme left appeared as a wreath over the factory symbol, RP with flames. The marks to the right appeared as later examples. The correlation between years and the use of these marks does not have any significance beyond the fact that the Pottery was attempting to hold its position of prestige in relation to its competitors; hence the inclusion of the name of the Pottery. Other varieties of the city name are known to exist.

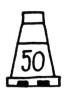 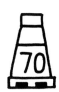 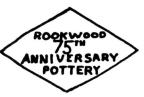

The above marks were created for the pieces of Rookwood ware produced during the year of an anniversary. The first such anniversary mark is the one signifying Rookwood's Fiftieth Year, 1930. This mark was usually applied in the form of an underglaze color, (blue or black) and represents a kiln with the number 50 within it. The mark used for the Seventieth Year is also a kiln with the number 70 contained in it, but differs in that it is also found impressed in the clay, and often accompanied by the name ROOKWOOD impressed alongside. The third anniversary mark at the right took the form of a diamond and signified Rookwood Pottery's 75th birthday.

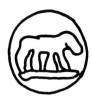

This mark appears on the underside of a Rookwood ashtray depicting one of the masks of drama, but is not a Rookwood mark. The pattern is an exact reproduction of an item brought from Italy by Mr. J.D. Wareham, director of the Pottery. The original pattern bore the mark in question, and therefore, it was preserved in the reproduction. The relief form represents Romulus, Remus and their Wolf Mother of Roman Mythology.

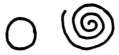

The above marks were instituted by Rookwood's master potter, Earl Menzel. The whorl was impressed on the underside of many thrown pieces and was merely an idiosyncrasy of the potter. The mark was made on the lathe, and is usually unaccompanied by Mr. Menzel's signature. It can be assumed to be a synonym for his mark, for these pieces were produced by his hand. The circle was applied, as an impression, to pieces whose shape might make them suitable for use as lamps, and was intended as a guide for drilling.

Initials, names, and inscriptions are also found incised into the decorative surface of some Rookwood. These are not marks, but the results of creation of pieces for friends, and commemoration of special events, and as such do not require further explanation.

ARTISTS' AND DECORATORS' MARKS

It became the custom at the Rookwood Pottery for the artists to incise or paint their initials or monograms on the pieces decorated or sculptured by them but this was not always so. In the fledgling days of the Pottery the signing of work was discouraged. Soon, however, a preference for the signed pieces made itself felt in the market, and the Pottery changes its policy. One must remember that these Artists' initials are presented here in their most ideal state — many hurriedly written examples exist, making the commonest of monograms sometimes impossible to decipher.

The artists not only cut their initials into the bottom of the ware, but painted them on, using some of the underglaze "paint" or engobe that was in use at the moment. This method was also employed when the artists signed pieces on the decorated surface. Many used their full names if their pieces were a special effort.

Marks were also impressed. This was done through the construction of a die, much the same as that employed to impress the factory mark. The decorators or potters formed these from clay, and once fired, they were permanent in nature and could be used repeatedly. It was necessary, of course, to construct them in reverse, the same as a rubber stamp. One artist intentionally failed to observe this rule, and as a result Carl Schmidt's mark is "mirrored," or reversed.

The use of dies was practiced primarily by the decorators of later years. Readily recognizable examples of these dies are the marks of Margaret Helen McDonald and Mary Graze Denzler.

There are decorators in the accompanying list. Some of these have as many as four different marks attributed to them. They are presented in the order of what is believed to be their earliest mark, first. An effort has been made to limit this presentation to only those marks and symbols which have been positively identified, and no full signatures have been included for these are self-explanatory.

Approximately one dozen other "decorators" marks will be found accompanying ware, circa 1946. These people are not identified in the following listing for they were designated as "junior artists" and did not participate in projects of original composition as did the staff artists. Their marks are found applied in underglaze color, and their duties consisted of applying specific colors to prepared designs.

Name	Mark	Name	Mark
Abel, Edward	E.A.	Cranch, E. Bertha I.	E.B.I.C.
Abel, Louise	(A)	Cranch, Edward P.	E.P.C EPG
Altman, Howard	HA.	Crofton, Cora	E
Asbury, Lenore	L.A.	Daly, Matt A.	MAD MADaly
Auckland, Fannie	FA	Demarest, Virginia B.	VBD
Auckland, William	WA WA	Denzler, Mary Grace	MGD
Baker, Constance A.	C.A.B.	Dibowski, Charles John	C.J.D.
Barrett, Elizabeth	EB	Diers, Edward	ED.
Bishop, Irene	I.B.	Duell, Cecil A.	(AD
Bonsall, Caroline F.	C.F.B.	Epply, Lorinda	E
Bookprinter, Anna M.	AMB AB	Fechheimer, Rose	R.F. R
Brain, Elizabeth W.	EWB	Felten, Edith R.	E.R.F.
Brennan, Alfred	AB	Foertmeyer, Emma D.	E.D.F.
Breuer, W. H.	WHB WB	Foglesong, Mattie	MF
Caven, Alice	AC	Fry, Laura A.	LA LA
Conant, Arthur P.	C	Furukawa, Lois	LF
Conant, Patti M.	PC	Glass, William T.	WG
Cook, Daniel	D.C.	Goetting, Arthur	AG
Covalenco, Catherine	CC	Hall, Grace M.	G.H.
Coyne, Sallie E.	S.E.C. SE	Hanscom, Lena E.	L.E.H.
Crabtree, Catherine	CC	Harris, Janet	JH

Name	Mark
Hentschel, W. E.	
Hickman, Katharine	
Hicks, Orville	*Hicks*
Hirschfeld, N. J.	N.J.H.
Holtkamp, Loretta	
Horsfall, Bruce	
Horton, Hattie	H.H.
Humphreys, Albert	A.H.
Hurley, Edward T.	E.T.H.
Jensen, Jens	
Jones, Katherine	KJ
King, Flora	FK.
King, Ora	
Klemm, William	W.K.
Klinger, Charles	
Koehler, F. D.	K
Laurence, Sturgis	S.L.
Lawrence, ELiza C.	ECL
Ley, Kay	LEY
Lincoln, Elizabeth N.	LNL
Lindeman, Clara C.	C.C.L.
Lindeman, Laura E.	L.E.L.
Lunt, Tom	TOM
Lyons, Helen M.	H.L.
Markland, Sadie	S.M.
Matchette, Kate C.	K.C.M.
McDermott, Elizabeth F.	
McDonald, Margaret Helen	MM
McDonald, William P.	WPMcD
McLaughlin, Charles J.	
Menzel, Reuben Earl	
Mitchell, Marianne D.	
Moos, Herman	HM
Munson, Albert	AM
Newton, Clara Chipman	C.N
Nichols, Maria Longworth	M L N
Noonan, Edith	EN.
Nourse, Mary	M.N.
Perkins, Mary Luella	MLP
Peters-Baurer, Pauline	
Pons, Albert	
Pullman, J. Wesley	

Name	Mark			
Rauchfuss, Marie	MR.			
Reed, O. Geneva	O.G.R.			
Rehm, Wilhelmine	WR			
Rettig, Martin	MR			
Rothenbusch, Fred	R			
Sacksteder, Jane	JS			
Sax, Sara	S.S.	𝄞	𝄞	
Scalf, Virginia	VS			
Schmidt, Carl	ℰ	⊚		
Sehon, Adeliza D.	A.D.S.			
Seyler, David W.	DWS			
Shirayamadani, Kataro	KS			
Smalley, Marian H.	M·H·S·			
Sprague, Amelia B.	ABS	ℬ		
Stegner, Carolyn	ℬ			
Steinle, Carrie F.	S	C.F.S.	C.S.	
Storer, Maria Longworth (Nichols)	M L S	M.L.N.		
Strafer, Harriette R.	H.R.S.			
Stuntz, H. Pabodie	⚜			
Swing, Jeanette	⚜			
Taylor, Mary A.	𝔐	𝔐		
Tischler, Vera	VT			
Todd, Charles S.	C.S.T.			
Toohey, Sallie	ℑ	ℑ	ℑ	ℑ
Valentien, Albert R.	A.R.V.			
Valentien, Anna M.	a.m.v.			
Van Briggle, Artus	AVB	AB		
Van Briggle, Leona	LVB.			
Van Horne, Katherine	K.H.			
Vreeland, Francis W.	F.V.			
Wareham, John D.	JDW	JDW	JDb.	
Wenderoth, Harriet	H.W.			
Wilcox, Harriet E.	H.E.W.			
Wildman, Edith L.	ELW			
Willitts, Alice	W			
Workum, Delia	DW			
Young, Grace	⚘			
Zanetta, Clotilda	C Z.			
Zettel, Josephine E.	茾	茾	茾	

ALPHABETICAL LIST OF ARTISTS AND THEIR WORKS BY CATALOG NUMBER

ROOKWOOD

Abel, Louise, 59, 493, 563

Altman, Howard, 550

Architectural Faience, 225, 402, 613, 617

Asbury, Lenore, 72, 155, 161, 234, 377, 387, 392, 411, 455, 475, 489, 514, 523, 566, 577, 585, 604, 611, 636

Auckland, Fanny, 142

Baker, Constance, 40, 135, 413

Barrett, Elizabeth, 11, 65, 113, 175, 189, 262, 465, 600, 635

Bishop, Irene, 19, 106, 376, 472, 580, 619

Bookprinter, Anna, 117

Brain, Elizabeth and Unknown, 37

Brennan, Alfred, 130

Commercial, 2, 9, 10, 15, 21, 24, 43, 46, 50, 66, 67, 80, 82, 98, 101, 111, 116, 129, 145, 146, 156, 166, 180, 181, 186, 214, 217, 230, 235, 252, 259, 265, 266, 269, 381, 389, 396, 398, 408, 415, 420, 423, 426, 431, 437, 439, 444, 453, 462, 469, 473, 474, 484, 488, 491, 508, 512, 513, 515, 517, 524, 527, 536, 547, 548, 551, 557, 561, 574, 575, 582, 594, 598, 602, 639, 647

Conant, Arthur, 169, 199, 391, 607

Cook, Daniel, 229

Coyne, Sallie, 30, 31, 34, 36, 85, 120, 153, 185, 188, 206, 212, 219, 410, 418, 445, 456, 477, 519, 525, 553, 581, 622, 642

Daly, M.A., 83, 103, 194, 383, 606

Demarest, Virginia, 33, 190, 228, 610

Denzler, Mary Grace, 176

Diers, Ed, 16, 39, 53, 63, 122, 167, 183, 184, 243, 257, 373, 384, 405, 460, 463, 501, 518, 528, 539, 569, 571, 578, 584, 588, 596, 643, 651

E.H.C., 48

Epply, Lorinda, 4, 148, 165, 170, 203, 231, 248, 253, 261, 263, 442, 476, 492, 505, 638, 644

Fechheimer, Rose, 78, 138, 200, 386, 605, 628

Felten, Edith, 41, 226

Fry, Laura, 79

Furukawa, Lois, 546

Hanscom, Lena, 429

Harris, Janet, 430

Hentschel, William, 86, 108, 227, 240, 247, 268, 379, 390, 397, 399, 446, 454, 479, 486, 537, 542, 590, 615

Hickman, Katherine, 385, 620

Holtkamp, Loretta, 516

Horsfall, Bruce, 164, 564

Horton, Hattie, 95

Humphreys, Albert, 38

Hurley, E.T., 77, 104, 136, 151, 177, 201, 221, 239, 254, 451, 458, 459, 482, 526, 529, 530, 531, 532, 533, 534, 535, 609, 625

Jensen, Jens, 29, 163, 211, 224, 270, 378, 545, 576, 612, 616, 630, 640, 653

Jones, Katherine, 159, 196, 433

King, Flora, 256

King, Ora, 110

Klemm, William, 20

Klinger, Charles, 403, 494

Ley, Kay, 400

Lincoln, Elizabeth, 1, 5, 7, 32, 74, 105, 197, 209, 232, 233, 236, 245, 394

Lindeman, Clara, 13, 470

Lindeman, Laura, 143, 144, 182

Lyons, Helen, 69

Markland, Sadie, 90

Matchette, Kate, 436

ROOKWOOD continued

McDermott, Elizabeth, 416, 428

McDonald, Margaret, 92, 99, 204, 271

McDonald, William, 137, 443, 507, 558

McLaughlin, Charles, 112, 554, 555

McLaughlin, Mary Louise, 614

Menzel, Earl, 17

Mitchell, Marianne, 109, 499

Moos, Herman, 12, 47

Munson, Albert, 44, 149, 213

Nichols, Maria Longworth, 223, 374, 485

Noonan, Edith, 497

Nourse, Mary, 73, 215, 599, 621

Perkins, Louella, 380

Pons, Albert, 133

Pullman, John Wesley, 81

Reed, Olga Geneva, 438

Rehm, Wilhelmine, 650

Rettig, Martin, 22, 23, 125, 141, 267

Rothenbusch, Fred, 57, 75, 89, 96, 123, 174, 192, 193, 210, 238, 272, 393, 407, 409, 425, 461, 466, 471, 487, 495, 496, 509, 543, 552, 560, 589, 591, 603

Sax, Sara, 27, 60, 62, 68, 76, 93, 131, 162, 208, 264, 395, 447, 500, 503, 504, 538, 540, 559, 562, 565, 567, 568, 592, 597, 608, 623, 629, 632, 646, 649

Schmidt, Carl, 58, 126, 147, 168, 179, 191, 216, 220, 242, 375, 382, 450, 480, 626, 631

Sehon, Adeliza, 61, 237

Shirayamadani, Kataro, 42, 45, 56, 118, 124, 157, 187, 207, 218, 249, 388, 404, 406, 417, 419, 421, 432, 435, 452, 457, 467, 481, 490, 506, 521, 541, 573, 586, 618, 627, 637, 648

Sprague, Amelia, 6, 152

Steinle, Carrie, 14, 178, 246, 654

Strafer, Harriette, 100, 449, 479

Stuntz, Helen, 107

Swing, Jeannette, 579

Todd, C.S., 94, 172, 173, 483, 511, 520, 522, 595, 641, 652

Toohey, Sallie, 8, 18, 49, 70, 115, 158, 258, 422, 502, 633

Unknown, 3, 55, 84, 87, 102, 132, 139, 160, 195, 205, 255, 414, 424, 427, 593, 645

Valentien, Albert, 25, 28, 52, 64, 97, 121, 127, 150, 222, 241, 448, 498, 510, 572, 601, 634,

Valentien, Anna, 26, 119, 244, 587

Van Horne, Katherine, 88, 134, 140, 202, 441, 624

Vreeland, Toby, 250

Wareham, John Dee 54, 401, 556

Wenderoth, Harriet, 114

Wilcox, Harriet, 71, 91, 171, 198, 251, 260, 412, 434

Wildman, Edith, 468

Willitts, Alice, 570

Young, Grace, 51, 128, 154, 464, 549

Zanetta, Clotilda, 583

Zettel, Josephine, 35, 440, 544

ALPHABETICAL LIST OF ARTISTS AND THEIR WORKS BY CATALOG NUMBER

KERAMICS

ALPHABETICAL LIST OF POTTERIES AND THEIR WORKS BY CATALOG NUMBER

KERAMICS

SATURDAY
JUNE 11TH
1994
FIRST ROOKWOOD SESSION
LOTS 1-272

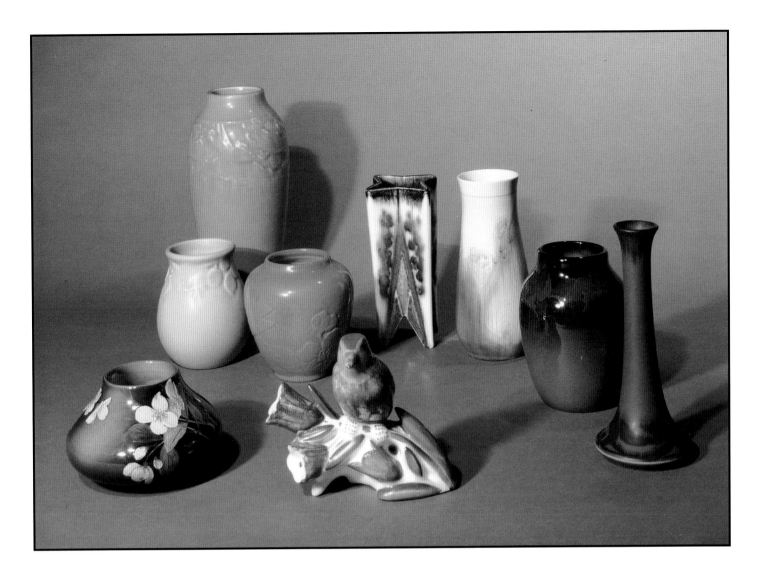

1 Standard glaze vase with clearly detailed dogwood flowers painted in 1894 by Elizabeth Lincoln. Marks on the base include the Rookwood logo, the date, shape number 536 E, W for white clay and the artist's initials. Height 3⅛ inches — $250-350

2 Group of three mat glaze Commercial vases in various colors, made at Rookwood in 1921, 1946 and 1947. Marks on the bases include Rookwood logos, dates, shape numbers 2481, 6459 and 2122. Height of the tallest piece is 9¼ inches. All in excellent condition. — $350-450

3 Polychromed bluebird paperweight decorated in 1946, most likely by a Junior Decorator. Marks on the base include the Rookwood logo, the date, shape number 6837, the number 644 in black slip and the artist's monogram in black slip. Height 5 inches. Exhibited: "Rookwood Pottery" The Yuma Art Center, 1978, catalog number 147. — $250-350

4 High glaze vase with four small feet decorated in 1928 by Lorinda Epply using repeating geometric designs. The interior is lined with mottled, slightly iridescent colors which drip down the outside rim. Marks on the base include the Rookwood logo, the date, shape number 6047 and the artist's monogram. Height 6¼ inches. Uncrazed. — $400-600

5 Mat glaze vase with stylized fruit blossoms, painted in 1921 by Elizabeth Lincoln. Marks on the base include the Rookwood logo, the date, shape number 1930 and the artist's initials. Height 6¾ inches. There are runs in the background colors but the piece was not marked with an "x". — $300-400

6 Standard glaze vase with autumn maple leaf decoration, painted by Amelia Sprague in 1901. Marks on the base include the Rookwood logo, the date, shape number 654 C and the artist's monogram. Height 5¼ inches. — $300-400

7 Mat glaze vase with black floral decoration on a purple ground, done in 1924 by Elizabeth Lincoln. Marks on the base include the Rookwood logo, the date, shape number 2307 and the artist's initials. Height 7⅛ inches. — $300-400

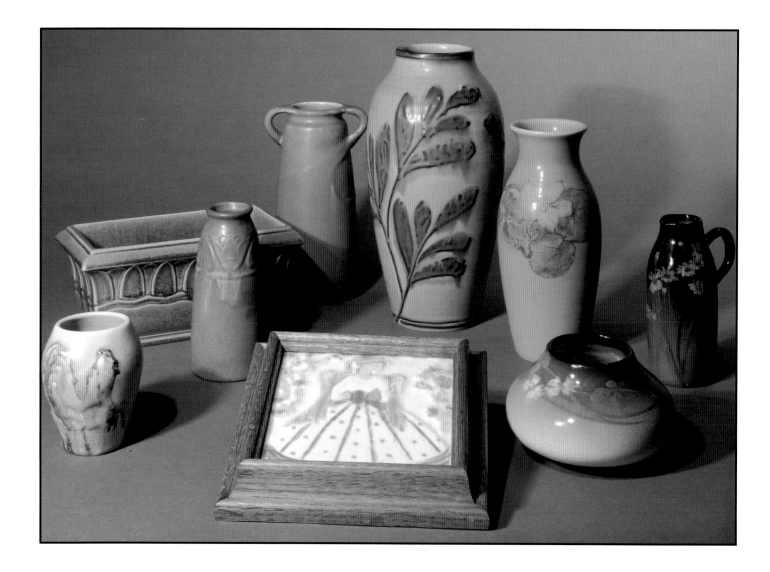

8 Mat glaze vase with a carved and painted rooster, done in 1905 by Sallie Toohey. Marks on the base include the Rookwood logo, the date, shape number 942 F, a wheel ground x and the artist's monogram. Height 3¾ inches. Glaze runs.

$500-700

9 Group of three Rookwood Commercial pieces including two vases and a planter, made in 1915, 1922 and 1923. Marks on the bases include Rookwood logos, dates and shape numbers 2113, 2865 and 2331. Height of the tallest piece is 7¾ inches. All in excellent condition.

$400-500

10 Colorful Vellum glaze trivet showing a young woman in formal dress standing in a rose bough. Marks on the back include the Rookwood logo, the date and shape number 3070. Size is approximately 5½ x 5½ inches. Uncrazed and recently framed.

$300-400

11 Tall Mat glaze vase with Art Deco floral decorations done in heavy slip, most likely by Elizabeth Barrett in 1931. Marks on the base include the Rookwood logo, the date, shape number 977 and a fan shaped esoteric mark. Height 10½ inches. Minor glaze discoloration and small glaze bubbles. Although not artist signed, the style is very reminiscent of Barrett.

$400-600

12 Mat glaze vase with colorful nasturtium decoration, done in 1924 by Herman Moos. Marks on the base include the Rookwood logo, the date, shape number 117 D and the artist's monogram. Height 8⅛ inches. One or two glaze bubbles near the base.

$500-700

13 Iris glaze vase with white clover decoration, painted in 1906 by Clara Lindeman. Marks on the base include the Rookwood logo, the date, shape number 536 E, W for white (Iris) glaze and the artist's initials. Height 3¼ inches.

$600-800

14 Standard glaze pitcher with floral decoration painted in 1902 by Carrie Steinle. Marks on the base include the Rookwood logo, the date, shape number 819, a Burley & Co. Chicago paper label and the artist's monogram. Height 5⅛ inches.

$300-400

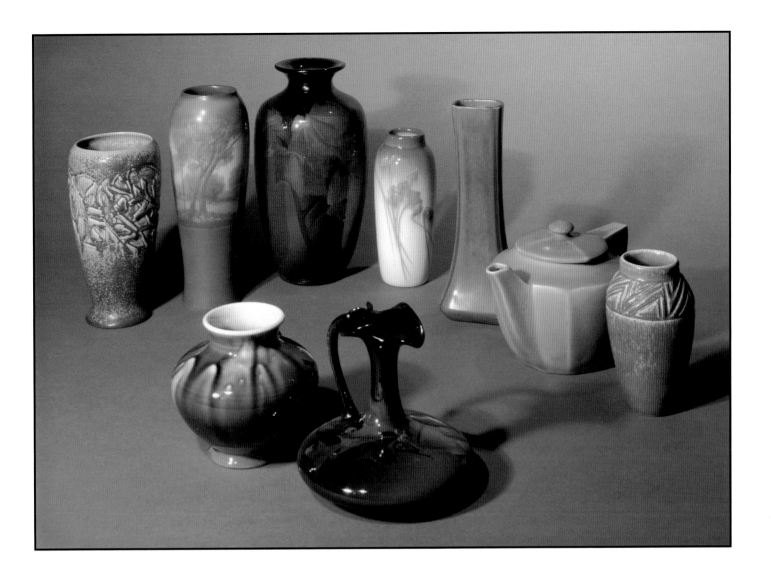

15 Commercial vase with embossed oak leaf and acorn decoration, covered in a crystalline blue over brown mat glaze at Rookwood in 1924. Marks on the base include the Rookwood logo, the date and shape number 2590. Height 7⅝ inches. Whatever its name, this is one of Rookwood's nicest mat glazes $200-300

16 Clean and crisp Vellum glaze banded scenic, painted in 1917 by Ed Diers. Marks on the base include the Rookwood logo, the date, shape number 2040 D, V for Vellum glaze and the artist's monogram. Height 9⅜ inches. Uncrazed and, rarely, are Vellums uncrazed from this period. $1500-2000

17 Multicolored vase in high glaze made at Rookwood in 1953 by Earl Menzel. Marks on the base include the Rookwood logo, the date, S for Special shape and Menzel's monogram and swirl mark. Height 4½ inches. A nice combination of glazes, this piece harkens back to the "1932" pieces which are thought to be the work of Menzel during the Depression when work was slow. $300-400

18 Standard glaze vase decorated with autumn maple leaves, done in 1901 by Sallie Toohey. Marks on the base include the Rookwood logo, the date, shape number 903 B and the artist's monogram. Height 10 inches. $400-600

19 Iris glaze vase with wild violet decoration by Irene Bishop done in 1907. Marks on the base include the Rookwood logo, the date, shape number 907 F, W for white (Iris) glaze and the artist's monogram. Height 6⅞ inches. The dark blue slip used in the flowers has run a bit. $800-1200

20 Standard glaze ewer with holly decoration painted in 1900 by William Klemm. Marks on the base include the Rookwood logo, the date, shape number 715 DD and the artist's monogram. Height 5⅞ inches. Exhibited: "Rookwood Pottery" The Yuma Art Center, 1978, catalog number 47. $350-450

21 Group of three Rookwood Commercial mat glaze pieces including two vases and a lidded teapot, made in 1913, 1922 and 1923. Marks on the bases include Rookwood logos, dates and shape numbers 913 F, 2249 and 697. Height of the tallest piece is 9¼ inches. All in excellent condition. $400-600

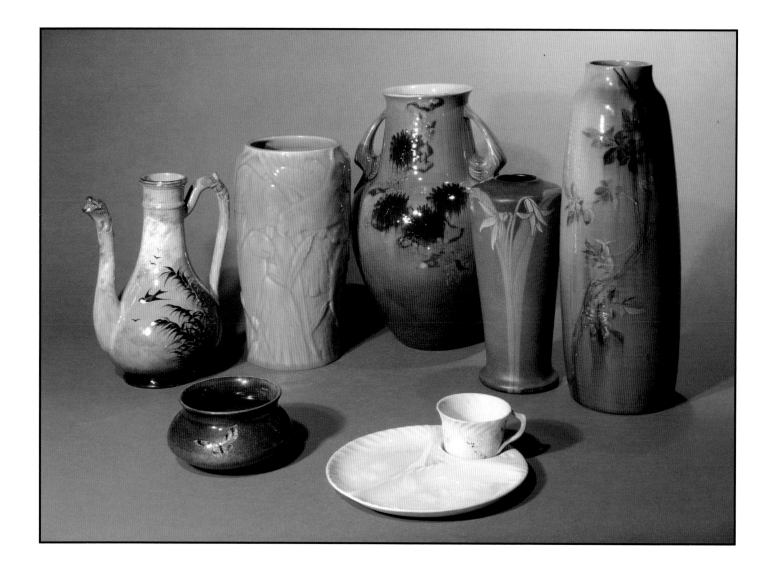

22 Turkish coffee pot in Limoges style glaze decorated with several swallows and oriental grasses in 1883 by Martin Rettig. Marks on the base include Rookwood in block letters, the date, shape number 51, G for ginger clay, a raised anchor mark and the incised name, "M. Rettig". Height 9⅛ inches. Missing lid. — $300-400

23 Nicely detailed Standard glaze bowl with grasses on one side and a pretty butterfly on the other, painted in 1885 by Martin Rettig. Marks on the base include Rookwood in block letters, the date, shape number 82, G for ginger clay and the artist's initials. Height 2½ inches. — $350-450

24 Commercial vase designed by Kataro Shirayamadani and made at Rookwood in 1929. Embossed on the vase are several highly detailed parrots perched in jungle foliage, the piece is covered in a translucent blue high glaze which allows the tan clay underneath to show through at high points. Marks on the base include the Rookwood logo, the date, shape number 6088 and a wheel ground x. Height 10½ inches. The glaze is fairly thick at the base and consequently several grinding chips are present, the largest about ¼ inch square. — $300-400

25 Large two handled Standard glaze vase by Albert Valentien, painted in 1888 and once part of the Rookwood on loan to the Cincinnati Art Museum. Decoration consists of chrysanthemums and oriental ribbons and, although not easy to see, there are patches of Tiger Eye effect especially in the lower half of the vase. Marks on the base include the Rookwood logo, the date, shape number 339 B, W for white clay, L for light Standard glaze, the number "179:00" indicating CAM acquisition and the artist's initials. Height 13 inches. There are several small blisters and minor inclusions in the glaze. — $1250-1500

26 Cameo glaze cup and salad plate with floral decoration, painted in 1888 by Anna Valentien. Marks on the plate include the Rookwood logo, the date, shape number 258, W for white clay, an incised W for white (Cameo) glaze and the artist's initials. The cup is marked with an incised W for white (Cameo) glaze and the artist's initials. Diameter of the plate is 8 inches. — $400-500

27 Rare Green Vellum glaze vase with three sets of tall yellow flowers and green leaves painted in 1909 by Sara Sax. Marks on the base include the Rookwood logo, the date, shape number 1652 D, V for Vellum glaze body, G.V. for Green Vellum glaze, a wheel ground x and the artist's monogram. Height 9⅛ inches. Glaze losses around half the foot account for the "x" and these have been professionally repaired. — $500-700

28 Tall Standard glaze vase, obviously hand thrown, decorated in 1889 by Albert Valentien with roses. Marks on the base include the Rookwood logo, the date, shape number 269 A, G for ginger clay, L for light Standard glaze and the artist's initials. Height 15 inches. There are several small blisters and inclusions in the glaze but the overall effect is quite impressive. — $1000-1500

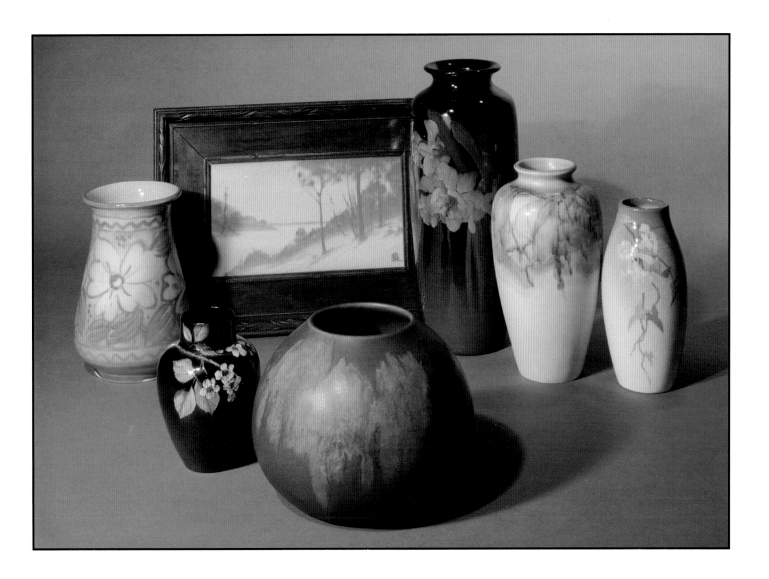

29 High glaze vase with overall floral decoration, painted in 1946 by Jens Jensen. Marks on the base include the $800-1000
 Rookwood logo, the date, shape number 6359, the number "95" in reddish brown slip and the artist's monogram.
 Height 7⅛ inches. The vase is uncrazed but has some minor glaze skips on the foot.

30 Standard glaze vase with nicely contrasting fruit blossoms on a dark ground, done in 1894 by Sallie Coyne. Marks $200-300
 on the base include the Rookwood logo, the date, shape number 162 D, W for white clay and the artist's initials.
 Height 5 inches. Damage to the rim has been professionally repaired. Minor glaze scratches.

31 Vellum glaze snow scene plaque painted in an Arts & Crafts manner by Sallie Coyne in 1919. The artist's $2000-2500
 monogram appears in the lower right hand corner. Marks on the back include the Rookwood logo and the date.
 Size is 5 x 9⅛ inches. Original frame. Exhibited: "Rookwood Pottery" The Yuma Art Center, 1978, catalog number
 78.

32 Mat glaze vase with rather abstract designs, done in 1922 by Elizabeth Barrett. Marks on the base include the $400-600
 Rookwood logo, the date, shape number 703 and the artist's initials. Height 5½ inches.

33 Tall Standard glaze vase with jonquil decoration, painted in 1902 by Virginia Demarest. Marks on the base $800-1000
 include the Rookwood logo, the date, shape number 904 C and the artist's initials. Height 11¾ inches. Very minor
 glaze scratches.

34 Mat glaze vase with red and green flowers on a yellow ground, painted in 1928 by Sallie Coyne. Marks on the $800-1000
 base include the Rookwood logo, the date, shape number 614 E and the artist's monogram. Height 8¼ inches.
 Very Clean.

35 Colorful Iris glaze vase decorated in 1903 by Josephine Zettel with yellow trumpet creepers and vines. Marks on $800-1000
 the base include the Rookwood logo, the date, shape number 939 D, an incised W for white (Iris) glaze and the
 artist's monogram. Height 6⅞ inches.

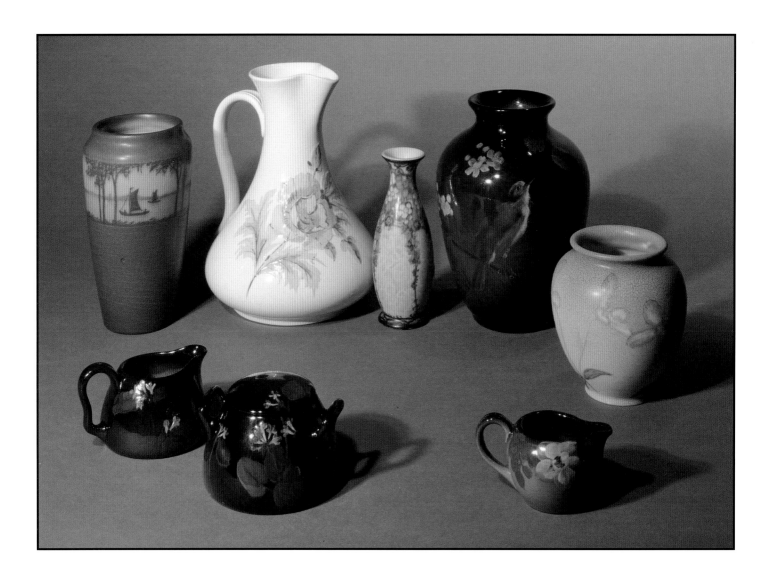

36 Rare Green Vellum glaze banded scenic vase done in 1909 by Sallie Coyne. Several sailboats are framed by the $2500-3500
 silhouettes of trees in the foreground. Marks on the base include the Rookwood logo, the date, shape number
 1369 E, V for Vellum glaze body, V/G for Green Vellum glaze and the artist's monogram. Height 7⅜ inches.

37 Standard glaze creamer and covered sugar bowl with floral decoration, painted in 1899 by Elizabeth Brain and $400-500
 an unknown artist. Both pieces have the same floral motif but different artist's marks. Marks on the base include
 the Rookwood logo, the date, shape number 770 and the artist's monograms. The sugar bowl is signed by Brain
 and is 3 inches tall. The creamer bears an unidentifiable mark and is 2½ inches tall.

38 High glaze pitcher with bright pink flowers, buds and leaves, painted in 1882 by Albert Humphreys. Marks on the $300-400
 base include Rookwood in block letters, the date, the number "8", an impressed anchor and the artist's initials.
 Height 9 inches. Exhibited: "Rookwood Pottery" The Yuma Art Center, 1978, catalog number 5, illustrated.

39 Vellum glaze vase with colorful trailing floral decoration done on a mottled green background. Painted in 1923 $400-600
 by Ed Diers, the piece is marked with the Rookwood logo, the date, shape number 357 F, V for Vellum glaze, a
 wheel ground x and the artist's monogram. Height 6¼ inches. Uncrazed.

40 Standard glaze vase with a small bird perched on a wild rose branch, done in 1900 by Constance Baker. Marks $600-800
 on the base include the Rookwood logo, the date, shape number 814 B and the artist's initials. Height 8⅛ inches.
 A moderately sized rim chip has been professionally repaired.

41 Standard glaze creamer with wild rose decoration by Edith Felten, painted in 1901. Marks on the base include the $150-200
 Rookwood logo, the date, shape number 832 and the artist's initials. Height 2⅛ inches.

42 Colorful mat glaze vase with floral decoration, done in 1939 by Kataro Shirayamadani. Marks on the base include $800-1200
 the Rookwood logo, the date, S for Special shape and the artist's cypher. Height 5 inches.

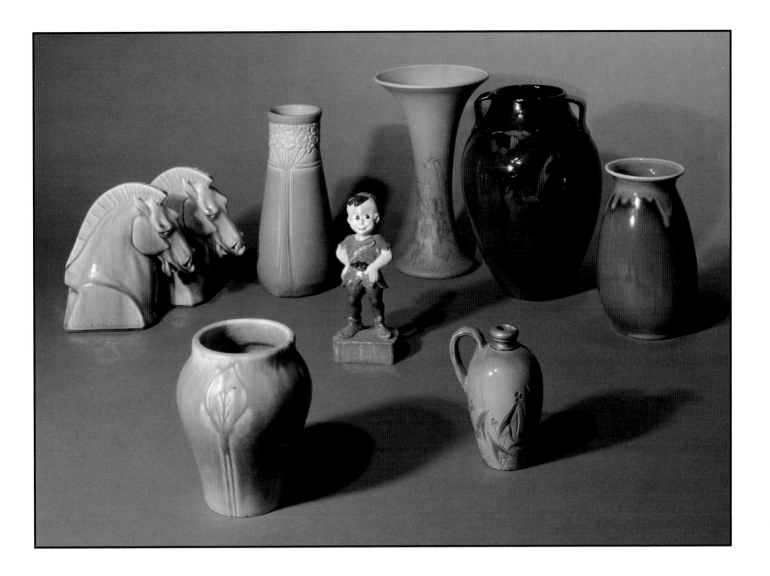

43 Commercial horse head bookends in Wine Madder glaze, made at Rookwood in 1956. Marks on the base $300-400
include the Rookwood logo, the date, shape number 6014 and the notation, "Rookwood Cinti.O.". Cast into the
side of each piece is their designer's name, William P. McDonald. Height 6 inches. There is a firing crack in the
base of one piece which enters the side about one inch.

44 Early mat glaze vase with three incised leaves, done in 1901 by Albert Munson. Marks on the base include the $300-500
Rookwood logo, the date, shape number 24 Z and the artist's monogram. Height 5⅛ inches.

45 Rare and handsome carved mat glaze vase done by Kataro Shirayamadani in 1904. Decoration consists of three $2000-2500
heavily carved, stylized flowering plants whose stems divide the vase into three panels. The yellow flower heads
join in a band encircling the piece near the rim. Marks on the base include the Rookwood logo, the date, shape
number 950 D, V for Vellum glaze body and the artist's cypher. Height 8⅛ inches. A stilt pull extends barely into
the side of the piece.

46 Rare, possibly unique, Commercial polychromed elf, made at Rookwood in 1948 and covered with a clear high $400-600
glaze. The childlike figure has a pink feather on his shirt and there is a small hole in his cap, possibly for a real
feather. Marks on the base include the Rookwood logo and the date. Height 6⅛ inches. We have not seen another
one of these and he does not appear in the shape record book.

47 Mat glaze trumpet shaped vase in pink with multicolored flowers at the base, painted in 1924 by Herman Moos. $400-600
Marks on the base include the Rookwood logo, the date, shape number 2619 D and the artist's monogram.
Height 9⅜ inches. Exhibited: "Rookwood Pottery" The Yuma Art Center, 1978, catalog number 93.

48 High glaze perfume jug with incised and painted floral decoration, done by an artist with the initials E.H.C. in $100-150
1883. Marks on the base include Rookwood in block letters, the date, shape number 61, W for white clay, an
impressed kiln and the artist's initials. Height 4⅞ inches. There are glaze blisters at the base and the handle has
been repaired.

49 Standard glaze vase with two flat strap handles, decorated with trumpet creepers by Sallie Toohey in 1900. Marks $400-600
on the base include the Rookwood logo, the date, shape number 604 C and the artist's monogram. Height 9⅛
inches. Very minor glaze scratch and one or two small bubbles in the glaze.

50 Colorful "1932" glaze vase in shades of rose, blue and brown, made at Rookwood in 1932. Marks on the base $250-350
include the Rookwood logo, the date and S for Special shape. Height 6¾ inches. Uncrazed.

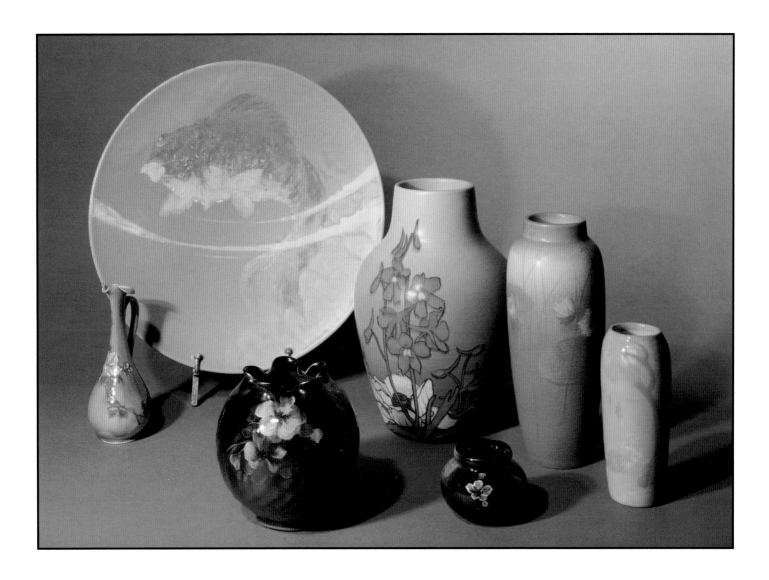

51 Delicate Standard glaze ewer with wild rose decoration, painted in 1888 by Grace Young. Marks on the base include the Rookwood logo, the date, shape number 381 C, W for white clay, L.Y. for light yellow (Standard) glaze and the artist's monogram. Height 7 inches. Small glaze scratch on top of spout. — $400-600

52 Rare Painted Mat glaze charger showing a large fish amid sea currents, done in 1901 by Albert Valentien. Marks on the back include the Rookwood logo, the date, shape number 188 A, a wheel ground x and the artist's initials in black slip. Diameter is 15⅛ inches. Firing flaws account for the "x" and most have been tastefully restored. There are some glaze flakes at the rim including one of thumbnail size. A related piece by Valentien was sold in the Glover Collection as lot 435. — $800-1200

53 Standard glaze vase with ruffled rim decorated with wild roses by Ed Diers in 1897. Marks on the base include the Rookwood logo, the date, shape number 612 C, a diamond shaped esoteric mark and the artist's monogram. Height 5⅝ inches. Exhibited: "Rookwood Pottery" The Yuma Art Center, 1978, catalog number 38. — $300-400

54 Unusual early Vellum glaze vase with pink poppy and blue columbine decoration, painted in 1904 by John Dee Wareham. Marks on the base include the Rookwood logo, the date, shape number 1007 C, V for Vellum glaze body and the artist's incised initials. Height 11⅛ inches. Done in the first official year for Vellum glaze, this vase clearly points up Wareham's stylishness and daring. — $4000-5000

55 Small Standard glaze vase with floral decoration and some Tiger Eye effect, painted in 1887 by an unknown artist. Marks on the base include the Rookwood logo, the date, shape number 76, R for red clay, an incised D for Dark Standard glaze and the artist's monogram, mostly obscured by a stilt pull. Height 2½ inches. — $200-300

56 Unusual Vellum glaze swamp scene with lotus blossoms and pads and Queen Ann's lace growing out of blue waters, painted in 1907 by Kataro Shirayamadani. Marks on the base include the Rookwood logo, the date, shape number 907 DD, V for Vellum glaze and the artist's cypher. Height 10¼ inches. — $3500-4000

57 Rare Iris glaze scenic vase painted in 1905 by Fred Rothenbusch. Unusual in glaze, the design of the scene is also quite rare for Rookwood being a very stylized Art Nouveau treatment with sensuous bending trees framing a bay complete with sailboats. The moon shines through the tree tops and reflects on the water below. Marks on the base include the Rookwood logo, the date, shape number 951 E, W for white (Iris) glaze and the artist's monogram. Height 6⅜ inches. — $3000-4000

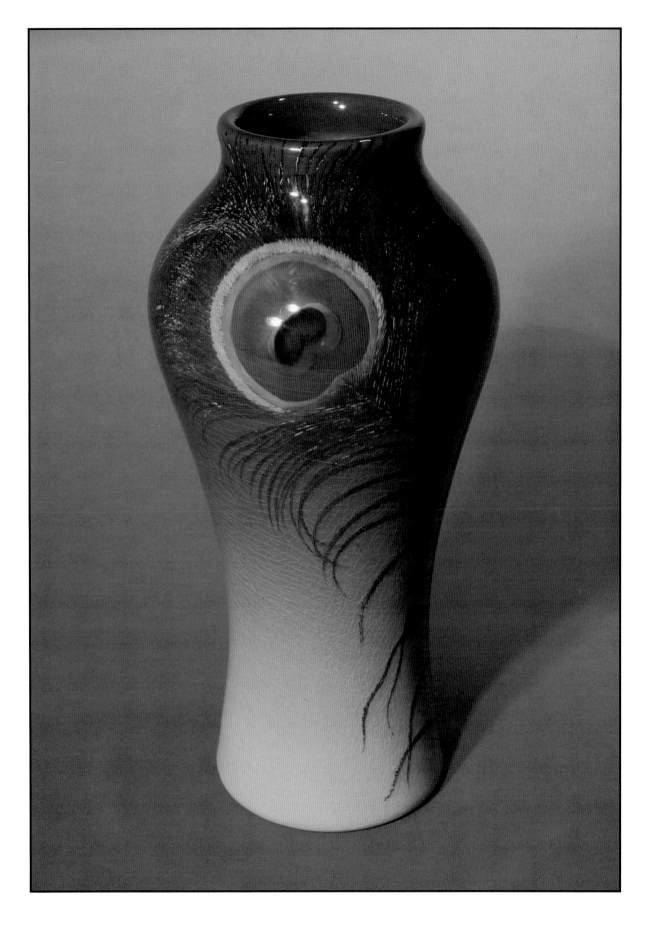

58 Rare and important Iris glaze vase with two highly detailed peacock feathers, one as beautiful as the other, $10000-12500
painted in 1902 by Carl Schmidt. Marks on the base include the Rookwood logo, the date, shape number 909 B,
W for white (Iris) glaze and the artist's monogram. Height 11⅜ inches. In addition to irises and Venetian harbor
scenes, Schmidt painted a small number of amazingly detailed peacock feather vases during his tenure at
Rookwood. Some of these have found their way into important museum collections, none arguably any nicer
than this one.

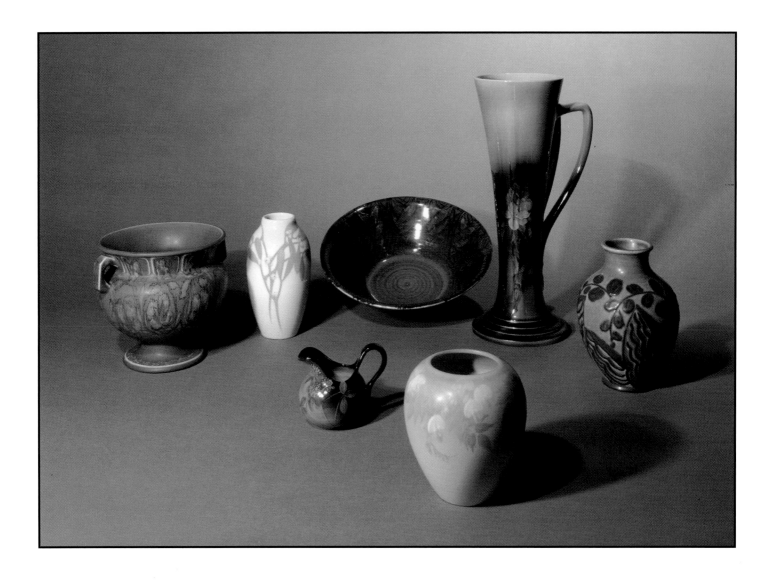

59 Nice two handled mat glaze vase with repeating floral decoration in red, yellow, green and blue on a purple ground, done in 1922 by Louise Abel. Marks on the base include the Rookwood logo, the date, shape number 2355 and the artist's monogram. Height 6¼ inches. $1000-1250

60 Iris glaze vase with mistletoe decoration by Sara Sax, painted in 1905. Marks on the base include the Rookwood logo, the date, shape number 900 D, W for white (Iris) glaze and the artist's monogram. Height 6⅜ inches. $1000-1250

61 Standard glaze pitcher with red clover decoration, done by Adeliza Sehon in 1897. Marks on the base include the Rookwood logo, the date, shape number 630, a diamond shaped esoteric mark and the artist's initials. Height 3 inches. $200-300

62 Black Opal glaze bowl with overlapping leaf patterns on the inside, painted in 1929 by Sara Sax. Marks on the base include the Rookwood logo, the date, shape number 2295 E and the artist's monogram. Diameter is 10⅛ inches. Uncrazed. $800-1200

63 Clean, crisp and beautifully decorated Vellum glaze vase with sweet peas, done in 1929 by Ed Diers. Marks on the base include the Rookwood logo, the date, shape number 1120, V for Vellum glaze and the artist's monogram. Height 5 inches. Uncrazed $1000-1250

64 Handsome Standard glaze two handled mug with wild rose decoration, painted in 1889 by Albert Valentien. Marks on the base include the Rookwood logo, the date, shape number 292 B, S for sage green clay, L for light Standard glaze and the artist's initials. Height 14 inches. An old repair to the foot covers what appears to be a chip to the edge. Exhibited: "Rookwood Pottery" The Yuma Art Center, 1978, catalog number 19. $600-800

65 Stylish Art Deco mat glaze floral vase with slip trail outlining and two shades of brown used for the color of the leaves, done in 1929 by Elizabeth Barrett. Marks on the base include the Rookwood logo, the date, shape number 2918 E and the artist's monogram. Height 6⅝ inches. $500-700

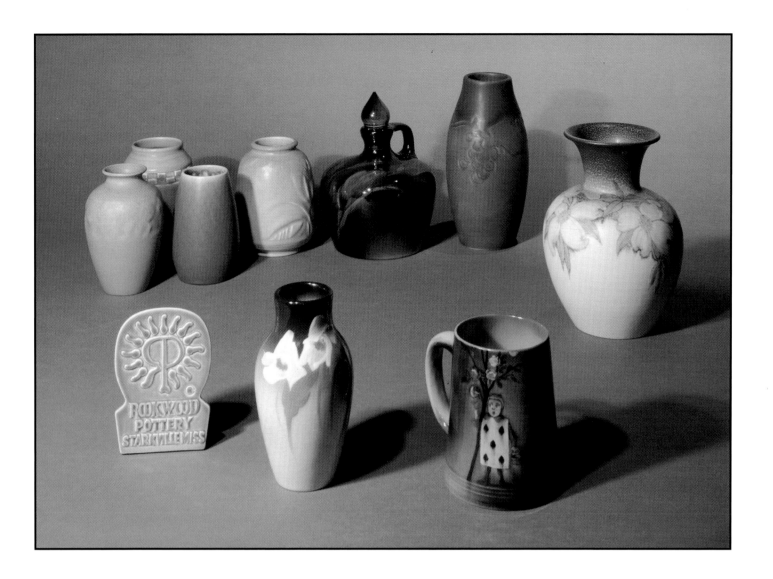

66 Group of four Commercial mat glaze vases made at Rookwood in 1924, 1930, 1931 and 1936. Marks on the $350-450
 bases include Rookwood logos, dates and shape numbers 2105, 2284, 6233 and 2591. Height of the tallest vase
 is 5¼ inches. Shape number 2284 has a long crack descending from the rim. The rest are in excellent condition.

67 Rookwood advertising sign made in Starkville in 1965. The sign shows the Rookwood logo and the notation,
 "Rookwood Pottery Starkville Miss". On the back are found the Rookwood logo and the date. Height 4½ inches. $400-600

68 Pretty Iris glaze vase with white flowers on a black to yellow ground, done in 1902 by Sara Sax. Marks on the
 base include the Rookwood logo, the date, shape number 926 E, W for white (Iris) glaze and the artist's
 monogram. Height 5¾ inches. $1500-1750

69 Standard glaze stoppered whiskey jug with corn decoration, painted in 1898 by Mary Lyons. Marks on base
 include the Rookwood logo, the date, shape number 676, a star shaped esoteric mark, the artist's monogram and
 an old paper label, possibly from Rookwood's own museum, with arcane marks and comments. Height 7⅜ $500-700
 inches.

70 Arts & Crafts style mat glaze vase with incised and painted grape decor, done in 1905 by Sallie Toohey. Marks on
 the base include the Rookwood logo, the date, shape number 939 C and the artist's monogram. Height 8 inches.

71 Rookwood Standard glaze mug featuring the "Five of Spades Child" from "Alice in Wonderland", painted in 1892 $400-500
 by Harriet Wilcox. Marks on the base include the Rookwood logo, the date, shape number 587, W for white clay
 and the artist's initials. Height 4½ inches. Small chip at rim has been professionally repaired. $700-900

72 Unusually well detailed mat glaze vase with dogwood decoration, painted in 1931 by Lenore Asbury. Marks on
 the base include the Rookwood logo, the date, shape number 6198 D and the artist's initials in black slip. Height
 7¾ inches. Uncrazed. $1000-1250

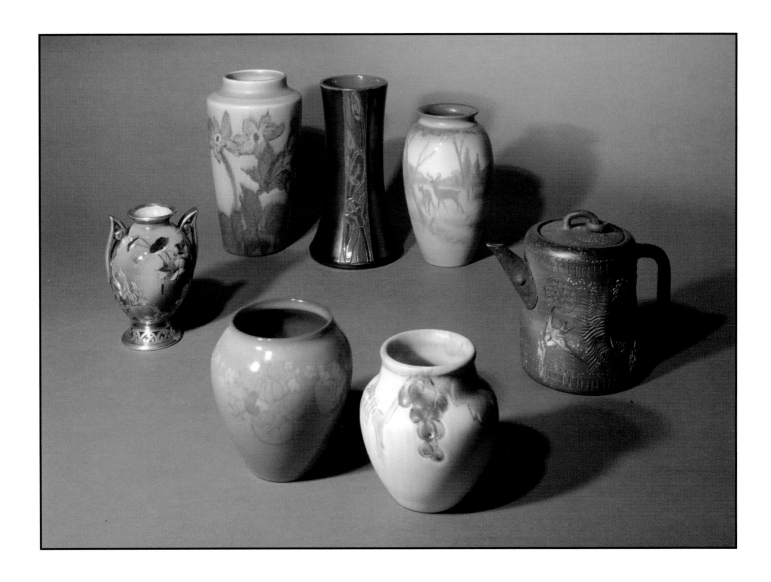

73 Very unusual Standard glaze two handled vase with floral decoration painted in 1892 by Mary Nourse and covered with extensive silver overlay by Gorham. Marks on the base include the Rookwood logo, the date, shape number 6 W for white clay, L for light Standard glaze and the artist's monogram. Height 5⅛ inches. The overlay is quite elaborate having a variety of designs and styles including floral and geometric and it is marked "R 137" and "Gorham Mfg. Co.". $2000-2500

74 Brightly painted mat glaze vase with pink floral decoration, done in 1927 by Elizabeth Lincoln. Marks on the base include the Rookwood logo, the date, shape number 1918 and the artist's initials. Height 8¾ inches. $800-1000

75 Unusual pink tinted high glaze vase with repeating groups of flowers, done in 1923 by Fred Rothenbusch. Marks on the base include the Rookwood logo, the date, shape number 1343, P for porcelain body, P probably for pink glaze and the artist's monogram. Height 4⅞ inches. Uncrazed. $800-1000

76 Rare and important French Red vase with multicolored tulips in mat and high glazes, carved and painted by Sara Sax in 1922. Marks on the base include the Rookwood logo, the date, shape number 1358 D, a wheel ground x and the artist's monogram. Height 8¼ inches. There are some very minor glaze flaws at rim and base which account for the "x". French Red pieces are fairly rare and always wonderful adventures in glaze and design. Sax seems to have done 90% of the French Red pieces and, as in this case, they are innovative and spectacular. $5000-7000

77 Unusual Vellum glaze scenic vase painted by E.T. Hurley in 1947 showing two deer in a winter forest setting. Marks on the base include the Rookwood logo, the date, S for Special shape, the incised number "5393" and the incised artist's initials. Height 7⅜ inches. Uncrazed. $2500-3500

78 Nice mat glaze vase with colorful painted and incised grape decor, done in 1904 by Rose Fechheimer. Marks on the base include the Rookwood logo, the date, shape number 170 Z, a paddle shaped esoteric mark and the artist's monogram. Height 4½ inches. $500-700

79 Rare and unusual dull finish lidded teapot with Japanesque decoration of chrysanthemums, birds and incised lines and symbols, done in 1884 by Laura Fry. The body is pinched, twisted and highlighted with fired on gold. The lid is incised and dotted with fired on gold and the finial has a single link attached to it. Marks on the base include Rookwood in block letters, the date, shape number 69, an impressed kiln mark and the artist's monogram. Height 6 inches. Minor restoration to spout. Exhibited and illustrated as item 3 in "Rookwood Pottery The Glorious Gamble" by Anita J. Ellis, Cincinnati Art Museum, 1992-1993, catalog published by Rizzoli in 1992 (color plate, page 68). $2000-3000

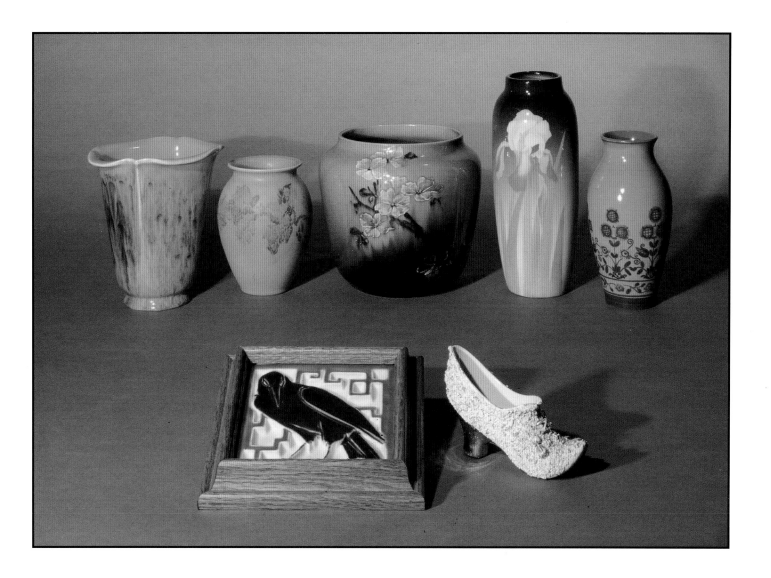

80 Fan shaped Commercial vase covered with Bengal Brown glaze at Rookwood in 1949. Marks on the base include the Rookwood logo, the date and shape number 6314. Height 7½ inches. Minor grinding chips on the base. — $150-250

81 Mat glaze vase with red berries, brown branches and green holly leaves painted in 1927 by John Wesley Pullman. Marks on the base include the Rookwood logo, the date, shape number 363 and the artist's monogram. Height 6¼ inches. — $400-500

82 Rookwood Vellum glaze Commercial trivet from 1927 showing a rook standing in front of a trellis. Marks on the back include the Rookwood logo, the date, shape number 1794 and a wheel ground x. Size is 5⅝ x 5⅝. Minor glaze flaw. Uncrazed and recently framed. — $300-400

83 Standard glaze jardiniere decorated with stylish wild roses by M.A. Daly in 1887. Marks on the base include the Rookwood logo, the date, shape number 180 C, S for sage green clay, L for light Standard glaze and the artist's initials. Height 7½ inches. — $700-900

84 Unusual William Dell Pottery shoe made in Cincinnati circa 1891. Details such as shoe laces and tassels are applied clay and the heel and other highlights are glazed with fired on gold. The sole of the shoe bears the stamped mark, "W.D. & Co.". Height 3½ inches. — $150-250

85 Tall Iris glaze vase with pretty white iris decoration, painted in 1907 by Sallie Coyne. Marks on the base include the Rookwood logo, the date, shape number 907 D, W for white (Iris) glaze and the artist's monogram. Height 10½ inches. There are two pin head size glaze nicks, one on the back side and the other high on the shoulder above and to the left of the iris flower. — $2500-3500

86 Blue tinted high glaze vase with Pennsylvania Dutch style floral decoration encircling the lower part of the piece, done in 1922 by William Hentschel. Marks on the base include the Rookwood logo, the date, shape number 356 D and the artist's monogram. Height 8 inches. Uncrazed. — $600-800

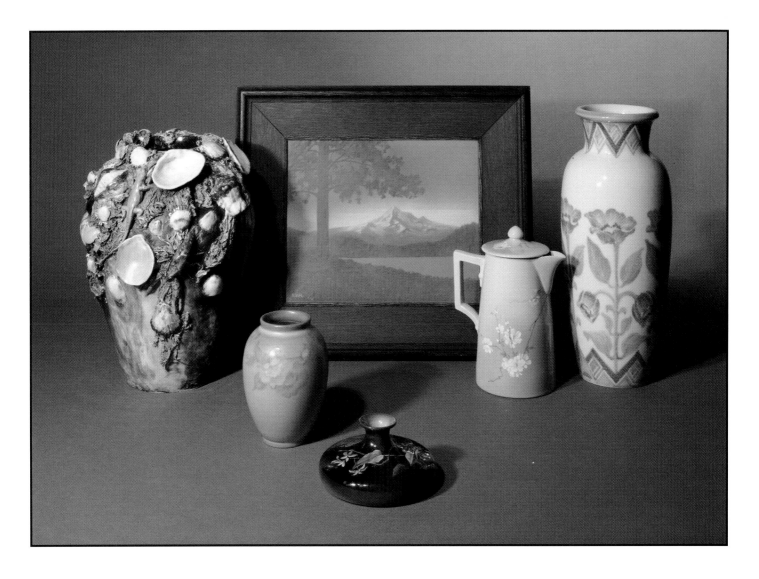

87 Rare and important Limoges style vase covered with applied seaweed, sea shells, a newt and a crayfish most $4000-6000
likely made by the T.J. Wheatley & Company Pottery in Cincinnati, around 1880. Although unmarked, this vase
bears a strong resemblance to Wheatley pieces recently sold in the Berberian Collection auction and another
featured in an Everson Museum exhibition called "Fragile Blossoms, Enduring Earth" from 1989, listed as catalog
number 3 and shown in color on page 14. The Everson piece has the same crayfish while the Berberian vase has
the same incrustation of shells and seaweed. Height 12 inches. There are minor chips to the applied decoration
and some minor restoration.

88 Arts & Crafts Vellum glaze plaque showing a snow capped mountain silhouetted by a tree in the foreground, $3000-4000
painted in 1914 by Katherine Van Horne. Marks on the back include the Rookwood logo, the date and V for
Vellum glaze. The artist's initials appear in the lower left hand corner. Size is 8½ x 10¼ inches.

89 Vellum glaze vase with pretty pink rose decoration on a taupe to rose ground, done in 1925 by Fred $400-600
Rothenbusch. Marks on the base include the Rookwood logo, the date, shape number 2191, V for Vellum glaze
and the artist's monogram. Height 5⅛ inches. The vase is uncrazed but does have a small glaze flaw at the rim.

90 Standard glaze vase with flower, leaf and berry decoration, painted in 1894 by Sadie Markland. Marks on the $200-300
base include the Rookwood logo, the date, shape number 687, W for white clay, L for light Standard glaze and
the artist's initials. Height 2⅞ inches. Exhibited: "Rookwood Pottery" The Yuma Art Center, catalog number 28.

91 Graceful Cameo glaze lidded chocolate pot with delicate fruit blossom decoration, done in an oriental manner by $500-700
Harriet Wilcox in 1888. The lid is also decorated. Marks on the base include the Rookwood logo, the date, shape
number 251, W for white clay, the artist's initials and W for white (Cameo) glaze in dark brown slip. Height 7½
inches. Uncrazed.

92 Tall and colorful high glaze lamp vase decorated with repeating rows of pink flowers which encircle the body $1000-1500
while multicolored geometric bands encircles the rim and base. The vase was painted in 1940 by Margaret
McDonald. Marks on the base include the Rookwood logo, the date and shape number 2785. The artist's
monogram appears on the side of the vase near the bottom. Cast into the center of the base is a circular
indentation, a guide should the store selling the vase for Rookwood wish to make it into a lamp (fortunately, it has
not been drilled). The side signature also indicates the potential for usage as a lamp. Height 13¼ inches.
Uncrazed and very crisp and clean.

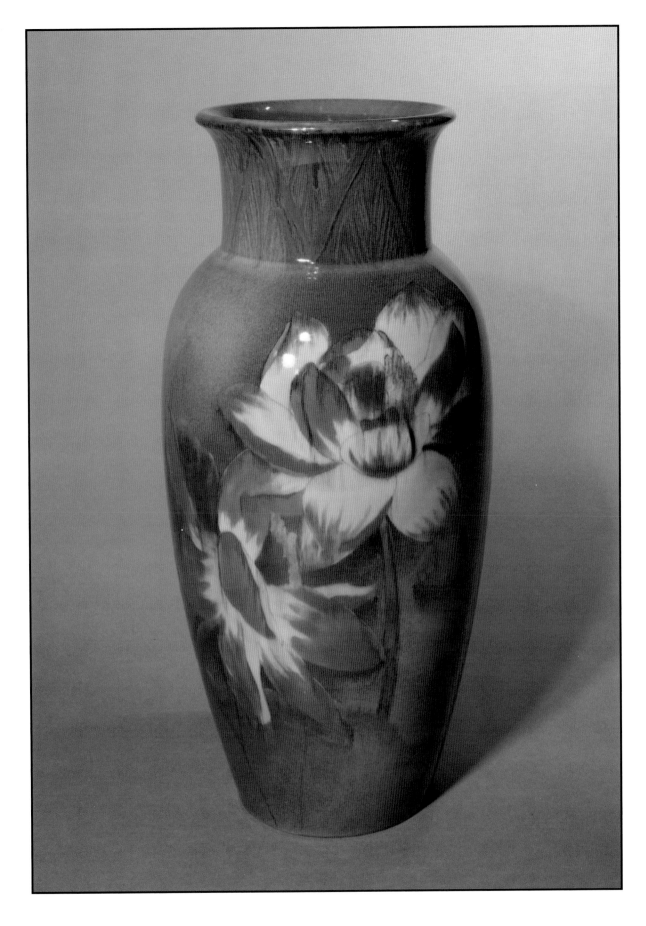

93 Monumental and important Black Opal glaze vase with lotus decoration painted in 1927 by Sara Sax. Marks on $8000-12000
 the base include the Rookwood logo, the date, shape number 384 and the artist's monogram. Height 17⅛ inches.
 Uncrazed. Originally one of a pair, this is the largest Black Opal vase ever documented and certainly one of the
 nicest. Purchased in 1937 for the then staggering sum of $100, the vase comes with photocopies of its original
 Rookwood sales receipt, the first written evidence of a name for the glaze line, "Black Opal". Exhibited and
 illustrated as item 90 in "Rookwood Pottery The Glorious Gamble", Anita J. Ellis, Cincinnati Art Museum, 1992-
 1993, catalog published by Rizzoli in 1992 (color plate, page 155).

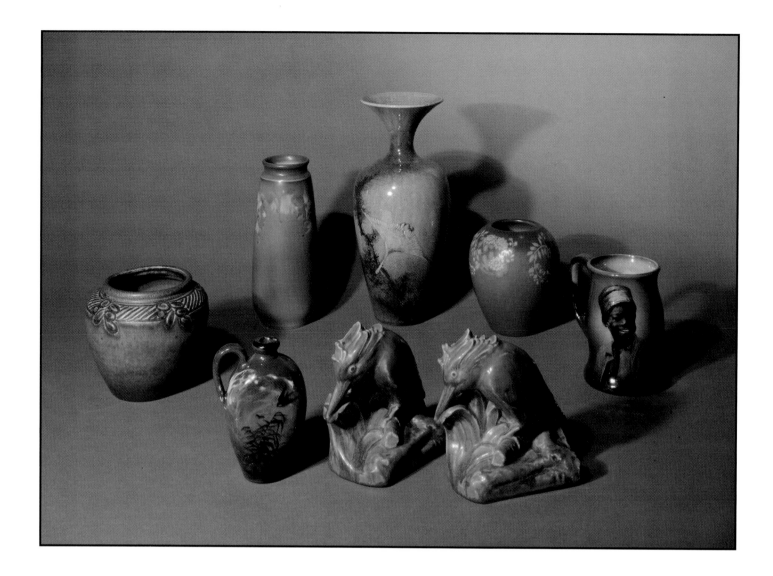

94 Carved and painted mat glaze vase with floral decoration by C.S. Todd, done in 1916. Marks on the base include $300-400
 the Rookwood logo, the date, shape number 965 and the artist's initials. Height 4⅝ inches.

95 Limoges style flat sided perfume jug with a swallow flying over oriental grasses, done in 1883 by Hattie Horton. $200-300
 Marks on base include Rookwood in block letters, the date , shape number 60, R for red clay, a kiln mark
 impressed twice and the artist's initials. Height 4¾ inches. There is a ½ inch flat chip off the base which is slightly
 visible from the side.

96 Vellum glaze vase with exotic floral decoration in a repeating border, done in 1922 by Fred Rothenbusch. Marks $700-900
 on the base include the Rookwood logo, the date, shape number 2069, V for Vellum glaze body and the artist's
 monogram. Height 7⅞ inches.

97 Early Standard glaze vase with flared rim showing a graceful crane gliding over pine boughs, done in an oriental $1000-1500
 manner by Albert Valentien in 1885. Marks on the base include Rookwood in block letters, the date, shape
 number 197 D and the artist's initials. Height 10⅞ inches.

98 Commercial kingfisher bookends in a slightly crystalline blue mat glaze, made at Rookwood in 1929. Marks on $350-450
 the base include the Rookwood logo, the date, shape number 2657 and the mold signature of the designer
 William McDonald. Height 5½ inches.

99 Vellum glaze vase with three groups of vining flowers in many colors, painted in 1914 by Margaret McDonald. $450-650
 Marks on the base include the Rookwood logo, the date, shape number 2100, V for Vellum glaze body and the
 artist's monogram. Height 5 inches.

100 Rare and handsome Standard glaze portrait mug painted in 1895 by Harriette Strafer. The subject is a black man $2500-3000
 wearing a bright blue shirt and yellow hat. Marks on the base include the Rookwood logo, the date, shape
 numbers 671, L for light Standard glaze and the artist's monogram. Height 5 inches. There are two pinhead sized
 glaze nicks on the rim and some minor glaze scratches.

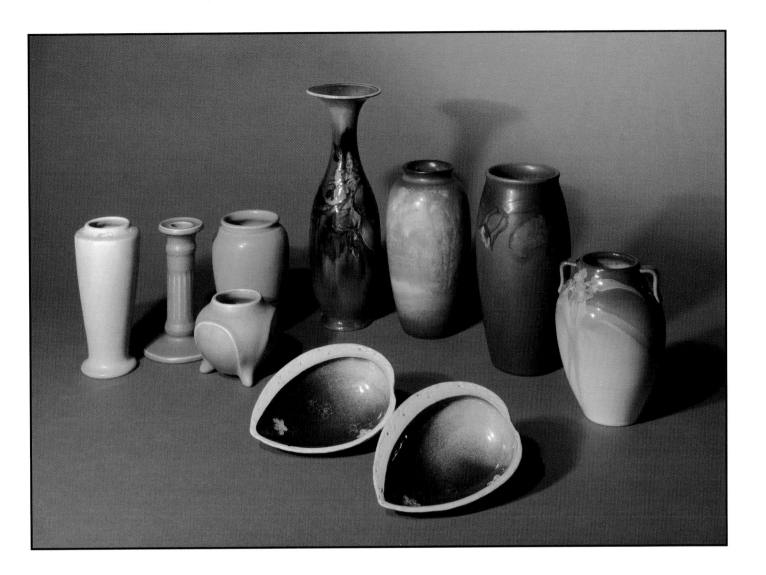

101 Group of four Commercial mat glaze pieces made at Rookwood in 1918, 1921, 1930 and 1936. Marks on the bases include Rookwood logos, dates and shape numbers 2199, 2093, 2112 and 2283. Height of the tallest piece is 6⅛ inches. All in excellent condition. $200-300

102 Pair of almond dishes in mat and Standard glaze decorated with painted and incised flowers by an unknown artist in 1888. Marks on the bases include the Rookwood logo, the date, shape number 279 and Y for yellow clay. Greatest distance across is 5¾ inches. $200-300

103 Standard glaze vase with floral decoration by M.A. Daly, painted in 1892. Marks on the base include the Rookwood logo, the date, shape number 608, W for white clay and the artist's initials. Height 10⅜ inches. There is a ¼ inch chip from the base. $400-600

104 Handsome fall landscape vase painted in 1948 by E.T. Hurley and covered with Vellum glaze. Marks on the base include the Rookwood logo, the date, shape number 922 D and the artist's initials. Height 7⅜ inches. Uncrazed. $2000-2500

105 Mat glaze Arts & Crafts vase with a band of stylized flowers at the top, painted and incised in 1920 by Elizabeth Lincoln. Marks on the base include the Rookwood logo, the date, shape number 917 C and the artist's initials. Height 8⅛ inches. $400-500

106 Iris glaze vase with blue floral decoration painted in 1906 by Irene Bishop. Marks on the base include the Rookwood logo, the date, shape number 604 E, W for white (Iris) glaze and the artist's monogram. Height 5⅞ inches. $800-1000

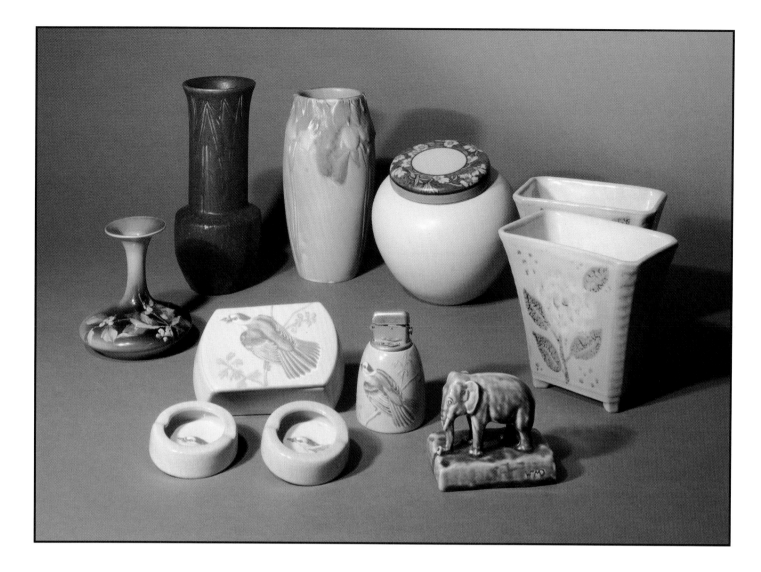

107 Standard glaze vase with flared rim, painted in 1894 with leaf and berry decor. Marks on the base include the Rookwood logo, the date, shape number 715 E, W for white clay and the artist's monogram. Height 5 inches. $300-400

108 Vase with incised geometric patterns under a blue volcanic mat glaze, done by William Hentschel in 1914. Marks on the base include the Rookwood logo, the date, shape number 690 C and the artist's monogram. Height 9⅞ inches. $400-500

109 Four piece high glaze smoking set with blue jay decoration, painted in 1948 by Ora King. Marks on the bases include the Rookwood logo, the date, shape numbers 6922 on the lighter, 6922 A on the ashtrays and 6922 B on the cigarette box. The artist's monogram appears on each piece. Height of the tallest piece is 2¾ inches. The lighter mechanism appears to be broken. Exhibited: "Rookwood Pottery" The Yuma Arts Center, 1978, catalog number 113. $500-700

110 Deeply carved and painted mat glaze vase with lemon tree decoration, done in 1905 by Marianne Mitchell. Marks on the base include the Rookwood logo, the date, shape number 917 B and the artist's monogram. Height 8⅞ inches. As with most pieces having heavy clay applications at the rim, there are several tight firing lines in the carved area which are quite solid. $500-700

111 Unusual covered jar with exotic floral decoration on the lid, painted in 1915 by C.J. McLaughlin and covered with Vellum glaze. Marks on the base include the Rookwood logo, the date, shape number 1708, V for Vellum glaze body and the artist's monogram. Height 6⅜ inches. $700-900

112 Commercial elephant paperweight made at Rookwood in 1926 and covered with a crystalline green mat glaze. Marks on the base include the Rookwood logo, the date and shape number 2797. Height 3¼ inches. $250-350

113 Pair of butterfat glaze footed vases with a floral spray on two sides, each painted in 1946 by Elizabeth Barrett. Marks on the bases include the Rookwood logo, the date, shape number 6036, the number 3169 incised and the artist's monogram. Height 6⅛ inches. $500-700

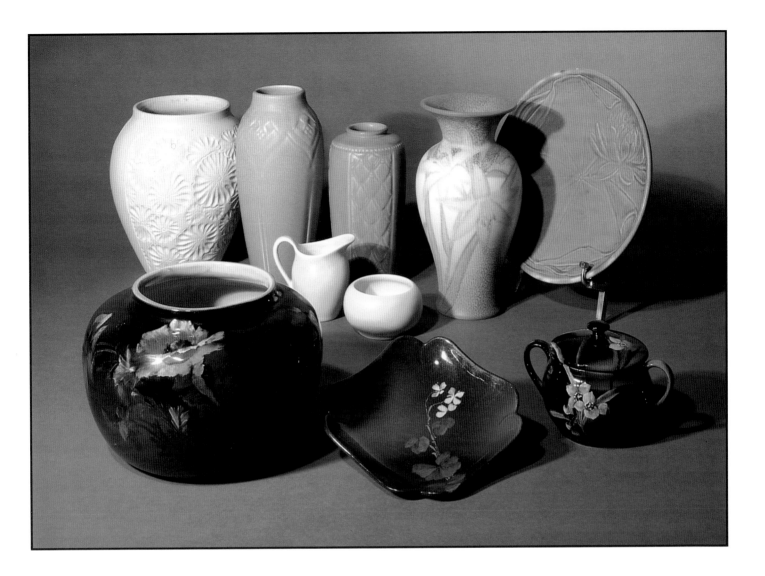

114 Unusual mat glaze lamp vase with impressed three dimensional floral decoration made in 1883 and bearing the initials of Harriet Wenderoth. Marks on the base include Rookwood in block letters, the date, shape number 2 Y for yellow clay and the artist's initials. Height 7⅞ inches. This seems to be a multiple but it does have Wenderoth's initials clearly incised. $300-400

115 Standard glaze jardiniere with red poppy decoration painted in 1891 by Sallie Toohey. Marks on the base include the Rookwood logo, the date, shape number 131, W for white clay, L for light Standard glaze and the artist's monogram. Height 5⅜ inches. There is a spider crack in mid body with one line running to the top of the rim. Exhibited: "Rookwood Pottery" The Yuma Art Center, 1978, catalog number 22. $300-400

116 Group of four Commercial pieces including a mat glaze creamer and sugar bowl and two vases with embossed designs. Made at Rookwood in 1928, 1925 and 1939. Marks on the bases include the Rookwood logo, the dates and shape numbers 547, 6676 and 2392. Height of tallest piece is 9 inches. All in excellent condition. $250-350

117 Cameo glaze plate with delicate floral decoration by Anna Bookprinter, done in 1886. Marks on the back include Rookwood in block letters, the date, shape number 288, R for red clay and the artist's initials. Distance across 6¼ inches. Glaze scratches on the surface. $100-150

118 Very colorful mat glaze vase with slightly stylized daylily decoration, done in 1937 by Kataro Shirayamadani. Marks on the base include the Rookwood logo, the date, shape number 2745 and the artist's cypher. Height 9 inches. This is a beautiful example of Shirayamadani's late work but has a six inch line extending downward from the rim which has been professionally repaired. $800-1000

119 Carved and painted mat glaze charger with lotus decoration, made in 1901 by Anna Valentien. Marks on the base include the Rookwood logo, the date, shape number 353 Z and the artist's initials. Diameter is 9¼ inches. $400-600

120 Handsome Standard glaze covered sugar bowl with yellow flowers that extend onto the lid, painted in 1894 by Sallie Coyne. Marks on the base include the Rookwood logo, the date, shape number 554, W for white clay and the artist's initials. Height 3¼ inches. $300-400

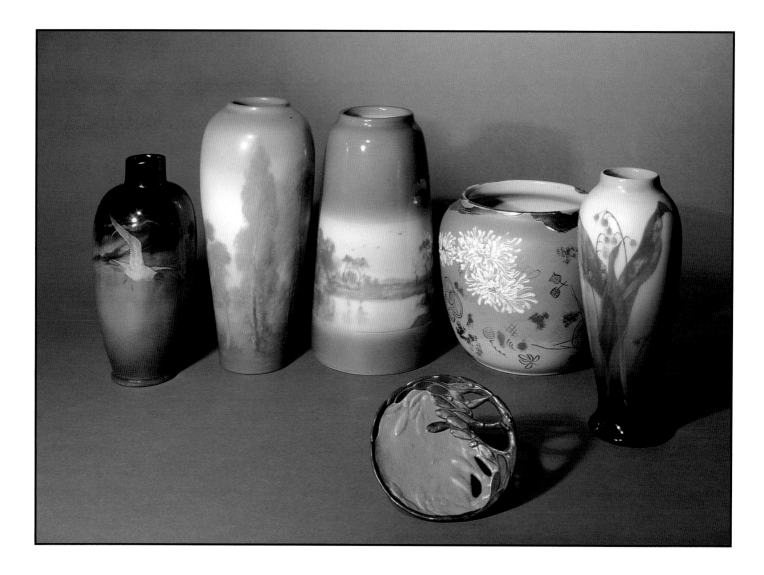

121 Unusual Standard glaze scenic vase showing five gulls flying through stormy skies, painted in 1897 by Albert Valentien. Marks on the base include the Rookwood logo, the date, shape number 786 C, a wheel ground x, Y for yellow (Standard) glaze and the artist's initials. Height 9⅞ inches. There are some minor underglaze runs which may account for the "x" and one or two very minor glaze scratches. — $1500-2000

122 Important Vellum glaze landscape vase painted in 1924 by Ed Diers. Having good size, the vase is one of the most finely crafted scenics we have seen. Trees in the distance are as detailed as those in the foreground and the heavy use of slip gives the trunks and branches a three dimensional quality. Colors are subtle but quite varied and the overall effect is breathtaking. Marks on the base include the Rookwood logo, the date, shape number 2033 C, V for Vellum glaze and the artist's monogram. Height 12⅛ inches. Uncrazed. — $7000-9000

123 Rare and extremely delicate banded Iris glaze scenic vase painted in 1911 by Fred Rothenbusch. The landscape consists of a lake in the foreground and trees and hills behind. Subtle shades of green, blue, pink and gray enhance the ivory ground and several birds are seen in the sky. Marks on the base include the Rookwood logo, the date, shape number 1654 C, the letter "F" above the logo, V for Vellum glaze body and the artist's monogram. Height 11½ inches. Uncrazed and very clean. — $7000-9000

124 Rare mat glaze reticulated card tray with embossed mistletoe decoration, partially trimmed with electroplated copper and known to be the work of Kataro Shirayamadani from 1901. This is a limited edition item designed and executed by Shirayamadani. Another example had its copper back covering opened to reveal the artist's cypher. Marks visible in the copper back of this piece include the Rookwood logo, the date and a shape number which would appear to be 267 Z. Presumably Shirayamadani's cypher is also present on this piece. Greatest distance across is 5⅜ inches. Good original condition with original patina on copper. — $2000-2500

125 Unusual dull finish jardiniere with chrysanthemum decoration highlighted with Japanesque designs in fired on gold, done in 1888 by Martin Rettig. Marks on the base include the notation, "M. Rettig '88", shape number 180 C, W for white clay, an incised S for smear (dull finish) glaze, and in fired on gold the notation, "R.W.P. G.L.K. '88". Most examples from this period that lack the Rookwood logo were probably made after hours as gifts for friends. In this case it is impossible to tell if G.L.K was the friend or whether R.W.P. might be shorthand for Rookwood Pottery. Perhaps G.L.K. helped with the fired on gold designs and was also Rettig's friend. It's fun to speculate. Height 7⅞ inches. — $400-600

126 Very crisp Iris glaze vase with lily of the valley decoration painted in 1909 by Carl Schmidt. Marks on the base include the Rookwood logo, the date, shape number 1667, a wheel ground x and the artist's monogram. Height 10⅜ inches. A glaze skip on the rim accounts for the "x" and has been professionally repaired. Uncrazed. — $2500-3500

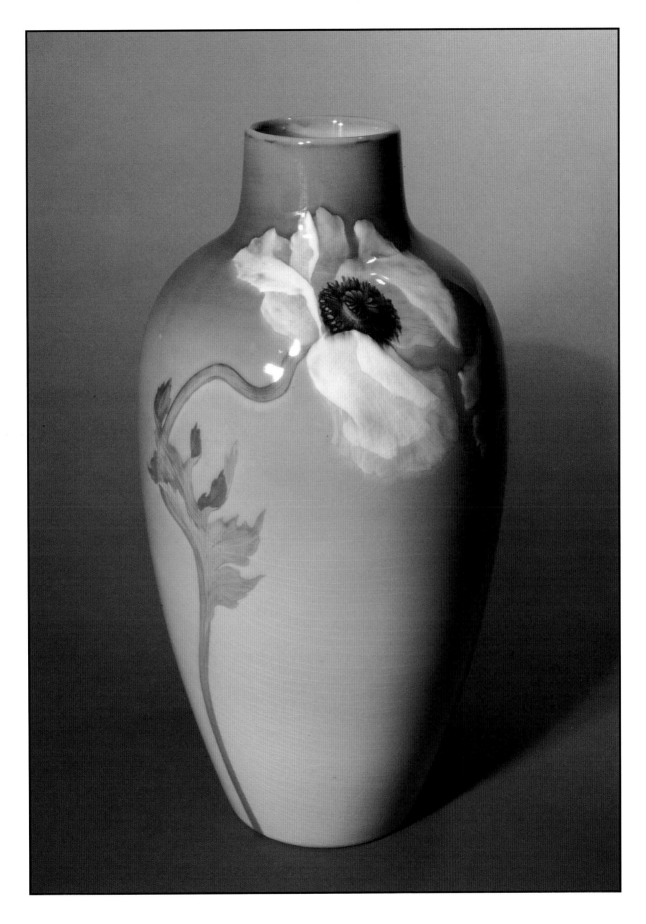

127 Important Iris glaze vase with nicely detailed white poppies done in an Art Nouveau manner, painted in 1902 by $10000-15000
 Albert Valentien. A very stylish vase used in at least two Rookwood advertising booklets, most notably the 1904
 "Blue Book" as number 37. Marks on the base include the Rookwood logo, the date, shape number 905 B and
 the artist's full signature. Height 14⅜ inches. Exhibited and illustrated as item 34 in "Rookwood Pottery The
 Glorious Gamble" by Anita J. Ellis, Cincinnati Art Museum, 1992-1993, catalog published by Rizzoli in 1992
 (color plate, page 99).

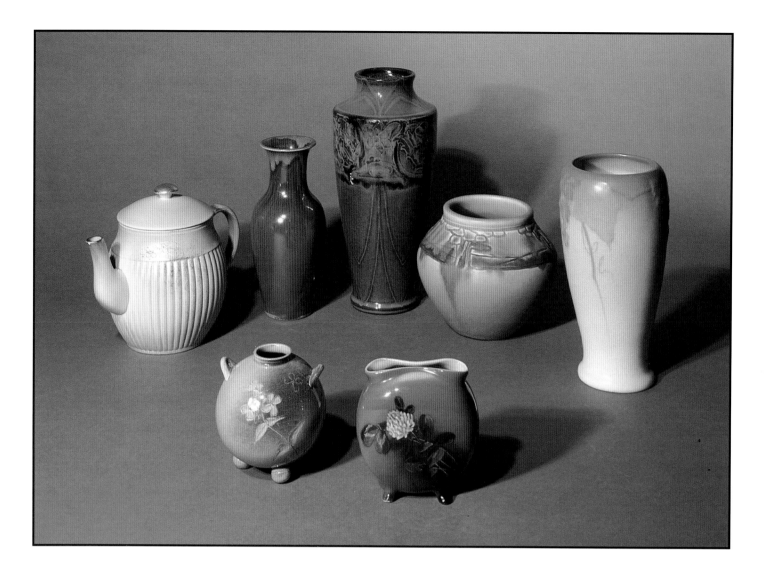

128 Pretty dull finish teapot with incised and painted flowers around the shoulder, all highlighted with fired on gold, $300-400
 done in 1886 by Grace Young. Marks on the base include the Rookwood logo, the date, shape number 193, Y for
 yellow clay and the artist's monogram. Height 6⅛ inches. There is a small chip on the spout and two nicks on the
 lid's covered rim.

129 Standard glaze Gypsy kettle with incised shamrock decoration done in 1886 by Alfred Brennan. Marks on the $300-400
 base include the Rookwood logo, the date, shape number 71 C, S for sage green clay and the artist's monogram.
 Height 3⅝ inches. Exhibited: "Rookwood Pottery" The Yuma Art Center, 1978, catalog number 13.

130 Handsome Rookwood "1932" vase with overlapping rust, brown and blue glazes. Marks on the base include the $400-600
 Rookwood logo, the date and shape number 6308 C. Height 6⅞ inches. Exhibited: "Rookwood Pottery" The
 Yuma Art Center, 1978, catalog number 1932.

131 Very stylish vase with incised and painted flowers and designs which repeat around the body, all covered with a $1000-1500
 rich Black Opal type glaze. The decoration was done in 1922 by Sara Sax. Marks on the base include the
 Rookwood logo, the date, shape number 1920, a wheel ground x and the artist's monogram. Height 9⅛ inches.
 There are a few minute glaze skips but the overall effect of this piece is quite nice.

132 Standard glaze pocket vase with clover decoration painted by an unknown artist in 1889. Marks on the base $200-250
 include the Rookwood logo, the date, shape number 90 C, L for light Standard glaze, S for sage green clay, an
 incised x and the artist's monogram. Height 3⅞ inches. Exhibited: "Rookwood Pottery" The Yuma Art Center,
 1978, catalog number 17, illustrated.

133 Unusual Arts & Crafts mat glaze landscape vase painted and incised by Albert Pons in 1907. Marks on the base $400-500
 include the Rookwood logo, the date, shape number 906 D and the artist's monogram. Height 4¼ inches.

134 Vellum glaze vase with carved and painted grapes, done in 1913 by Katherine Van Horne. The grapes, vines and $400-500
 leaves are very three dimensional. Marks on the base include the Rookwood logo, the date, shape number 1779,
 V for Vellum glaze body, V for Vellum glaze and the artist's monogram. Height 7⅝ inches. Slight glaze peppering.

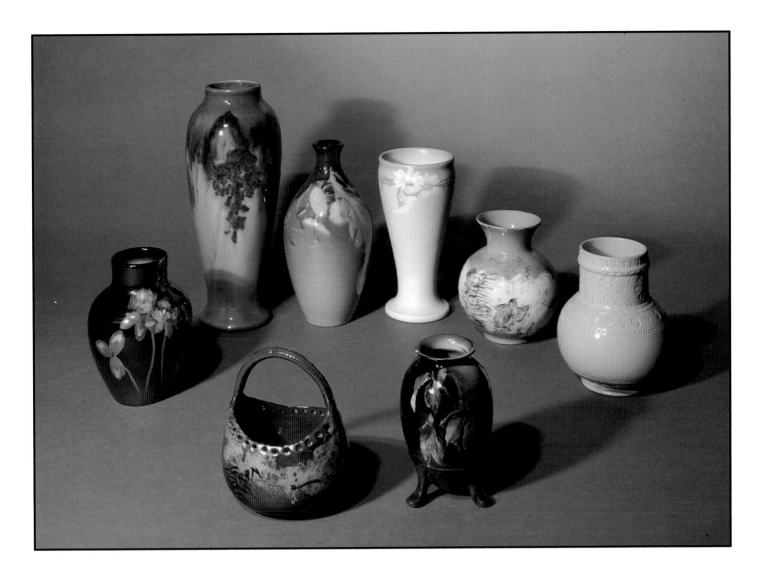

135 Standard glaze vase with red clover decoration by Constance Baker, painted in 1902. Marks on the base include the Rookwood logo, the date, shape number 927 F and the artist's initials. Height 5½ inches. $300-500

136 High glaze vase with wisteria decoration, painted by E.T. Hurley in 1924. Marks on the base include the Rookwood logo, the date and the artist's initials. The shape number has been drilled through. Height 10¾ inches. $1250-1750

137 Interesting Limoges style glaze basket with reticulated rim, painted in 1883 by William McDonald. The decoration on both sides includes a dragonfly moving toward a stand of oriental grasses. Marks on the base include Rookwood indistinctly in block letters, the date and the artist's initials. Though not marked as such, this is probably shape number 33. Height 4¾ inches. $400-500

138 Pretty Iris glaze vase with dandelions laid on a ground shading from medium blue to caramel, done in 1901 by Rose Fechheimer. Marks on the base include the Rookwood logo, the date, shape number 745 B, W for white (Iris) glaze and the artist's monogram. Height 8 inches. $1750-2250

139 Standard glaze egg shaped, footed vase with floral decoration painted in 1891 by an unknown artist. Marks on the base include the Rookwood logo, the date and shape number 597 D. Height 4¾ inches. There is a ¼ inch chip at the rim. Exhibited: "Rookwood Pottery" The Yuma Art Center, 1978, catalog number 21. $150-200

140 Vellum glaze vase with daisies twining around the top portion of the piece, painted in 1913 by Katherine Van Horne. Marks on the base include the Rookwood logo, the date, shape number 1833, V for Vellum glaze body and the artist's monogram. Height 7¼ inches. $350-450

141 Limoges style glaze vase decorated by Martin Rettig in 1882 with oriental grasses, two quail and two flying swallows. Marks on the base include Rookwood in block letters, the date, shape number 1 G for ginger clay, an impressed anchor mark and the artist's initials. Height 5⅛ inches. Exhibited: "Rookwood Pottery" The Yuma Art Center, 1978, catalog number 3. $300-400

142 Early high glaze vase with borders of die stamping, most likely the work of Fanny Auckland. The base is incised with the notation, "Rookwood Pottery Cin O 1881" in script. Rookwood pieces from 1881 are quite rare and die stamped pieces by Auckland are equally hard to find. Height 5⅜ inches. There are some spiral lines descending from the rim which are probably firing stress cracks. $400-500

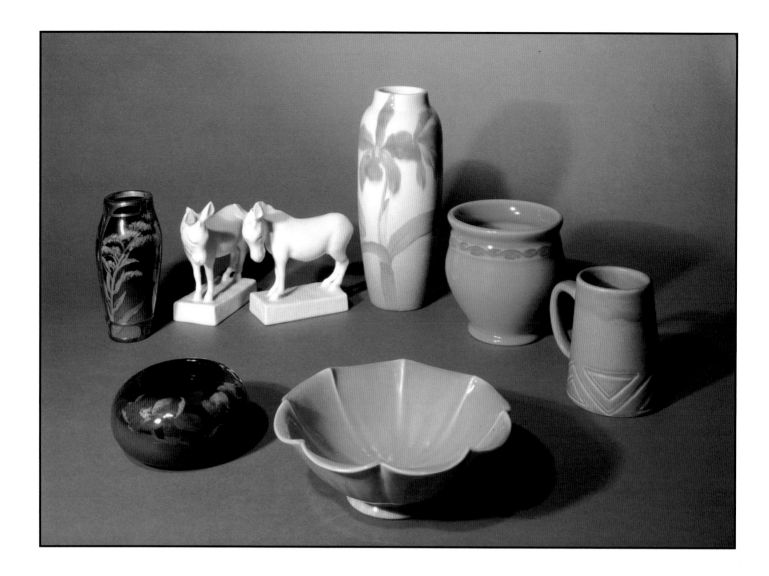

143 Standard glaze vase with goldenrod decoration, done in 1907 by Laura Lindeman and covered with handsome $1750-2250
Art Nouveau silver overlay by Gorham. Marks on the base include the Rookwood logo, the date, shape number
30 F and the artist's monogram. The overlay is marked with the Gorham hallmarks and the initials NHL. Height 6
3/8 inches. This is a very late example of Gorham silver overlay on Rookwood and a rather late use of Standard
glaze.

144 Standard glaze bowl with bright red floral decoration painted in 1900 by Laura Lindeman. Marks on the base $300-400
include the Rookwood logo, the date, shape number 214 C and the artist's initials. Height 2½ inches. Exhibited:
"Rookwood Pottery" The Yuma Art Center, 1978, catalog number 44.

145 Unusual pair of mule bookends in white mat glaze, made at Rookwood in 1934. Marks on the base include the $700-900
Rookwood logo, the date, shape number 6216 and the cast in monogram of designer William McDonald. Height
5⅞ inches.

146 Rookwood "1932" glaze bowl in crystalline blue and rich yellow coloring. Marks on the base include the $300-400
Rookwood logo, the date, shape number 6313 and a cross shaped esoteric mark. Diameter is 8⅜ inches. Minor
grinding chip on base.

147 Iris glaze vase with orchid decoration done in 1903 by Carl Schmidt. Marks on the base include the Rookwood $2000-2500
logo, the date, shape number 907 D, W for white (Iris) glaze and the artist's monogram. Height 10⅛ inches.

148 Unusual decorated porcelain bodied vase made in 1915 by Lorinda Epply. Decoration consists of leaves and $400-500
vines in black slip encircling a band at the shoulder. Marks on the base include the Rookwood logo, the date,
shape number 2195, the letter Y, a wheel ground x and the artist's monogram. Rookwood introduced its Soft
Porcelain ware in 1915 and this is certainly one of the earliest examples to be decorated. Height 5⅛ inches. There
is a strange line at the rim that looks like a crack but which can not be felt.

149 Early Arts & Crafts mat glaze mug with geometric designs at the base, done in 1901 by Albert Munson. Marks on $250-350
the base include the Rookwood logo, the date, shape number 345 CZ and the artist's monogram. Height 4¼
inches.

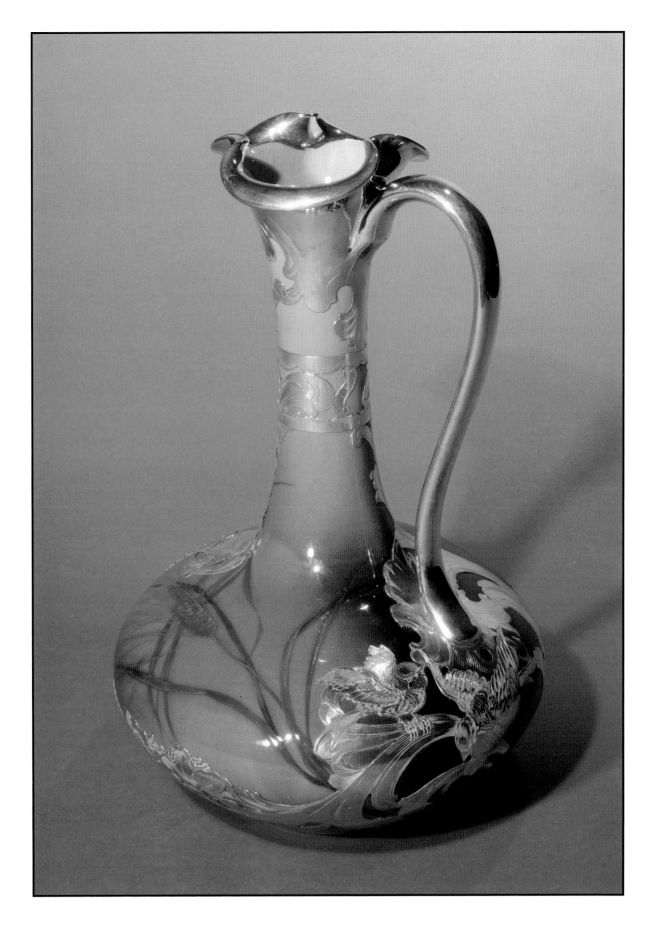

150 Tall and handsome Standard glaze ewer with wheat decoration by Albert Valentien and spectacular silver overlay $8000-12000
 by Gorham, all done in 1892. Marks on the base include the Rookwood logo, the date, shape number 438 A, W
 for white clay, L for light Standard glaze and the artist's initials. The silver is marked "Gorham Mfg. Co. R 786".
 The elaborately engraved silver has two rather prominent birds worked into its design near the handle. Height
 12½ inches. There are two small spots of missing silver, otherwise this is one of the largest and nicest silver
 overlays we have seen.

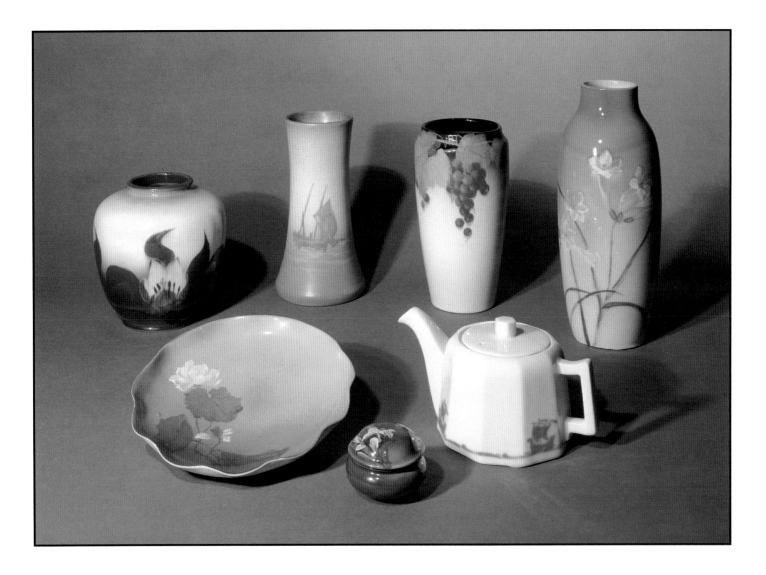

151 High glaze vase with bright, somewhat stylized lotus decoration, painted in 1945 by E.T. Hurley. Marks on the $400-600
base include the Rookwood logo, the date, shape number S 2180, the incised number "2004" and the artist's
initials. Height 6⅝ inches. Uncrazed with some glaze pooling near the base and possibly missing a lid.

152 Cameo glaze plate with white poppy decoration painted in 1889 by Amelia Sprague. Marks on the base include $250-350
the Rookwood logo, the date, shape number 205 C, W for white clay, W for white (Cameo) glaze and the artist's
initials. Diameter is 8½ inches.

153 Vellum glaze marine scenic vase showing two fishing boats under sail with nets in the water, painted by Sallie $2000-2500
Coyne in 1912. A person is hoisting one of the sails on the larger boat. Marks on the base include the Rookwood
logo, the date, shape number 1358 D, V for Vellum glaze body and the artist's monogram. Height 9 inches.

154 Small Standard glaze covered box with yellow iris decor, painted in 1890 by Grace Young. Marks on the base $200-300
include the Rookwood logo, the date, shape number 591 C, L for light Standard glaze and the artist's monogram.
Height 2 inches.

155 Nicely detailed and colorful Iris glaze vase with grape decor, done in 1909 by Lenore Asbury. Marks on the base $800-1200
include the Rookwood logo, the date, shape number 1869 D, W for white (Iris) glaze, a wheel ground x and the
artist's initials. Height 8¾ inches. Uncrazed. There is a one inch firing separation descending from the rim which
caused the piece to be "xed". This is not a crack but a firing flaw which has glaze flowing into it.

156 Rookwood Commercial Blue Ship teapot made circa 1925. Marks on the base include the Rookwood logo and $200-250
shape number M-15. Part of an extensive dinnerware set, the Blue Ship pieces have no flames around the logo
but are products of the 20's and 30's. Height 4 inches.

157 Tall high glaze vase with white daffodil decoration painted in 1945 by Kataro Shirayamadani. Marks on the base $1250-1750
include the Rookwood logo, the date, shape number 932 C, the incised number 6007 and the artist's incised
initials. Height 11½ inches. The piece is uncrazed but has some pooling of underglaze color near the shoulder.

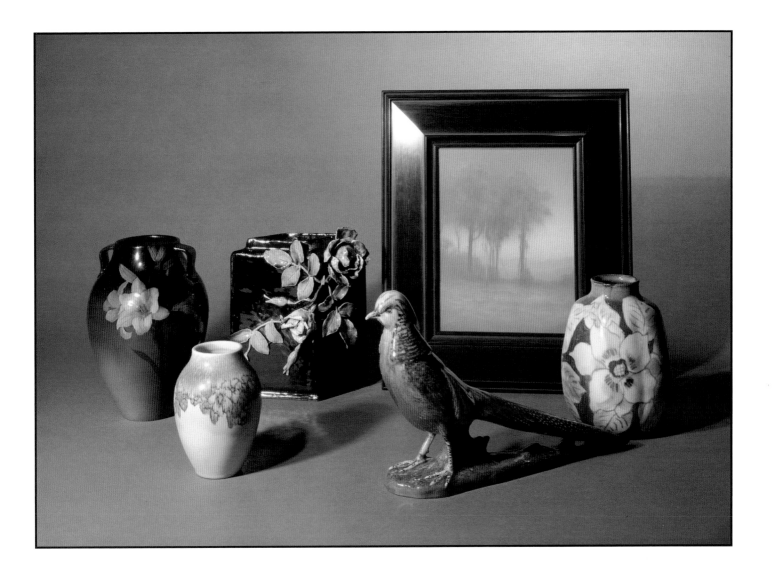

158 Standard glaze vase with two strap handles, decorated with daylilies, circa 1907, by Sallie Toohey. Marks on the base include the Rookwood logo, the artist's monogram and the partially obscured date. Height 9¼ inches. The vase has been drilled and cracked, and one of the handles has also been damaged. All of the damage has been restored. $300-400

159 Mat glaze vase with orange, yellow and green flowers on a yellow ground, painted in 1924 by Katherine Jones. Marks on the base include the Rookwood logo, the date, shape number 604 F and the artist's initials. Height 5¼ inches. Exhibited: "Rookwood Pottery" The Yuma Art Center, 1978, catalog number 90. $350-450

160 Early Cincinnati Limoges style vase with applied red and white roses, thought to be Wheatley Pottery from about 1881. The piece is unmarked. Height 9⅜ inches. $300-400

161 Misty Vellum glaze scenic plaque painted in 1913 by Lenore Asbury. The artist's initials appear in the lower right hand corner. Marks on the back include the Rookwood logo, the date and V for Vellum glaze body. Size is 10⅞ x 8½ inches. $3000-3500

162 Interesting polychromed high glaze pheasant decorated in 1926 by Sara Sax. Marks on the base include the Rookwood logo, the date, shape number 2832, the number "6942" in black slip and the artist's monogram also in black slip. Height 8¾ inches. Polychromed pheasants are fairly unusual and to find one signed by a regular Rookwood artist is very different. This lot and another in the sale cost $36.05 each when finally purchased from the Loring Andrews Company, a Rookwood retailer here in Cincinnati. Photocopies of the original sales receipt are available to the purchaser of this lot. $600-800

163 High glaze ribbed vase with magnolia decoration, painted in 1944 by Jens Jensen. Marks on the base include the Rookwood logo, the date, shape number 6364 and the artist's monogram in red slip. Height 7½ inches. Typical of Jensen, every inch of this vase is decorated. $1000-1250

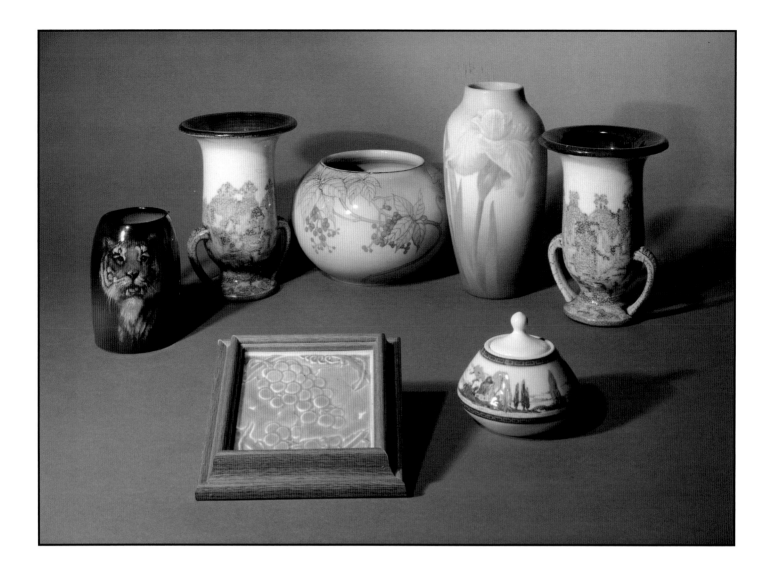

164 Handsome Standard glaze mug decorated by Bruce Horsfall in 1895 with a nicely detailed, snarling tiger. Marks on the base include the Rookwood logo, the date, shape number 793 and the artist's monogram. Height 5⅝ inches. Very minor glaze scratches, possibly claw marks. — $1250-1500

165 Colorful and stylish Butterfat glaze two handled vase with geometrically detailed floral decoration, painted in 1929 by Lorinda Epply. The interior of the vase is glazed with mottled, slightly iridescent colors generally used on some of Rookwood's more adventuresome pieces. Marks on the base include the Rookwood logo, the date, shape number 6110 and the artist's monogram in black slip. Height 8½ inches. Uncrazed. The purchaser of this lot will be allowed to buy lot 170 for the same price. — $1250-1500

166 Polychromed Commercial Vellum glaze trivet with blue grapes and green leaves, made at Rookwood in 1919. Marks on the back include the Rookwood logo, the date and shape number 1683. Size is 5⅝ x 5⅝ inches. Minor glaze pitting. Uncrazed and recently framed. — $300-400

167 Clean and colorful high glaze vase with Virginia creeper decoration, crisply painted in 1924 by Ed Diers. Marks on the base include the Rookwood logo, the date, shape number 1375 and the artist's monogram. Height 5⅞ inches. Uncrazed. — $2000-2500

168 Early Vellum glaze vase with spectacular white iris decoration, done in 1905 by Carl Schmidt. Marks on the base include the Rookwood logo, the date, shape number 977, a V for Vellum glaze body, an incised V for Vellum glaze, a wheel ground x and the artist's monogram. Height 10¼ inches. There is a small ⅛ inch pit on the shoulder in the back and two areas where the glaze appears to be loose but very stable. Despite its flaws, here is one of the showiest Vellums from this period ever to come on the market. — $1250-1750

169 Unusual lidded high glaze rose jar having a repeating scene of a small cottage in a grove of willow and poplar trees, painted in 1920 by Arthur Conant. Marks on the base include the Rookwood logo, the date, shape number 2337, a wheel ground x and the artist's monogram. Height 4 inches. Conant scenics are always a treat and this one is very clean. — $2500-3000

170 Colorful and stylish Butterfat glaze two handled vase with geometrically detailed floral decoration, painted in 1929 by Lorinda Epply. The interior of the vase is glazed with mottled, slightly iridescent colors generally used on some of Rookwood's more adventuresome pieces. Marks on the base include the Rookwood logo, the date, shape number 6110 and the artist's monogram in black slip. Height 8½ inches. Uncrazed. The purchaser of lot 165 will be allowed to buy this lot for the same price. — $1250-1500

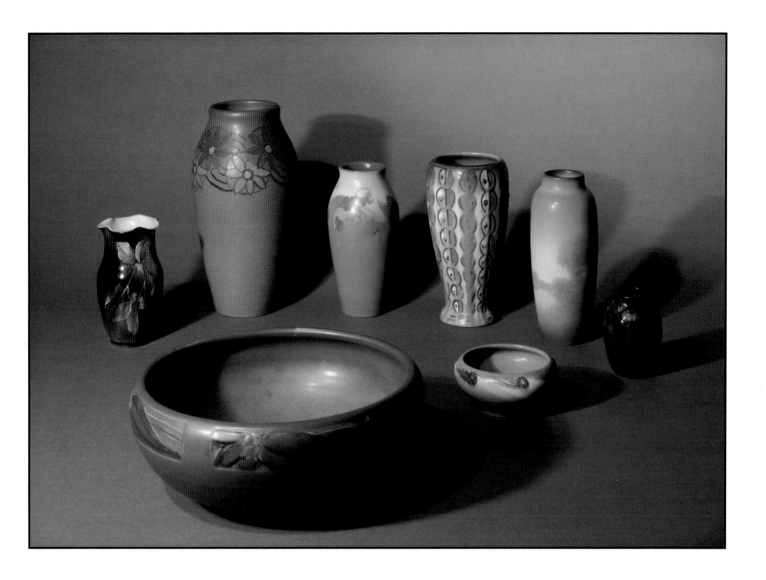

171 Standard glaze vase with leaf and berry decoration and ruffled rim, painted in 1889 by Harriet Wilcox. Marks on the base include the Rookwood logo, the date, shape number 513, W for white clay, LY for light yellow (Standard) glaze and the artist's initials. Height 5½ inches. $300-400

172 Stylish Arts & Crafts mat glaze bowl carved and painted in 1914 by C.S. Todd. Around the rim are five repeating rectangular panels, each containing a floral spray in red, yellow and green. Marks on the base include the Rookwood logo, the date, shape number 1196 and the artist's initials. Diameter is 10½ inches. $1000-1250

173 Mat glaze vase with stylized floral decoration done in 1918 by C.S. Todd. The base is marked with the Rookwood logo, the date, shape number 925 C and Todd's initials. Height 10⅛ inches. $600-800

174 Crisply painted Vellum glaze vase with wild violet decoration, done in 1927 by Fred Rothenbusch. Marks on the base include the Rookwood logo, the date, shape number 925 E and the artist's monogram. Height 7¼ inches. Uncrazed. $1000-1250

175 Strong Art Deco style vase with vertical repeating designs outlined by slip trailing and painted in blue, brown and yellow by Elizabeth Barrett in 1928. Marks on the base include the Rookwood logo, the date, shape number 1779 and the artist's monogram. Height 7¾ inches. $1000-1250

176 Vellum glaze bowl with a repeating band of red flowers and mauve swirls, painted in 1915 by Mary Grace Denzler. Marks on the base include the Rookwood logo, the date, shape number 957 E, V for Vellum glaze body and the artist's monogram. Height 1⅞ inches. $150-200

177 Very crisp and clean and delicately decorated Vellum glaze scenic vase, painted in 1938 by E.T. Hurley. Marks on the base include the Rookwood logo, the date, shape number 907 F and the artist's initials. Height 7½ inches. Uncrazed. $2000-2500

178 Standard glaze vase with red clover decoration, painted in 1902 by Carrie Steinle. Marks on the base include the Rookwood logo, the date, shape number 654 E and the artist's monogram. Height 3½ inches. $200-300

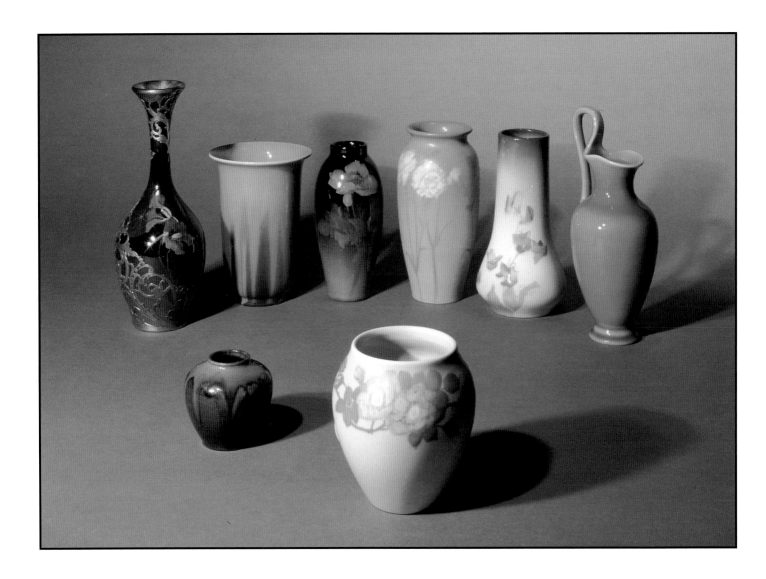

179 Very impressive Standard glaze vase from 1900 with heavy silver overlay and finely detailed nasturtium decoration by Carl Schmidt. The overlay is by the Alvin Silver Company and is perhaps the heaviest we have ever seen. Worked into the silver are several wild roses and lots of scroll work. Marks on the base include the Rookwood logo, the date, shape number 847 and the artist's monogram. The silver is marked with the Alvin logo and the notation, "999/1000 Patented". Height 10¾ inches. $5000-7000

180 Very exotic Rookwood "1932" vase having at least three different glazes laid one on top of the other including a rich Coromandel with lots of glitter. Marks on the base include the Rookwood logo, the date and shape number 6307 F. Height 3 inches. $300-400

181 Commercial "1932" glaze vase having a crystalline blue drip over dove gray glaze, all of which have a slight luster effect. Marks on the base include the Rookwood logo, the date, shape number 6306 and a cross shaped esoteric mark. Height 7 inches. $300-400

182 Standard glaze vase with bright floral decoration, painted in 1905 by Laura Lindeman. Marks on the base include the Rookwood logo, the date, shape number 901 D and the artist's initials. Height 7¼ inches. Minor glaze scratches. $350-450

183 Very clean and beautifully detailed Vellum glaze vase with wild rose decoration, done in 1927 by Ed Diers. Marks on the base include the Rookwood logo, the date, shape number 1343, V for Vellum glaze and the artist's monogram. Height 5 inches. Uncrazed. $1250-1750

184 Very crisp and clean Vellum glaze vase with carnation decoration, painted in 1925 by Ed Diers. Marks on the base include the Rookwood logo, the date, shape number 2544, an incised V for Vellum glaze and the artist's monogram. Height 8⅛ inches. Very little crazing. $1750-2000

185 Iris glaze vase with sweet pea decoration painted in 1910 by Sallie Coyne. Marks on the base include the Rookwood logo, the date, shape number 1278 E, W for white (Iris) glaze and the artist's monogram. Height 8⅛ inches. A two inch line descends from the rim. $1000-1250

186 Commercial high glaze ewer made at Rookwood in 1939. Marks on the base include the Rookwood logo, the date and shape number 6008 E. Height 9⅞ inches. Minor grinding chips on the base. $100-150

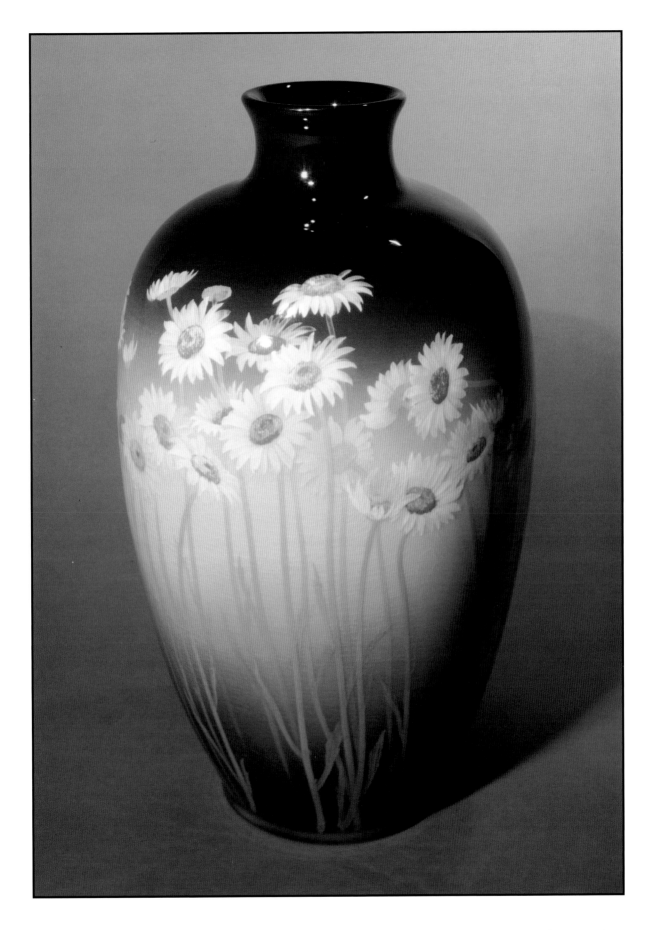

187 Large and important Black Iris glaze vase painted in 1908 by Kataro Shirayamadani. Decoration consists of $20000-25000
 dozens of white daisies in various stages of development, encircling the vase. Marks on the base include the
 Rookwood logo, the date, shape number 787 B and the artist's cypher. Shirayamadani created a similar piece in
 Standard glaze in 1897 which we sold as lot 111 in the Glover Collection Auction. Height 14⅞ inches.

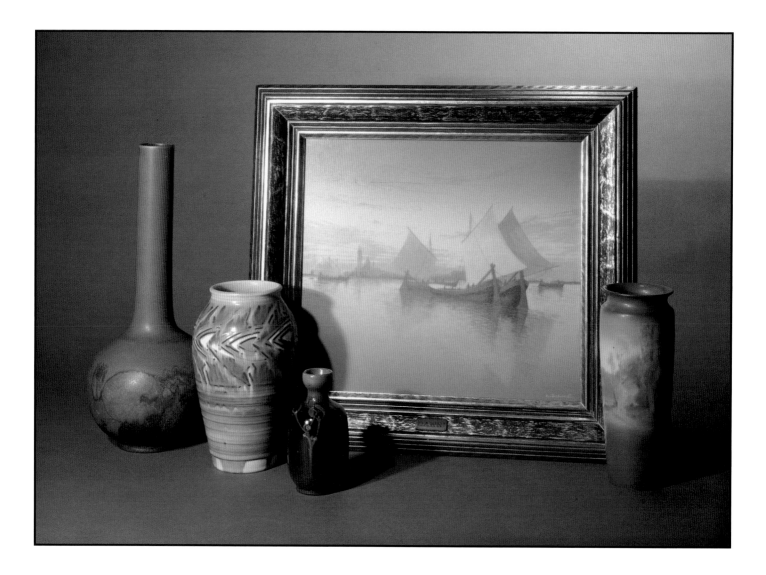

188 Tall mat glaze vase decorated with lotus blossoms by Sallie Coyne in 1925. Marks on the base include the $1000-1500
Rookwood logo, the date, shape number 2825 A and the artist's monogram. Height 16¼ inches.

189 Colorful mat glaze vase with geometric slip trail decoration, done by Elizabeth Barrett in 1930. Marks on the base $500-700
include the Rookwood logo, the date, a partially obscured shape number, a wheel ground x and the artist's
monogram. Height 9¼ inches. There is a small grinding chip on the base and the piece has been drilled.

190 Standard glaze vase with three repeating sprays of mistletoe, done in an Art Nouveau manner by Virginia $350-450
Demarest in 1901. Marks on the base include the Rookwood logo, the date, shape number 625, most of an
original Rookwood salesroom label and the artist's initials. Height 5⅝ inches.

191 Large and important Vellum glaze Venetian harbor scenic plaque painted by Carl Schmidt in 1926. Few $15000-20000
Rookwood plaques are as large and fewer still as detailed and as clean. Workers on even the smallest boats are
visible, details of the buildings in the background are extensive and clouds, often lacking in Schmidt's later work,
accent the sky. Marks on the back include the Rookwood logo and the date. The artist's name appears in the
lower right hand corner and a metal tag on the frame, most likely original to the piece, proclaims the title,
"Dawn!". Size is 14¼ x 16⅛ inches. Uncrazed.

192 Pleasant banded scenic Vellum glaze vase done in 1920 by Fred Rothenbusch. Marks on the base include the $1750-2250
Rookwood logo, the date, shape number 1882, V for Vellum glaze , a wheel ground x and the artist's monogram.
Height 9⅝ inches. There are a few very minor glaze bubbles.

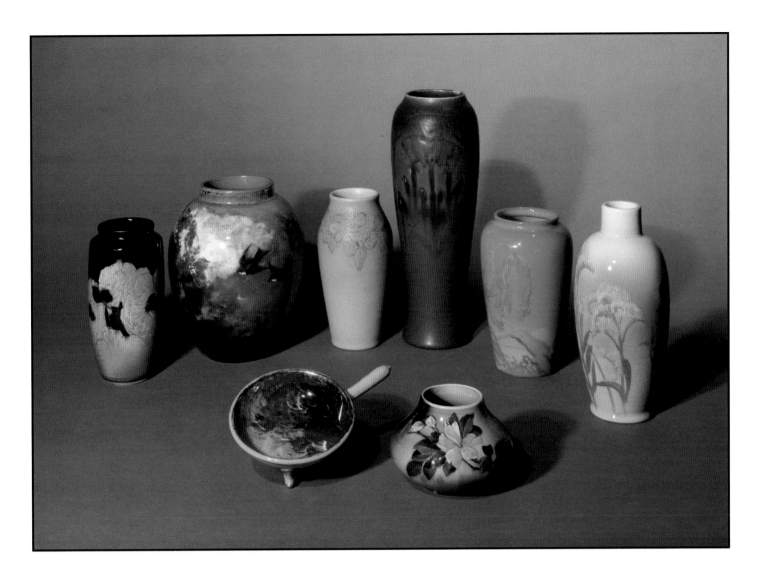

193 Striking Sea Green glaze vase with unusual coloration, painted in 1900 by Fred Rothenbusch. The Yellow flowers $4000-6000
 are done in heavy slip and laid on a rich black ground. Tiny silver crystals appear at the shoulder and at the rim.
 If this were an Iris glaze piece, it would be called Black Iris. Perhaps this is a "Black Sea Green". Marks on the
 base include the Rookwood logo, the date, shape number 734 DD, G for Sea Green glaze, a wheel ground x and
 the artist's monogram. Height 6⅝ inches.

194 Limoges style vase painted circa 1882 by M.A. Daly, most likely while at Matt Morgan Pottery. Decoration $400-500
 consists of two birds flying toward a bamboo grove with clouds in the background. The base bears the incised
 initials of the artist. The orange clay body is consistent with Matt Morgan, Daly's employeer until he joined
 Rookwood in 1882. Height 7¾ inches.

195 Limoges style shallow dish with three feet and a handle, decorated with a spider and bat motif in 1882 by an $125-150
 unknown artist. Marks on the base include Rookwood in block letters, the date, G for ginger clay and the
 indistinct initials of the artist. Largest distance across is 6¾ inches.

196 Mat glaze vase with pastel colors and floral decor, done in 1929 by Katherine Jones. Marks on the base include $400-500
 the Rookwood logo, the date, shape number 925 E and the artist's initials. Height 7 inches.

197 Tall mat glaze vase with incised and painted stylized floral decoration, done in 1919 by Elizabeth Lincoln. Marks $700-900
 on the base include the Rookwood logo, the date, shape number 2040 C, V for Vellum glaze body and the artist's
 initials. Height 11¾ inches. Uncrazed.

198 Standard glaze vase with crisp wild rose decoration painted in 1889 by Harriet Wilcox. Marks on the base $300-400
 include the Rookwood logo, the date, shape number 536 E, W for white clay and the artist's initials. Height 3
 inches. Small burst glaze bubble near the base.

199 Striking high glaze scenic vase in the inimitable style of Arthur Conant, painted in 1920. The scene consists of a $2500-3000
 willow tree and red flowering bushes near a lake in which swim two white birds. Purple mountains are in the
 background. Marks on the base include the Rookwood logo, the date, shape number 938 D and the artist's
 monogram. Height 6¾ inches. Uncrazed.

200 Iris glaze vase with nicely painted goldenrod decoration, done in 1902 by Rose Fechheimer. Marks on the base $2000-2500
 include the Rookwood logo, the date, shape number 786 D, W for white (Iris) glaze and the artist's monogram.
 Height 8⅜ inches.

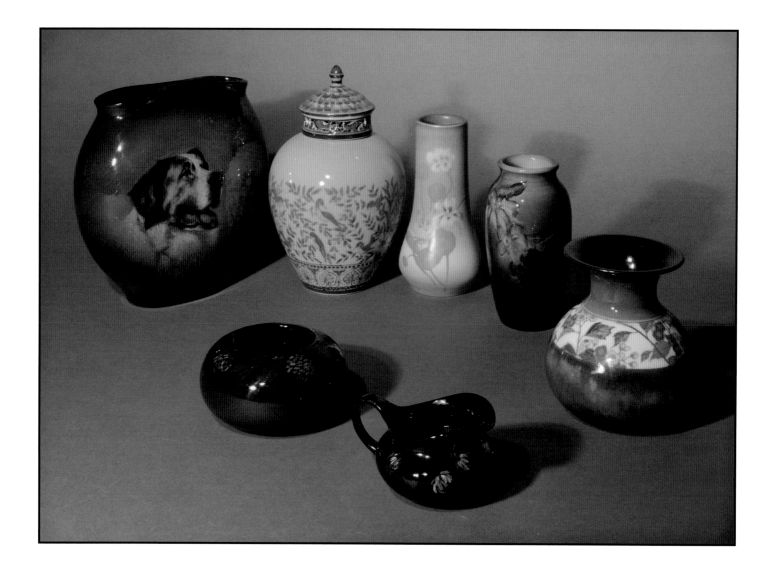

201 Large Standard glaze pillow vase with St. Bernard decoration by E.T. Hurley, done in 1901. Marks on the base include the Rookwood logo, the date, shape number 707 AA, a wheel ground x and the artist's initials. Height 9¼ inches. Moderate glaze burn and underglaze runs. $500-700

202 Standard glaze closed bowl decorated with pine boughs and pine cones by Katherine Van Horne in 1908. Marks on the base include the Rookwood logo, the date, shape number 214 C and the artist's monogram. Height 2½ inches. This is most certainly one of the last Standard glaze pieces made at Rookwood. $250-350

203 Nicely decorated potpourri jar with both inner and outer lids, painted in 1923 by Lorinda Epply and covered with a blue tinted high glaze. The art work consists of 18 birds perched in flowering bushes with repeating borders encircling the base. The reticulated outer lid is cast with small birds in its design and has repeating designs painted on. Marks on the base include the Rookwood logo, the date, shape number 2451 and "-P-" and the artist's monogram incised. Height 9¾ inches. The inner lid is signed by Epply and painted but has been broken and glued. It is not visible when the outer lid is in place. Uncrazed. $1000-1250

204 Vellum glaze vase with nasturtium decoration, done by Margaret McDonald in 1914. Marks on the base include the Rookwood logo, the date, shape number 1278 F, V for Vellum glaze and the artist's monogram. Height 7⅝ inches. $700-900

205 Standard glaze creamer with clover decoration, painted by an unknown artist in 1899. Marks on the base include the Rookwood logo, the date, shape number 548 and the indistinct monogram of the artist. Height 2½ inches. Minor underglaze skips on rim and handle. $150-200

206 Sea Green glaze vase with wild rose decoration by Sallie Coyne, painted in 1903. Marks on the base include the Rookwood logo, the date, shape number 80 B, G for Sea Green glaze, a wheel ground x and the artist's monogram. Height 6¾ inches. Minor underglaze flaws account for the "x". $1500-2000

207 Yellow tinted high glaze vase with colorful floral decoration and rich purple glaze on the interior, done in 1924 by Kataro Shirayamadani. There is a band of flowers encircling the vase which is quite obvious and there is another band of flowers just above the base which is quite hard to see, perhaps obscured by the glaze. Marks on the base include the Rookwood logo, the date, shape number 2759 and the artist's cypher. Height 5⅝ inches. Uncrazed. $2000-2500

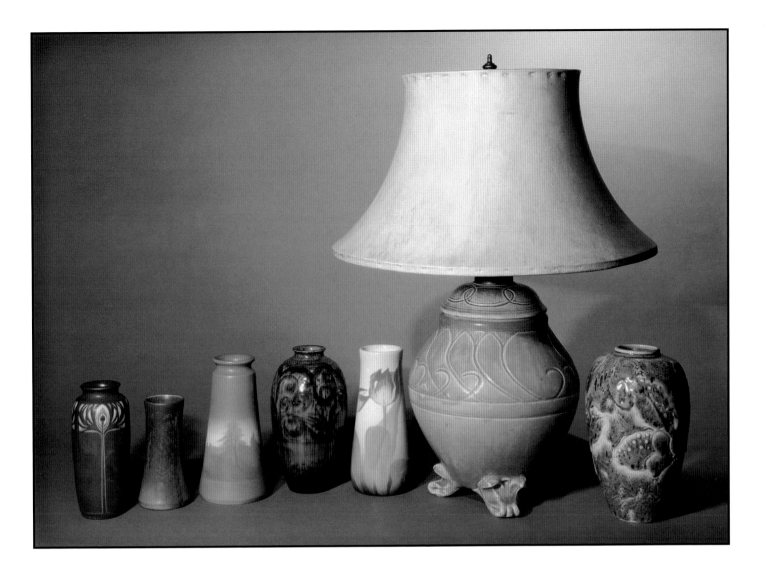

208 Rare carved Green Vellum glaze vase with peacock feather decoration, done by Sara Sax in 1909. Each of the three feathers is outlined by incising and deeply carved on either side of the eye. The overall effect is much like the deep carving on French cameo glass. Marks on the base include the Rookwood logo, the date, shape number 904 E, G.V. for Green Vellum glaze, V for Vellum glaze body and the artist's monogram. Height 7⅛ inches. $3000-4000

209 Mat glaze vase with carved and painted abstract designs, done in 1920 by Elizabeth Lincoln. Marks on the base include the Rookwood logo, the date, shape number 1358 F and the artist's initials. Height 5⅞ inches. Minor grinding nicks on the base. $300-400

210 Unusual banded Vellum glaze scenic vase done in 1911 by Fred Rothenbusch. Marks on the base include the Rookwood logo, the date, shape number 1655 E, V for Vellum glaze body, V for Vellum glaze, the number "1" stamped just above the logo and the artist's monogram. Height 7⅞ inches. Rarely are Vellums from this period uncrazed as is this one. $1500-2000

211 Unusual high glaze vase with crystalline inclusions at base and rim, decorated in 1946 by Jens Jensen with a band of swirls and flourishes. Marks on the base include the Rookwood logo, the date, S for Special shape, the number 8959 and the artist's monogram in slip. Height 8¼ inches. This glaze was called "Wine Madder" by Rookwood and is more often seen on Commercial pieces. The use of a crystalline glaze, in conjunction with it, is very modern in technique and appearance. $600-800

212 Handsome Iris glaze vase with delicate tulips painted in 1906 by Sallie Coyne. Marks on the base include the Rookwood logo, the date, shape number 950 D, W for white (Iris) glaze and the artist's monogram. Height 8⅛ inches. Uncrazed. $3500-4000

213 Rare oil lamp base with ceramic cap, incised and glazed in a rich mottled green mat by Albert Munson in 1901. Marks on the base include the Rookwood logo, the date, shape number 51 AZ and the artist's monogram. Height of the ceramic portion only is 12¼ inches. Rookwood made a number of lamp bases at the turn of the century, some electric and some for oil. The oil lamps typically had a copper font capped by a ceramic collar which reflected the glaze and decoration of the base. Very few of the bases, fonts and caps have survived together. This piece has been converted to electricity and has lost its Duplex burner and had a hole drilled in the copper font. Both problems are fairly easy to correct. The shade is leather and is not original. $2000-2500

214 Commercial vase with embossed floral decoration, covered with a rich, variegated Bengal Brown glaze and made at Rookwood in 1959. Marks on the base include the Rookwood logo, the date, shape number 6893 and the notation, "Rookwood Cinti, O.". Height 9⅛ inches. $200-300

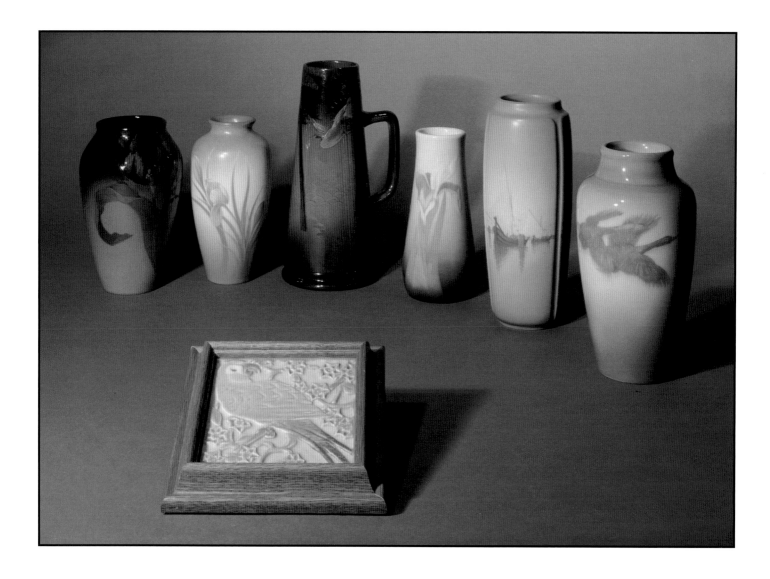

215 Standard glaze vase with bright red tulips decorated in an Art Nouveau manner in 1902 by Mary Nourse. Marks on the base include the Rookwood logo, the date, shape number 913 C, L for light Standard glaze and the artist's initials. Height 8½ inches. Small ⅛ inch unobtrusive glaze burn on rim. $500-700

216 Beautiful, clean and extremely well painted Vellum glaze vase with crocuses, done in 1926 by Carl Schmidt. Marks on the base include the Rookwood logo, the date, shape number 614 E, V for Vellum glaze and the artist's monogram. Height 8⅝ inches. Uncrazed and exceptional. $3500-4500

217 Rookwood mat glaze Commercial trivet with a multicolored parrot perched in a flowering tree. Marks on the back include the Rookwood logo, the date, the letter "T" and shape number 3077. Size is approximately 5¾ x 5¾. Minor glaze pitting. Recently framed. $300-400

218 Handsome Standard glaze tankard done in an Arts & Crafts manner by Kataro Shirayamadani in 1897. Tall pine trees seem to rise from stylized clouds while three cranes fly through the tops of the trees. Marks on the base include the Rookwood logo, the date, shape number 564 B, a diamond shaped esoteric mark and the artist's cypher. Height 11¼ inches. There is a tiny glaze nick at the rim and an unobtrusive diagonal line, mid body on the back side, which does not appear on the inside. $4000-5000

219 Pretty Iris glaze vase with mauve and white irises and buds, painted in 1905 by Sallie Coyne. Marks on the base include the Rookwood logo, the date, shape number 950 D, W for white (Iris) glaze and the artist's monogram. Height 8¼ inches. $3000-3500

220 Extremely clean and finely painted Vellum glaze Venetian harbor scenic vase, done in 1926 by Carl Schmidt. The vase is made with vertical spaces separating it into three large panels. Each panel is decorated with a different array of boats with a consistent horizon lending continuity from panel to panel. Marks on the base includes the Rookwood logo, the date, shape number 2934, V for Vellum glaze and the artist's monogram. Height 10⅝ inches. Uncrazed with minute glaze dimple. The panels are a rare variation and the art work is some of Schmidt's finest. $8000-10000

221 Very clean and crisply painted Iris glaze vase showing four black geese in flight, done in 1904 by E.T. Hurley. Marks on the base include the Rookwood logo, the date, shape number 943 C, W for white (Iris) glaze and the artist's initials. Height 9½ inches. Uncrazed. $5000-7000

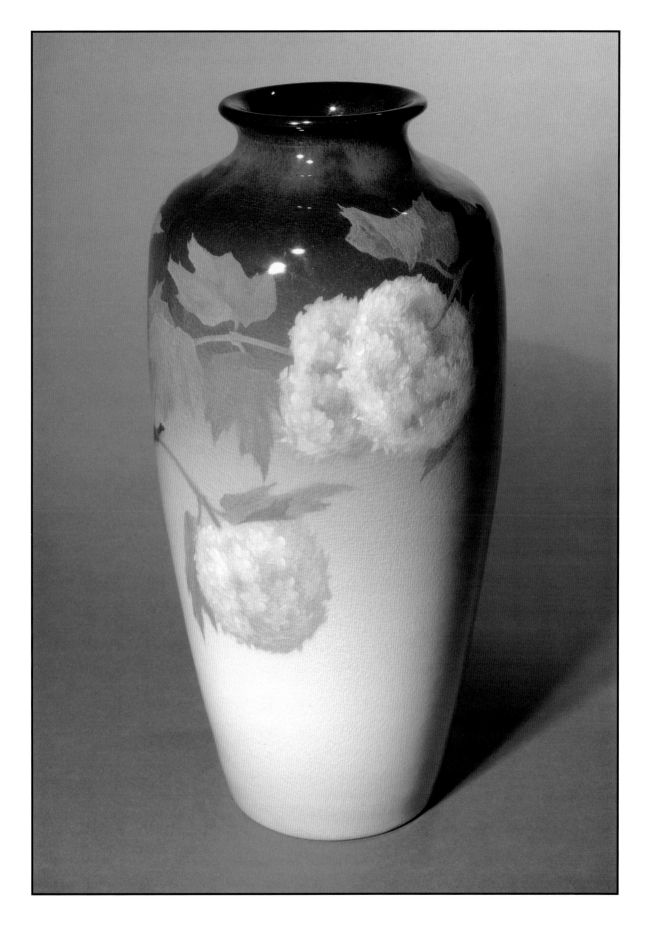

222 Tall and impressive Iris glaze vase with hydrangea decoration, painted in 1905 by Albert Valentien. Marks on the $10000-12500
 base include the Rookwood logo, the date, shape number 614 B, W for white (Iris) glaze and the artist's full
 name. Height 14⅛ inches. Valentien's last year in Cincinnati was 1905 and, as this vase demonstrates, his was a
 great loss to Rookwood.

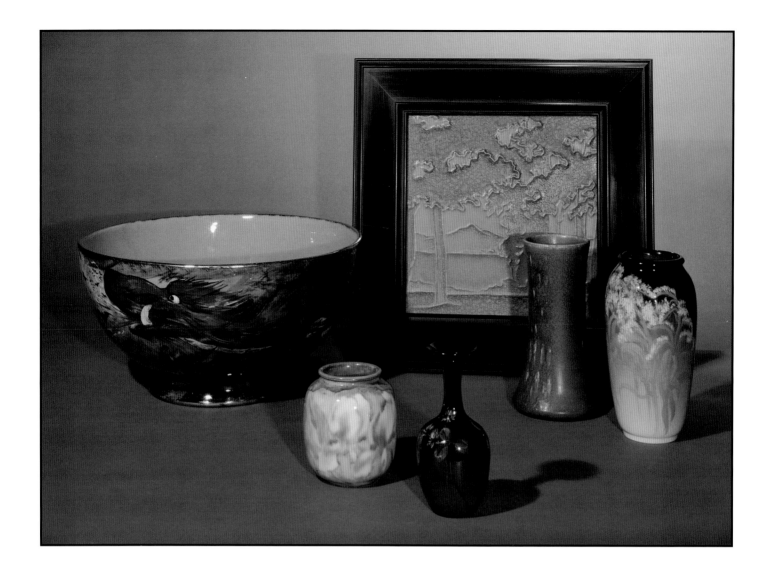

223 Large and important Limoges style glaze punch bowl dated 1882, almost certainly the work of Maria Longworth $4000-6000
Nichols. The exterior of the bowl shows a large, fire breathing dragon being ridden by several black devils. As the
dragon flies through the clouds it is preceded by a large group of bats. Fired on gold trims and accents the
decoration and is used on the interior to simulate clouds. The base is stamped "Rookwood", "1882" and "G" for
ginger clay. Height is 8¼ inches and the diameter is 16⅜ inches. Although not marked, this would seem to be
shape 163 (See Peck's "The Second Book of Rookwood Pottery" page 53 for a very similar example.) Originally
owned by Howard Agustus Smith of Rochester, New York, the bowl has descended in his family. Oral tradition
indicates that it may possibly have been purchased at the Columbian Exposition in Chicago in 1893.

224 High glaze vase decorated by Jens Jensen in 1948 with several white irises. Marks on the base include the $400-600
Rookwood logo, the date, shape number 6194 F and the artist's monogram. Height 4¼ inches. Very little crazing.

225 Handsome Rookwood Architectural Faience landscape tile made circa 1915 and done in mat glazes. Marks on $700-900
the back include the notations, "Rookwood Faience 1226 Y 2". Size 11⅞ x 11⅞ inches. The upper right hand
corner has been broken off and professionally repaired.

226 Standard glaze vase having a flared rim, decorated by Edith Felten with white clover. Marks on the base include $300-400
the Rookwood logo, the date, shape number 863 and the artist's initials. Height 6¾ inches. Very minor glaze
scratches.

227 Arts & Crafts mat glaze vase with three vertical bands of subtly carved designs done in 1911 by William $600-800
Hentschel. Marks on the base include the Rookwood logo, the date, shape number 1358 D and the artist's
monogram. Height 8¾ inches.

228 Iris glaze vase with goldenrod decoration, nicely contrasted on a black to cream ground, painted in 1902 by $3000-4000
Virginia Demarest. Marks on the base include the Rookwood logo, the date, shape number 892 C, W for white
(Iris) glaze and the artist's initials. Height 8¾ inches.

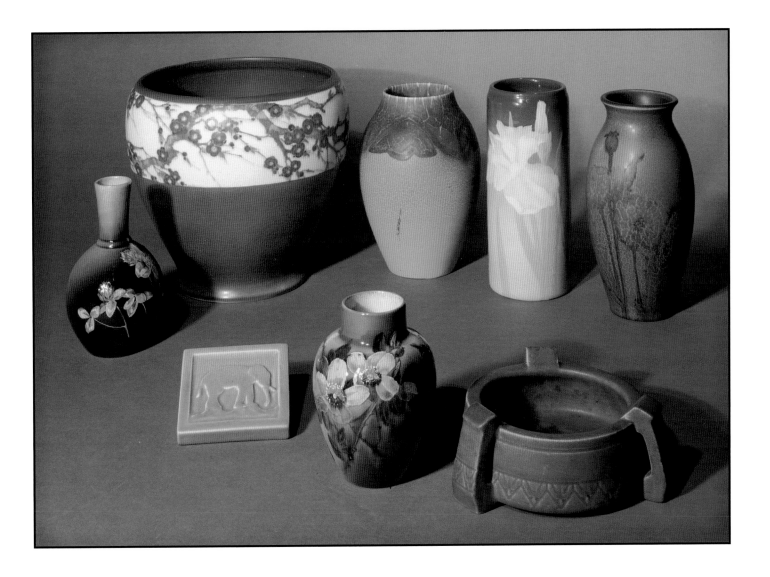

229 Standard glaze vase with bright clover decoration painted in 1894 by Daniel Cook. Marks on the base include the Rookwood logo, the date, shape number 352, W for white clay and the artist's initials. Height 6⅛ inches. There are two small dark lines on the inside of the rim which are very tight and do not appear to come through. $200-300

230 Commercial elephant paperweight covered in a green to pink mat glaze and made at Rookwood in 1921. Marks on the back include the Rookwood logo, the date and shape number 2054. Size is 3½ inches square. $150-250

231 Large Vellum glaze jardiniere with a band of oriental cherry blossoms surrounding the top half of the piece, done in 1920 by Lorinda Epply. Everything not decorated with blossoms, inside and out, is glazed in a rich maroon. Marks on the base include the Rookwood logo, the date, shape number 2466, V for Vellum glaze body and the artist's monogram. Height 8⅝ inches. Exhibited: "Rookwood Pottery" The Yuma Art Center, 1978, catalog number 79. $1000-1500

232 Standard glaze vase with wild rose decoration by Elizabeth Lincoln, painted in 1892. Marks on the base include the Rookwood logo, the date, shape number 162 D, W for white clay and the artist's initials. Height 5⅛ inches. $300-400

233 Mat glaze vase with a band of trailing flowers at the shoulder, painted in 1920 by Elizabeth Lincoln. Marks on the base include the Rookwood logo, the date, shape number 604 D, V for Vellum glaze body and the artist's initials. Height 7⅝ inches. $400-600

234 Iris glaze vase with white iris decoration by Lenore Asbury, painted in 1905. Marks on the base include the Rookwood logo, the date, shape number 952 D, an incised W for white (Iris) glaze and the incised artist's initials. Height 8¼ inches. There are two pin head size glaze nicks, one on a flower stem and the other about ½ inch down inside the rim. $1000-1500

235 Commercial mat glaze Arts & Crafts bowl with three buttressed feet, made at Rookwood in 1907. Marks on the base include the Rookwood logo, the date, shape number 1309 and a V shaped esoteric mark. Distance across is 6½ inches. Small chip off the bottom of one foot. $150-250

236 Mat glaze vase having red poppies on a dark green ground, painted in 1928 by Elizabeth Lincoln. Marks on the base include the Rookwood logo, the date, shape number 356 D and the artist's initials. Height 8⅜ inches. $500-700

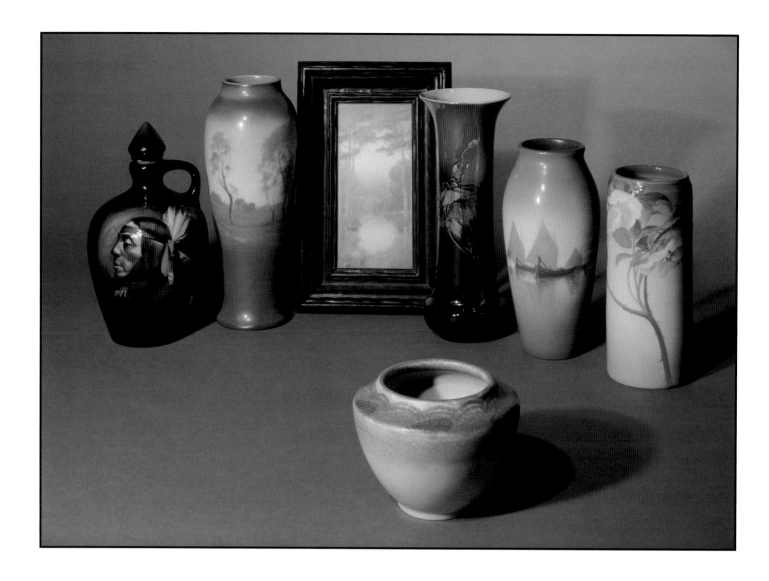

237 Good Standard glaze stoppered whiskey jug featuring the handsome portrait of Chief Lean Wolf, painted by Adeliza Sehon in 1901. The base is marked with the Rookwood logo, the date, shape number 512 B, the artist's initials and the notation, "Lean Wolf Chief of Hidatsa. -Sioux-". Height 9⅜ inches. Very minor glaze scratches. $4000-6000

238 Banded scenic Vellum glaze landscape vase painted in 1918 by Fred Rothenbusch. Marks on the base include the Rookwood logo, the date, shape number 1667 and the artist's monogram. Height 11 inches. $2000-3000

239 Delicate Vellum glaze plaque with birch trees silhouetted by a pink sky, painted in 1927 by E.T. Hurley. The artist's initials appear in the lower left hand corner. The back is marked with the Rookwood logo and the date. Size is 7⅞ x 4 inches. Uncrazed and very colorful. $2500-3000

240 Mat glaze vase with carved and painted designs around the shoulder, done in 1913 by William Hentschel. Marks on the base include the Rookwood logo, the date, shape number 1927 and the artist's monogram. Height 4 inches. $400-600

241 Very pretty Standard glaze vase with nicely detailed poppies done in 1890 by Albert Valentien. Marks on the base include the Rookwood logo, the date, shape number 535 C, W for white clay, L for light Standard glaze and the artist's initials. Height 10⅜ inches. $800-1000

242 Good Vellum glaze Venetian harbor scene vase painted by Carl Schmidt in 1921. Marks on the base include the Rookwood logo, the date, shape number 925 D, V for Vellum glaze body and the artist's monogram. Height 8¼ inches. $2500-3500

243 Very crisp and clean Iris glaze vase with wild rose decoration, painted in 1905 by Ed Diers. Marks on the base include the Rookwood logo, the date, shape number 952 D, an incised W for white (Iris) glaze and the artist's monogram. Height 8⅛ inches. Virtually uncrazed. $2000-3000

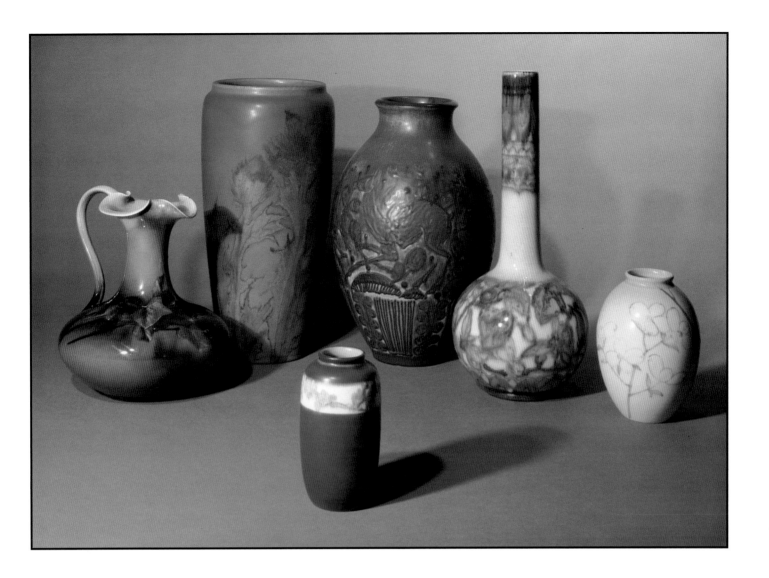

244 Tall Standard glaze ewer with English ivy decoration painted by Anna Valentien in 1892. Marks on the base $400-600
include the Rookwood logo, the date, shape number 495, W for white clay, L for light Standard glaze and the
artist's initials. A wheel ground V (another version of Rookwood's second mark) was visible beneath the
attachment point of the handle but has been professionally covered. Height 10 inches. Exhibited: "Rookwood
Pottery" The Yuma Art Center, 1978, catalog number 24.

245 Tall mat glaze vase with thistle decoration, painted in bright colors by Elizabeth Lincoln in 1924. Marks on the $800-1200
base include the Rookwood logo, the date, shape number 1369 D and the first "L" of Lincoln's initials. Height 15
1/8 inches. A large drill hole has removed the rest of Lincoln's mark and there is a ¼ x ¼ inch grinding chip off the
base which is only in the glaze.

246 Vellum glaze vase with a dark blue background and a band of cherry blossoms painted around the shoulder, $300-400
done in 1917 by Carrie Steinle. Marks on the base include the Rookwood logo, the date, shape number 924, V
for Vellum glaze body and the artist's monogram. Height 6 inches.

247 Large and impressive Art Deco vase covered with lightly crystalline green, brown and blue mat glazes by William $3000-3500
Hentschel in 1927. Decoration consists of three leaping deer amid exotic foliage, all accented and outlined with
slip trailing. Marks on the base include the Rookwood logo, the date, shape number 2246 C and the artist's
monogram. Height 14⅜ inches. Large Art Deco examples of Hentschel's work are uncommon and quite desirable.

248 Tall high glaze vase with floral decoration in soft blue, green, maroon and brown, painted in 1925 by Lorinda $1500-2000
Epply. Marks on the base include the Rookwood logo, the date, shape number 2825 A and the artist's monogram.
Height 16¼ inches. Uncrazed.

249 Delicate Vellum glaze vase with dogwood decoration by Kataro Shirayamadani, painted in 1944. Marks on the $800-1000
base include the Rookwood logo, the date, shape number 6184 E and the artist's initials. Height 7 inches.
Uncrazed but with some minor glaze discoloration.

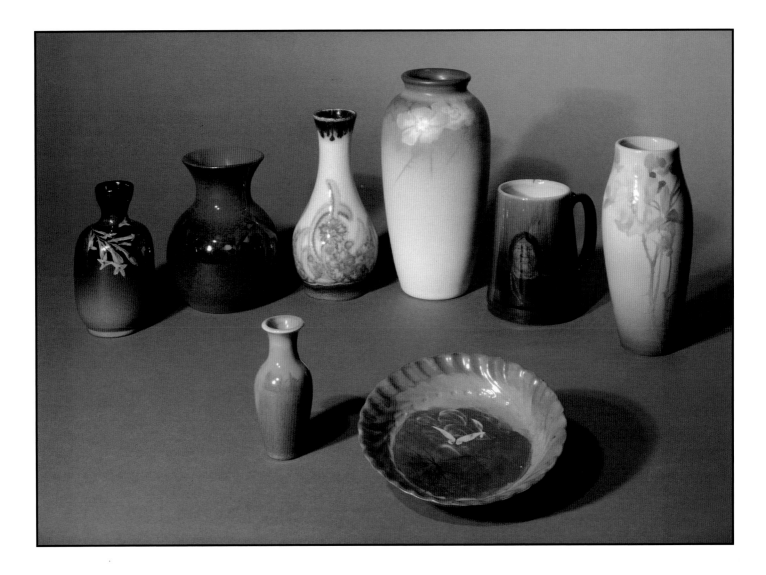

250 Standard glaze vase with floral decoration done in 1900 by Toby Vreeland. Marks on the base include the Rookwood logo, the date, shape number 625, a wheel ground x and the artist's initials. Height 5⅝ inches. Minor glaze discoloration near the base. — $300-400

251 Black Opal glaze vase with floral decoration painted in 1925 by Harriet Wilcox. The interior is glazed in a rich orange. Marks on the base include the Rookwood logo, the date, shape number 402 and the artist's initials. Height 6 inches. Uncrazed and very clean. — $1250-1500

252 Colorful Rookwood "1932" vase featuring at least three different crystalline glazes applied one over the other. Marks on the base include the Rookwood logo and the date. Anything else is covered by glaze. Height 4 inches. — $125-175

253 Attractive high glaze vase with what may be stylized hyacinth decoration, painted in 1927 by Lorinda Epply. The interior is nicely glazed with a mottled blue-black which drips partway from the rim. Marks on the base include the Rookwood logo, the date, shape number 2963 and the artist's monogram. Height 7½ inches. Uncrazed. — $700-900

254 Vellum glaze vase with wild rose decoration by E.T. Hurley, done in 1911. Marks on the base include the Rookwood logo, the date, shape number 922 C, V for Vellum glaze and the artist's initials. Height 9⅛ inches. — $500-700

255 Limoges style dish with a single blue butterfly flying over grasses, painted by an unknown artist in 1884. Marks on the back include Rookwood in block letters, the date, shape number 87 and G for ginger clay. Diameter is 6½ inches. Small rim chip has been professionally repaired. — $125-175

256 High glaze mug bearing the portrait of a Native American painted by Flora King in 1946. Marks on the base include the Rookwood logo, the date, shape number 587 C and in red slip, the notation "Big Looking Glass", the artist's initials and an indistinct number. Height 4⅞ inches. Small glaze flaw at rim. — $350-450

257 Very pretty Iris glaze vase with pink wild rose decoration, done in 1903 by Ed Diers. Marks on the base include the Rookwood logo, the date, shape number 30 E, W for white (Iris) glaze, the number "19" and the artist's monogram. Height 7¾ inches. Very little crazing and great color. — $2000-2500

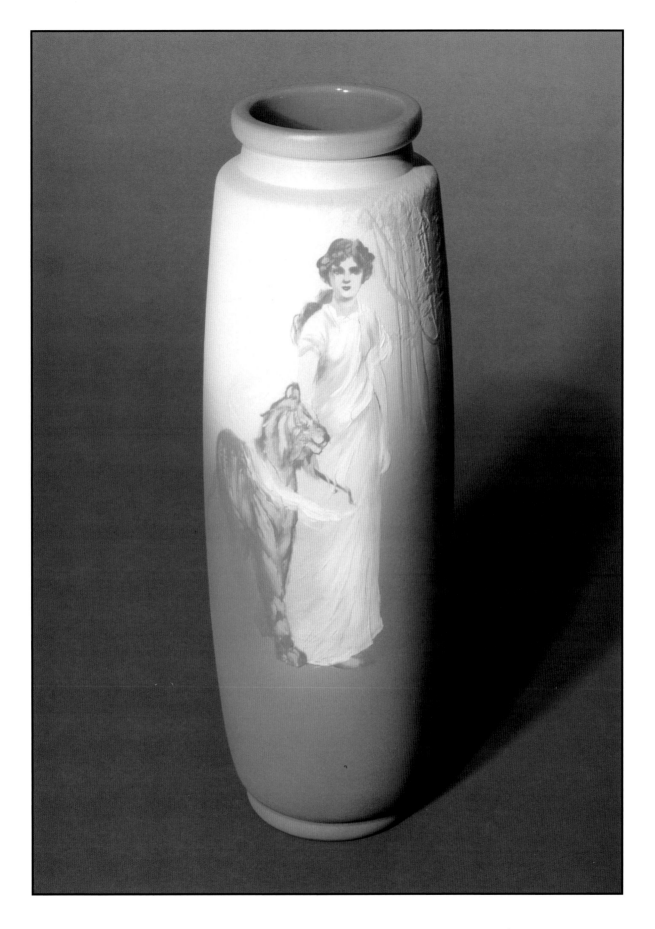

258 Rare and important Aerial Blue vase in "dull finish", painted in 1895 by Sallie Toohey. Decoration consists of a $12500-15000
young woman walking in a forest with a tiger at her side. In her right hand is a baton wrapped with bunting
which trails out behind her, perhaps blown by the wind. Marks on the base include the Rookwood logo, the date,
shape number 589 C, the artist's monogram and the number "273" bracketed by crescent moons. While covered
with Rookwood's "dull finish", the blue clay body and the Joseph Bailey crescent moon esoteric marks point to
Aerial Blue. On page 116 of S.G. Burt's book, "2,292 pieces of early Rookwood Pottery in the Cincinnati Art
Museum in 1916", item 55 is listed as "Aerial blue, smear glaze" while item 64 is listed as "Aerial Blue bisc(uit)."
This piece, like lot 1157 in Rookwood III, is a blue body under a dull (smear) glaze. Height 8⅝ inches.

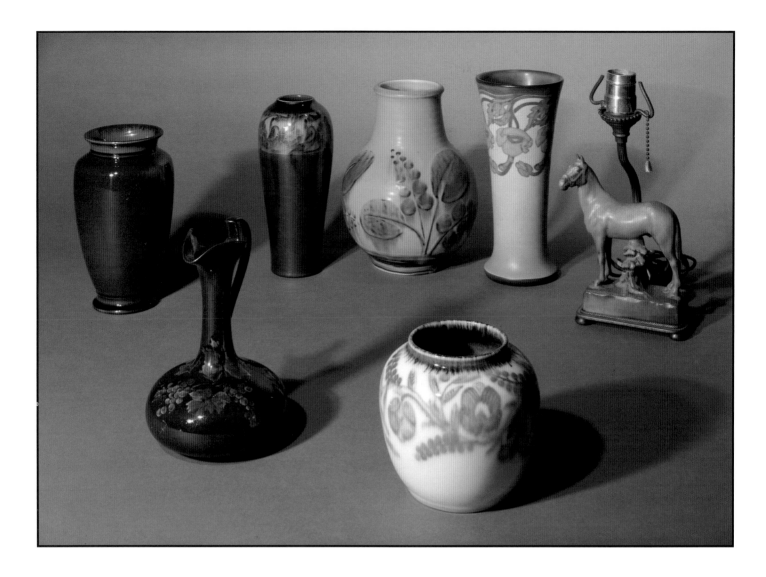

259 Tall Commercial vase with rich Coromandel glaze vase made at Rookwood in 1933. Marks on the base include $500-700
the Rookwood logo, the date and S for Special shape. Height 7⅛ inches. Uncrazed.

260 Handsome ewer with hints of Tiger Eye effect in the Standard glaze covering the grape and grape leaf decoration, $400-600
painted in 1888 by Harriet Wilcox. Marks on the base include the Rookwood logo, the date, shape number 433,
R for red clay, D for dark Standard glaze and the artist's initials. Height 6⅞ inches.

261 Rare decorated aventurine glaze vase done by Lorinda Epply circa 1920, having a band of abstract flowers on the $900-1200
shoulder. Marks on the base include the partially obscured Rookwood logo and date, the artist's monogram and a
Clover Collection label, # 754. Height 8⅛ inches. Minor grinding flakes on base.

262 Art Deco style vase in mat glaze with slip trail floral decoration done in 1929 by Elizabeth Barrett. Marks on the $600-800
base include the Rookwood logo, the date, shape number 2914 and the artist's monogram. Height 8½ inches.

263 Colorful high glaze vase with nicely detailed floral decoration, done in 1933 by Lorinda Epply. Marks on the base $600-800
include the Rookwood logo, the date, shape number 6319 D and the artist's monogram. Height 4⅝ inches.
Uncrazed.

264 Very handsome Arts & Crafts Vellum glaze vase with stylized poppies trailing down from the rim, carved and $2500-3500
painted by Sara Sax in 1917. Outlined in black, the poppies repeat around the vase and are lightly carved or
incised to enhance their dimensionality. Marks on the base include the Rookwood logo, the date, shape number
1357 D, V for Vellum glaze body, V for Vellum glaze and the artist's monogram. Height 9⅛ inches.

265 Beautifully glazed "Man-O-War" paperweight from 1930, made into a lamp, possibly by Rookwood. Marks on $300-400
the base include the Rookwood logo, the date, shape number 6140 and an original Rookwood paper showroom
label showing the price in 1930 to be $6.67. The fittings are of good quality and seem to have been made
especially for the figure. A hole in the base allows the Rookwood logo to be seen. Height of the ceramics portion
only is 6¼ inches. A small base chip is easily covered by the brass trim.

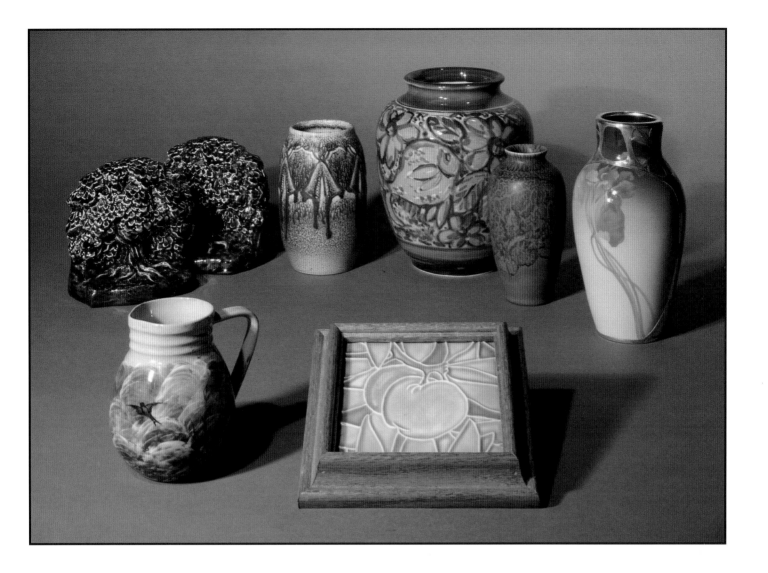

266 Rare commercial bookends in the form of a mighty tree, glazed in a rich Coromandel glaze at Rookwood in 1929. Marks on the base include the Rookwood logo, the date and shape number 6023. The monogram of designer, William McDonald, appear on the back of each piece. Height 5½ inches. $600-800

267 Limoges style pitcher showing a small swallow amid clouds and grasses, painted in 1882 by Martin Rettig. Marks on the base include Rookwood in block letters, the date, shape number 54, an impressed anchor mark, G for ginger clay, the number "3" below the shape number which probably should have been the letter "C" and the artist's initials. Height 4¾ inches. Tight line at rim near the handle. $300-400

268 Rare Ombroso glaze vase with repeating abstract designs, carved and painted in 1915 by William Hentschel. Marks on the base include the Rookwood logo, the date, shape number 155 and the artist's monogram. Height 6⅛ inches. Uncrazed. $700-900

269 Commercial Vellum glaze trivet with polychromed apple decor, made at Rookwood in 1921. Marks on the back include the Rookwood logo, the date and shape number 1263. Size is approximately 5½ x 5½ inches. Uncrazed and recently framed. $250-350

270 Very colorful high glaze vase with overall decoration of flowers and bizarre fish, painted in 1945 by Jens Jensen. Marks on the base include the Rookwood logo, the date, shape number 6707, the number "8064" in red slip and the artist's monogram also in red slip. Height 8½ inches. Uncrazed. $1500-2000

271 Mat glaze vase with floral decoration by Margaret McDonald, painted in 1930. Marks on the base include the Rookwood logo, the date, shape number 614 G, a fan shaped esoteric mark and the artist's monogram. Height 6¼ inches. $400-500

272 Rare silver overlaid Iris glaze vase with beautifully detailed wild violet decoration by Fred Rothenbusch, painted in 1903. Marks on the base include the Rookwood logo, the date, shape number 926 C, W for white (Iris) glaze and the artist's monogram. Height 8⅜ inches. Small breaks in the silver overlay have been professionally repaired. Iris glaze pieces with silver overlay are extremely rare. $5000-7000

SATURDAY
JUNE 11TH
1994
KERAMICS 1994
LOTS 273-372

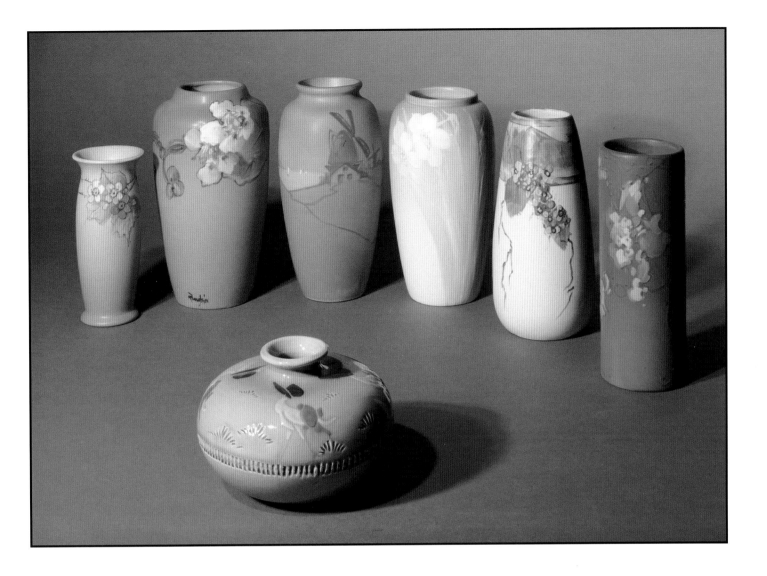

273 Weller Hudson glaze vase with multicolored floral decoration, painted circa 1925 by Sarah Timberlake. The base is marked with the ink stamped "Weller Ware" logo. Height 7 inches. Fine original shape. $200-300

274 Weller Hudson vase decorated with colorful nasturtium flowers, leaves and vines encircling the upper half of the piece, done circa 1920 by Sarah McLaughlin. The base is marked with the ink stamped "Weller Ware" logo and McLaughlin's signature is painted low on the base in black slip. Height 9⅛ inches. Excellent original condition. $500-700

275 Weller Rhead Faience vase painted and incised by an artist whose initials are C.M.M. circa 1902. The decoration is of three geese with black bonnets and blue ribbons on their tails following each other around the shoulder. Incised flowers and a band at the waist of the vase accent the decoration. The base is stamped with the notation, "1 0 2 X". The artist's initials are not present on this lot but several others with the exact decor are signed by C.M.M. Height 4¼ inches. A small chunk from the rim has been professionally repaired. $400-600

276 Weller Dresden vase painted circa 1907 by Levi J. Burgess, showing a Dutch harbor with sailboats in the bay and several windmills in the background. The base has the incised notation, "Weller Matt X 314" and Burgess's incised initials. Height 9⅜ inches. An interesting artist signed vase in great original shape. $600-800

277 Weller Hudson Light glaze vase with colorful jonquil decoration, done by an unknown artist. The base is stamped "Weller" in small block letters. Height 8⅞ inches. Good original condition. $400-600

278 Pretty Weller "White and Decorated" vase with a band of exotic flowers at the rim which trail down the side, painted by an unknown artist, circa 1915. As is typical, the base is not artist signed, and is stamped "Weller" in large block letters. Height 8¾ inches. Good original shape. $300-500

279 Pretty Weller Hudson vase with stylized flowers on a rich blue ground, painted circa 1920 by Mae Timberlake. The base is stamped "Weller" in large block letters and the artist's initials are painted on the side of the vase at mid body in blue slip. Height 8⅝ inches. Excellent original condition. $500-700

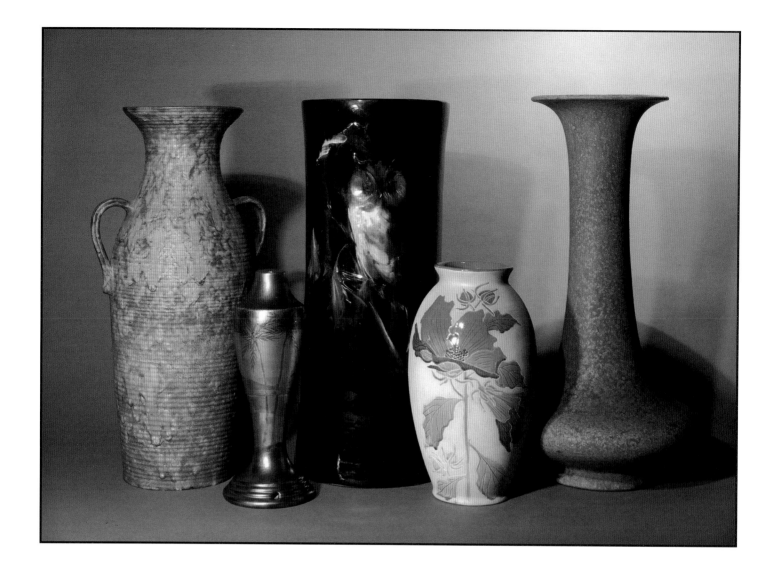

280 Very large Arts & Crafts style two handled Weller Ansonia floor vase done in shades of green, yellow and raspberry over a hand thrown body. The base is incised "Weller Hand Made" in script. Height 23½ inches in "as made" condition. $700-900

281 Very clean and nicely painted Owens iridescent lamp base done circa 1906 by John Lessell. A scene of palm trees and distant mountains in gold, red, blue and black cover the surface. The name "Lessell" is incorporated into the dark color on the base. Height 13½ inches. Very similar to Weller's Lasa, Lessell reprised his colorful iridescent finish after moving to Owens and later at Camark. This piece is in remarkably good shape, having none of the usual scratches and blemishes common to Lasa. $700-900

282 Weller umbrella stand decorated with an owl perched in a tree by an unknown artist, made circa 1900. The background color is a deep midnight blue which is difficult to categorize. The base is stamped with the number "27". Height 24 inches. Spider cracks in the base, one or two of which come up the side a bit. Glaze scratches. $1750-2250

283 Tall and impressive Roseville Woodland vase with exotic floral decoration, made circa 1905 and marked with a Rozane wafer seal. An unusually large example, the color, treatment and size make this a fine example. Height 14 inches. The collar has had extensive professional restoration and a drill hole in the base has been patched. $2000-3000

284 Monumental Roseville Pauleo vase covered in a rich, organic yellow-green mat glaze with delicate sheen. The piece is unmarked but the shape can be found in Huxford's "Roseville Pottery Second Series" on page 35. Pauleo can be many different things but the most impressive are the mottled mat and semi-gloss glazes on simple shapes. Roseville must have been successful with this line, opening a Pauleo Shop in New York City. Height 24⅜ inches. Excellent original condition. $1000-1250

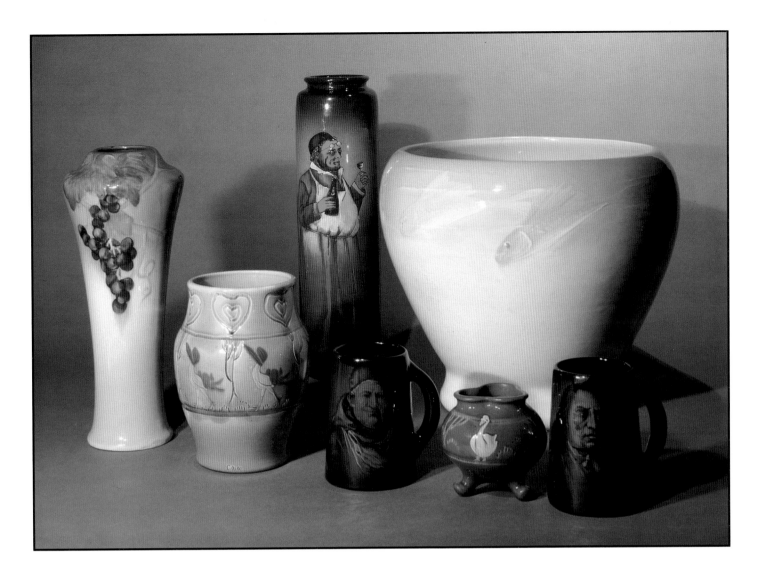

285 Tall Weller Etna vase with colorful grape decoration. The base is stamped "Weller" in small block letters and the name "Etna" is incised there. Impressed on the side of the vase is the word "Weller". Height 14⅞ inches. There are two flat chips on the base but the vase has strong colors and is from a crisp mold. $400-600

286 Unusual Weller Rhead Faience vase with six geese painted and incised by an artist whose initials are C.M.M. Each goose is wearing a black bonnet and has a blue ribbon on its tail. Incised trees and flowers separate the geese and incised hearts within hearts accent the collar. The base is marked with the notation, "X 478 3". Height 8¼ inches. $800-1200

287 Unusual and very tall Weller "Second Line Dickensware" vase in gloss glaze showing a monk tasting wine, done circa 1900 by Mary Gellie. The rust background color is quite unusual. Stamped into the base is a "Dickensware Weller" logo, an incised x in a one inch circle, a small circle and the impressed number "548". The artist's initials are painted on the side in slip. Height 17⅞ inches. Good original condition. $1750-2250

288 Weller Louwelsa mug bearing the smiling visage of a monk, done circa 1898 by Levi J. Burgess. The base is stamped with the circular "Louwelsa Weller" logo and the notation, "56 F C". The artist's initials are found just under the handle. Height 5⅞ inches. Very minor glaze scratches. $300-500

289 Weller Rhead Faience vase on three small feet showing three geese with incised trees and flowers in a repeating scene. The base is stamped twice with the number 589. Height 4½ inches. Although this piece is not signed, a similar vase signed by C.M.M. is pictured in McDonald's "All About Weller" on page 58. $400-600

290 Large and possibly rare high glaze jardiniere with three swimming fish done in heavy slip circa 1900 by an unknown artist. Given the palate and style of decoration this is possibly Weller's Auroro glaze. The artist initial "D" appears on the side in slip. The only other mark on the piece is the letter "S" stamped into the inside bottom. Height 14 inches. There are two unimportant spider cracks in the base and a tight line at the rim. There are also some glaze discolorations. $1000-1250

291 Handsome Native American portrait mug painted by Levi J. Burgess for Weller circa 1898. The Louwelsa piece is marked on the base with the stamped in numbers, "562" and "5". The artist's initials are painted in slip just under the handle. Height 5⅞ inches. Very minor glaze scratches. $500-700

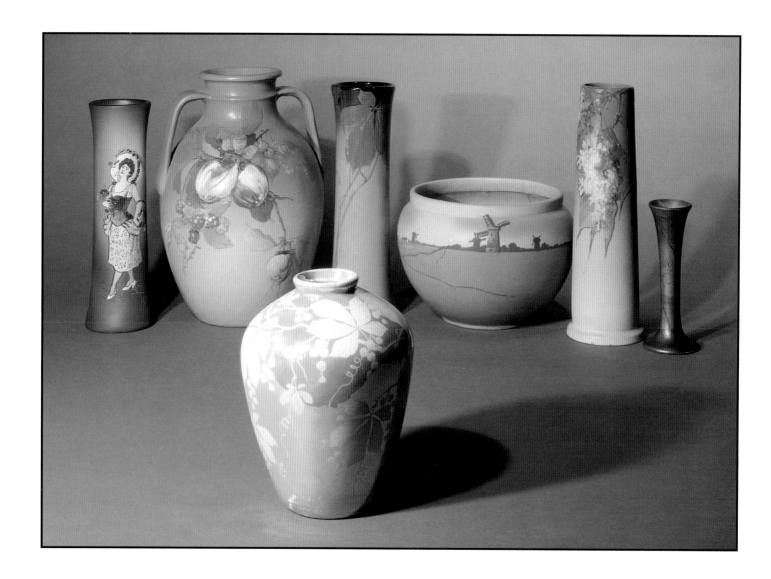

292 Tall Weller "Second Line Dickensware" vase decorated circa 1900 by Levi J. Burgess. The incised and painted $1250-1500
artwork consists of a Victorian lady carrying a basket of flowers while holding more flowers in her right arm. She
is also wearing a hat with flowers on the brim and her dress has flower designs in the skirt. The base is marked
with the "Dickensware Weller" impressed logo and several rather obscure numbers. The name "L.J. Burgess" is
incised just below the woman's portrait. Height 12 inches. Excellent detail and superb condition. Edie Buschle
says the lady looks like Maureen Stapleton.

293 Large and exceptional Weller Hudson two handled vase decorated with finely detailed quince and blackberries $1250-1750
by Hester Pillsbury, circa 1925. The base is signed "Weller Pottery" in script and the name "Pillsbury." appears
low on the side of the vase. Height 13½ inches. There are two very tight lines at the rim. The color and quality of
decoration on this vase are exceptional.

294 Rare Weller Besline vase with acid etched Virginia creeper decoration on an orange luster surface. Typically, the $400-600
vase is unmarked. Height 8⅛ inches. Very clean original condition with nicely detailed artwork.

295 Beautiful Weller Eocean vase with mauve Virginia creeper decoration on a background shading from near black $700-900
at the top to celery green. Decorated by Levi J. Burgess circa 1905, the vase represents one of the nicest floral
treatments from the period. The base is stamped with the notation, "801 10" and the incised letter "F". The initials
of Burgess are painted in mauve slip near the base. Height 12⅝ inches.

296 Large Weller "Dresden" jardiniere with a Dutch scene of boats in the harbor and windmills, painted by an $700-900
unknown artist circa 1908. The base is incised "Weller Matt". Height 7 inches, diameter 10 inches. Good detail
and very clean.

297 Tall Weller Hudson vase with colorful and nicely detailed hanging flowers and leaves, painted circa 1920 by $600-800
Mae Timberlake. The base is stamped "Weller" in large block letters and Timberlake's name appears in black slip
on the foot. Height 13 inches. There are two small glaze flakes off the foot.

298 Weller Lasa scenic bud vase. The piece is unmarked and has a small nick on the base which is nearly invisible $200-300
when seen from the side. Height 7¼ inches.

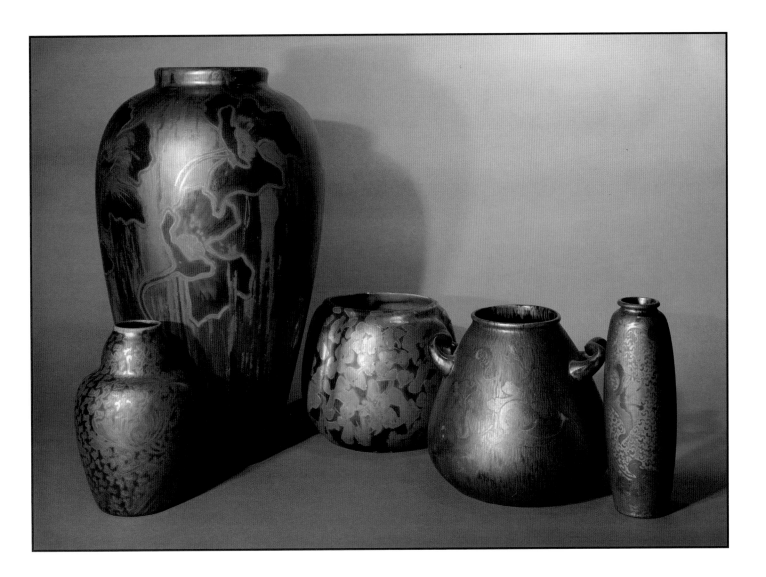

299 Handsome Weller Sicard vase decorated by Jacques Sicard circa 1904 with flowing chrysanthemum flowers and $2250-2750
buds. The glaze is exceptionally bright and colorful and the piece is in excellent shape. Sicard's name can be
found on the side of the vase and the name "Weller" is impressed in the base in small block letters. Height 9
inches.

300 Monumental and important Weller Sicard vase with beautifully stylized Art Nouveau poppy decoration, done $8000-10000
circa 1905 by Jacques Sicard. The vase is boldly signed "Sicardo Weller" on the side. Height 21¾ inches.
Excellent original condition with strong color and fantastic decoration.

301 Weller Sicard jardiniere with floral decoration in gold, done circa 1904 by Jacques Sicard. The background colors $600-800
are varied but a bit overfired. The base is stamped with the number "32" and "Weller" in small block letters.
Height 8 inches. There is a tight line at the rim.

302 Spectacular Weller Sicard two handled vase with excellent color done circa 1905 by Jacques Sicard. Decoration $1250-1750
consists of several snails in various sizes and some sort of leafy vegetation. The base bears the cast in number
"36" apparently a shape number and the work is signed "Weller Sicard" low on the side. Height 8⅜ inches. There
is a glaze flaw which extends from the very bottom of the piece up the side about ½ inch and which goes about
half way around the base. It is not readily visible when the vase is at eye level and not visible at all from the
front. There are also the usual small grinding chips on the base.

303 Beautifully glazed Weller Sicard vase with extensive floral decoration done by Jacques Sicard, circa 1905. The $2000-2500
piece is signed "Weller Sicard" on the side and the base is stamped "Weller" in small block letters. Other incised
marks on the base have been obscured by the glaze. Height 10⅛ inches. This vase has the incredible range of
color seen in great Sicard. Excellent original condition.

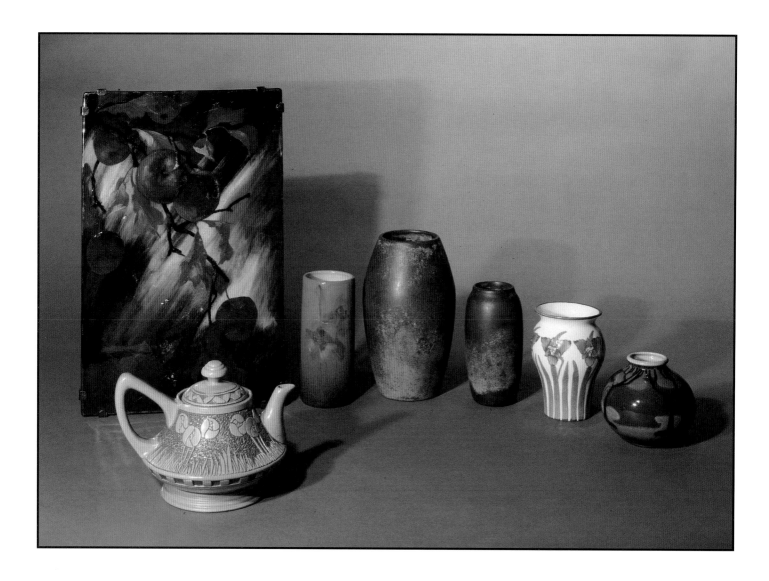

304 Rare Weller Aurelian rectangular plaque with life size apple decoration, painted circa 1898 by Frank Ferrell. The $700-900
 artist's last name appears in the lower right hand corner. Although not marked, the background coloration is
 certainly Aurelian. Size is 16½ x 10⅞ inches. There are several glaze scratches, a small ½ x ¼ inch patch of glaze
 loss which has been filled and colored, some bubbles in the glaze and typical patches of loose glaze. A
 removable coating of varnish has been applied to the surface to lessen the appearance of the glaze scratches. The
 plaque comes with a very old, probably original metal framework and chain for hanging.

305 Handsome Rozane Della Robia teapot done in two shades of green and deeply carved by an artist whose initials $1000-1500
 are E.B. The stylized floral treatment certainly shows Frederick Hurten Rhead's English Arts & Crafts influence.
 The base is marked with the Rozane Ware wafer seal and the incised initials of the artist. Height 5⅜ inches. There
 are two small flakes off the spout and at mid body which have been professionally repaired.

306 Rare Weller "Blue Louwelsa" vase decorated with poppies by an unknown artist, circa 1900. Blue Louwelsa is a $400-600
 pleasant attempt to duplicate Rookwood's Aerial Blue glaze and Roseville's Azurine. Few pieces of any of these
 seem to exist. The base is stamped with the circular "Louwelsa Weller" mark with the notation, "X 516" inside
 the wording. Incised in the base is the number "7". Height 6⅛ inches. Great shape.

307 Extremely clean and handsome Clewell copper clad vase with green incrustations over the rich orange-red $800-1000
 copper patina, made by Charles Walter Clewell in Canton, Ohio. The pottery blank is Weller and the base is
 marked "Clewell 60-2-9", inscribed in the copper with a stylus. Height 8½ inches. A very lush surface in near
 original condition.

308 Very clean Clewell copper clad vase with fabulous patina made by Charles Walter Clewell in Canton, Ohio. The $500-700
 rich orange-red copper surface is covered with heavy green incrustations. The base is inscribed with a stylus
 "Clewell 354-2-6". Height 6⅛ inches. Good color and near original condition.

309 Vance-Avon vase designed by Frederick Hurten Rhead and made circa 1903. Decoration consists of repeated $400-500
 blue flowers with green stems, done by slip trailing and slip painting, all covered with a clear high glaze. The
 base is stamped with the Vance-Avon logo in green slip. Height 5⅜ inches. Excellent original condition.

310 Rare Avon Faience landscape vase painted in 1903 by Frederick Hurten Rhead. Done in a clear high glaze, the
 vase is divided in quadrants by four similar trees which extend from bottom to top. The base is marked with the $600--800
 Avon logo, the date and the name "Rhead". Height 4 inches. Very minor glaze scratches.

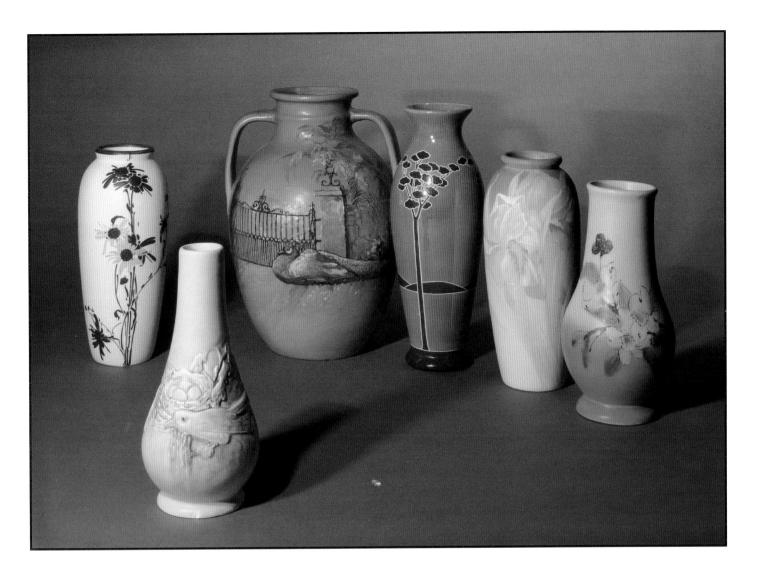

311 Very stylish Weller "White and Decorated" vase with daisies in yellow and black painted on a white ground by $500-700
an unknown artist, circa 1915. The base is stamped "Weller" in small block letters and as in most cases is not
artist signed. Height 10¾ inches and in excellent original condition.

312 Rare and unusual carved Weller Hudson vase showing a bird and nest in a tree, all in very high relief. Done by $800-1000
Mae Timberlake, the colors are much like those of Hudson Perfecto. The only markings on the vase are the artist's
last name, incised in the clay just below the bird's tail. Height 9⅝ inches. A⅜ inch chip in the base will have been
professionally repaired by auction time.

313 Large and beautiful Weller Hudson Pictorial vase showing a peacock resting near a large wrought iron gate and $3000-4000
stone fence. The base is marked with the letter "A" in black slip. Although not artist signed, the work is very much
like other peacock vases signed by Mae Timberlake and it seems reasonable to attribute this piece to her. Height
13½ inches. This is an important and rare Hudson vase and it is in excellent original condition.

314 Unusually crisp and clean Weller Marengo vase done in an even more unusual maroon and pink palate. The $700-900
deep colors are at once striking and beautiful. Height 13 inches. Unmarked. Very minor glaze abrasions.

315 Handsome Weller Hudson-Light vase with nicely detailed white and pink iris decoration. The base is stamped $400-500
"Weller" in small block letters. Height 11 inches. There are a few small glaze imperfections which occurred in
the making.

316 Weller Hudson vase with floral decoration by Hester Pillsbury painted circa 1930. The base is marked with the $400-600
name "Weller" in script. Height 10⅛ inches. Uncrazed and very clean.

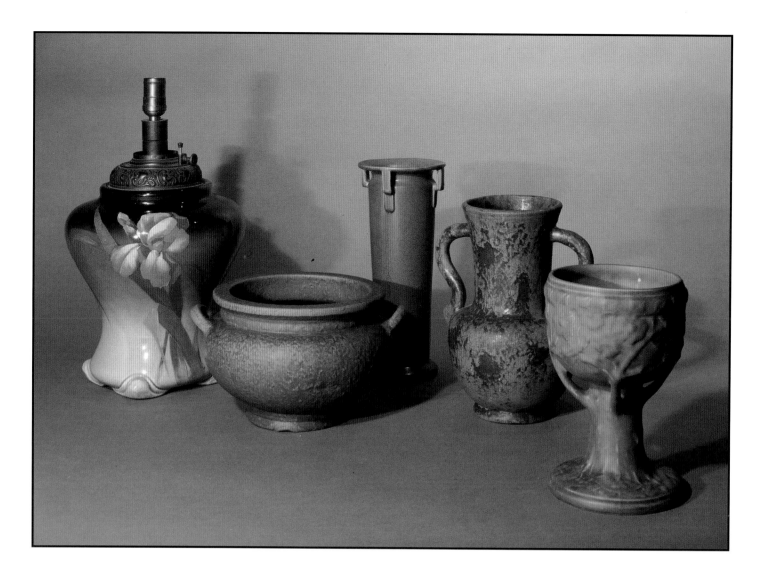

317 Weller Louwelsa lamp base with nicely painted iris decoration, done by an unknown artist in the early part of this century. The original oil font and burner have been adapted to electrical use. The base is stamped with the Louwelsa Weller logo and other marks obscured by the glaze. The artist's monogram near the bottom of the piece, by the iris stems. Height 10⅞ inches. Excellent original condition. — $400-600

318 Roseville Egypto two handled urn with a thick rich organic mat glaze. The piece is unmarked but is a classic Egypto shape, made in several sizes. Height 6⅜ inches. The green glaze on this piece is exceptional and condition is excellent. — $500-700

319 Tall Weller mat green vase with four angular handles connecting the body to the rim. The base is stamped "WELLER' in block letters. Height 11¼ inches. Nice leathery glaze and excellent condition. — $300-400

320 Weller two handled Coppertone vase. The base is incised, "Weller Hand Made" in script. Height 10⅜ inches. Nice glaze and excellent original condition. — $200-300

321 Roseville compote in green mat glaze. Whether Egypto or Matt Green, the piece is a good clean example of Arts & Crafts Roseville. Height 9⅛ inches. Unmarked and in excellent original condition. The shape is shown in Huxford's "Roseville Pottery First Series" on page 41. — $400-600

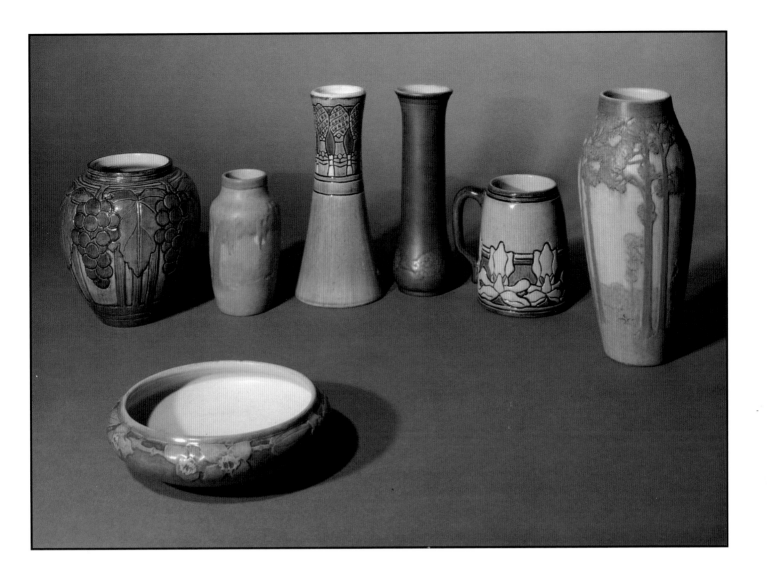

322 Handsome and important Newcomb Pottery vase with stylized and deeply carved grape decoration done in 1905 $7000-10000
by Maria De Hoa LeBlanc. The base is marked with the Newcomb logo, the date (AG 50?), Q for buff clay, the
initials JM for potter Joseph Meyer and the artist's monogram. Height 6¾ inches. Excellent original condition.

323 Colorful Newcomb Pottery mat glaze bowl with deeply carved flowers in pink and yellow on a blue ground, $700-900
done in 1920 by Sadie Irvine. The base is marked with the Newcomb logo, the date (KZ 54), shape number 246
and the artist's monogram. Diameter is 7⅜ inches. Excellent original condition.

324 Deeply carved Newcomb Pottery vase with Spanish moss and misty moonlit scene, done in 1923 by Sadie Irvine. $1750-2250
The base is stamped with the Newcomb Pottery logo, the date (NE 51), the potter Joseph Meyer's initials, shape
number 79 and the artist's monogram. Height 6 inches. Small grinding flake off the base.

325 Newcomb Pottery high glaze vase with carved and painted mushrooms done in 1904 by an unknown artist. $2500-3000
Marks on the base include the Newcomb logo, the date (ZZ 20), W for white clay, the initials JM for potter Joseph
Meyer and the artist's monogram. Height 9½ inches. Excellent condition.

326 Rare, possibly experimental, Newcomb Pottery vase with carved floral decoration done by Alma Florence Mason $1000-1500
in 1912. The glaze is a metallic iridescent finish much like Weller Sicard. The base is marked with the Newcomb
logo, the date (FO 82), the initials JM for potter Joseph Meyer, B in a circle for buff clay and the artist's initials.
Height 9⅜ inches.

327 Newcomb Pottery high glaze mug deeply carved and painted by an unknown artist in 1906. The carved flowers $1500-2000
appear to be stylized irises. Markings on the base include the Newcomb logo, the date (BK 57), Q for buff clay,
the initials JM for potter Joseph Meyer and the artist's monogram. Height 5⅜ inches. Beautiful and solid.

328 Tall and important Newcomb Pottery scenic vase, deeply carved and painted by Sadie Irvine in 1918. Having
great detail and many subtle colors, the moonlit woodland scene is one of the most pleasant and well composed $8000-10000
we have seen. The base is marked with the Newcomb logo, the date (JK 40), shape number 133, the initials JM
for potter Joseph Meyer and the artist's monogram. Height 10½ inches. Excellent original condition.

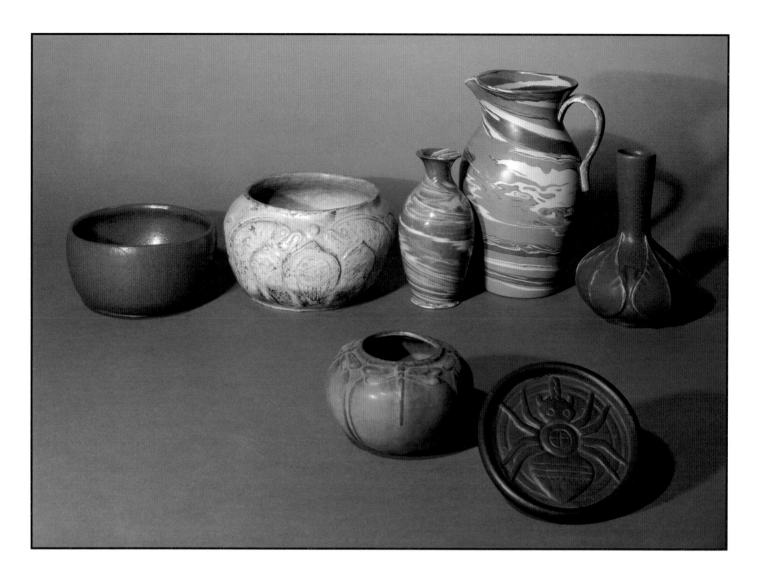

329 Rare and early Overbeck bowl made circa 1909 by Margaret Overbeck. Decoration consists of overlapping ovals $1000-1500
in brown slip either painted or slip trailed over a somewhat lighter brown background. The base is marked with
the incised notation, "Overbeck 50-D" and the incised cypher consisting of an orientalized "M" inside the letter
"O". Size is 3⅛ inches high by 6⅞ inches in diameter. There is a tight line at the rim. In a recent meeting with
Kathleen R. Postle, noted Overbeck author and researcher, this lot and lot 330 were examined and discussed in
detail. Mrs. Postle could see no reasonable doublt that this lot (and lot 330) is an early and experimental
Overbeck work by Margaret Overbeck, done shortly before her death in 1911. The red clay which is unusual for
Overbeck was used in early examples, dug from the family farm before more suitable clays could be
commercially obtained. Mrs. Postle notes the use of cyphers by the Overbeck sisters on their drawings although
this particular mark has not been catalogued. Mrs. Postle also feels the glazes are common to Overbeck as is the
decorative style of this lot. Copies of correspondence between the consignor and Mrs. Postle will be supplied to
the purchaser. Please refer to lot 330.

330 Rare, early and important Overbeck bowl with deeply carved and incised fish decoration, done circa 1909 by
Margaret Overbeck. The bowl is obviously hand built and in addition to fish and seaweed has several incised $4000-5000
oriental characters just below the rim. The base is marked with the notation, "M. Overbeck 56-D" in black slip
and the incised cypher consisting of an orientalized "M" inside the letter "O". Size is 4½ inches high by 8½ inches
in diameter. For more information on this lot, please refer to the previous lot.

331 Van Briggle vase with four embossed dragonflies encircling the shoulder, made circa 1907-1912. The glaze, a
soft blue, makes an interesting contrast to the reddish brown clay underneath. The base is incised with the Van $500-700
Briggle logo and the notation "Van Briggle Colo Spgs". Height 3 inches. Excellent original condition.

332 Rare high glaze Niloak swirled vase. Unmarked. Height 6½ inches. Purchased by the consignor with two marked
examples, this piece has been authenticated as Niloak. $300-400

333 Rare Niloak pitcher in multicolored swirled clay, glazed only on the interior. Handled pieces of Niloak are not
common. The base is stamped with the Niloak logo. Height 9½ inches. Excellent original condition. $400-600

334 Van Briggle spider plaque, made in 1906 and covered in a green- black mat glaze. The back is incised with the
Van Briggle logo, the notation, "Van Briggle 1906 Colorado Springs" and shape number 491. Diameter is 5¼ $400-500
inches. Excellent original condition.

335 Van Briggle vase from 1914 with four heavy embossed leaves rising from the base and covered in a rich mottled
blue mat glaze. Incised in the base are the Van Briggle logo, the date, the notation, "Van Briggle Colo Spgs" and a $500-700
shape number which is partly obscured. Height 7⅛ inches. Excellent original condition.

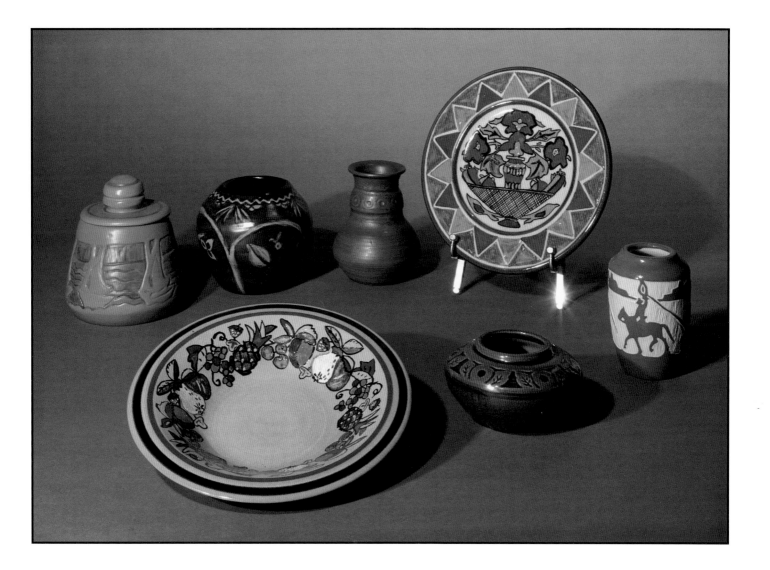

336 University of North Dakota School of Mines lidded humidor showing six sailboats in a band around the body, done in 1941 by Van Camp. The base is marked with the UND logo and the incised notation, "Van Camp 7-2-41". The lid is also incised with the artist's name. Height 5⅝ inches. Excellent original condition. $1000-1500

337 University of North Dakota School of Mines high glaze low bowl with colorful fruit decoration painted in 1949 by M. Jacobson. Marks on the base include the UND logo, the date, "2-15-49" and the artist's name. Diameter is 9⅛ inches. Excellent original condition. $400-500

338 University of North Dakota School of Mines "Bentonite" vase with fanciful bird decoration done by "Jarvis". The base is marked with the UND logo and the incised name "Jarvis". Height 4⅜ inches. There is an ⅛ inch glaze nick low on the side of the piece. $700-900

339 Unusual Arts & Crafts style thrown vase with a band of incised circles on a collar around the neck, designed by Margaret Cable and made at University of North Dakota School of Mines. The base is marked with the UND logo and the notation, "M. Cable 41". The piece is covered with a leathery green mat glaze. Height 5 inches. Excellent original condition. $400-600

340 University of North Dakota School of Mines "Prairie Rose" bowl, designed by Flora Huckfield and done in rust and black high glazes. Marks on the base include the UND logo and shape number 51. Height 2⅝ inches. Excellent original condition. $400-600

341 Colorful high glaze University of North Dakota School of Mines charger decorated in 1934 by Hazel Rohde showing a basket full of dark blue flowers rimmed with green and blue triangles. Marks on the back include the UND logo and the incised notation "Hazel Rohde 1934". Diameter is 8⅞ inches. There are a few minor burst glaze bubbles. $400-500

342 Rare and possibly important carved University of North Dakota School of Mines vase made by Julia Mattson. Pictured in an early UND photo reproduced in "University of North Dakota Pottery The Cable Years" on page 9, figure 6, the piece dates from the 1930's. Done in medium blue and white, the vase shows a repeated scene of a cowboy with lasso riding past a distant mesa. The base is marked with the UND logo and the incised notation "132 J Mattson Cowboy." Height 4½ inches. Excellent original condition. $1000-1500

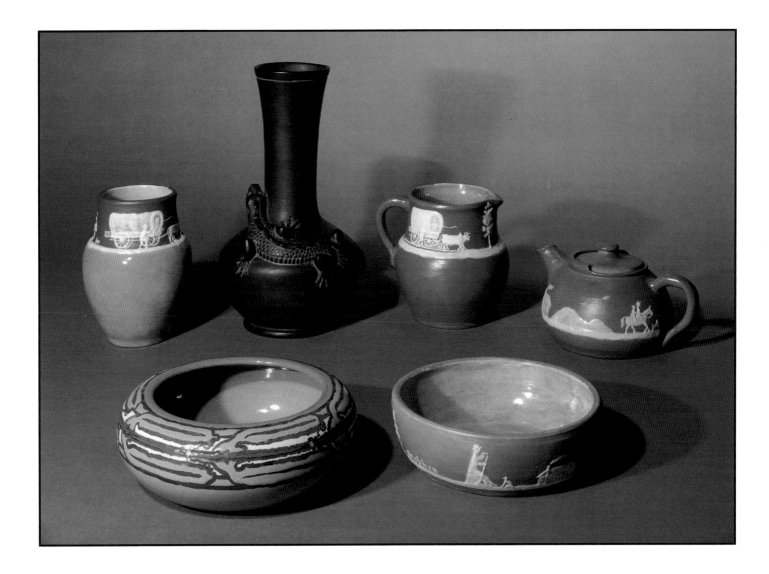

343 Early Pisgah Forest cameo vase showing a typical covered wagon scene done on the mat green collar of the piece, the interior glazed in gloss pink and the lower part of the exterior done in gloss mottled blue. Marks on the base are the embossed Pisgah Forest logo with the date, 1932. Height 6½ inches. Excellent original condition and a handsome example of Walter Stephen's early career. $500-700

344 Handsome S.E.G. low bowl with a repeating and reflected scene of clouds, trees and a small house with smoke rising from its chimney. The base is marked "S.E.G." and has an obscured date and artist signature. Diameter is 8⅝ inches. Excellent original condition. $800-1000

345 Rare Norse dragon vase made between 1903 and 1913 and covered in a black mat glaze with green highlights, reminiscent of old bronze. The base carries the stamped Norse logo and the number 25. Height 12 inches. Minor glaze rubs. $800-1000

346 Pisgah Forest (Stephen Pottery) pitcher in green mat glaze having a cameo "Covered Wagon" scene, made by Walter B. Stephen in 1946. The interior is lined with a pink gloss glaze. The base bears the "Stephen" potter at the wheel logo and date and the name "W.B. Stephen" in blue slip. Height 5¼ inches. Excellent original condition with some unobjectionable clay separation just below the wagon and oxen. $400-600

347 Pisgah Forest (Stephen Pottery) green mat glaze bowl with cameo "Covered Wagon" scene encircling the exterior, made by Walter Stephen in 1953. The interior is lined in pink gloss glaze. The base is marked with the embossed "Cameo Stephen LongPine Ardenne" logo and the date. Written in cameo on the side of the piece is the name, "Stephen". Diameter is 7¼ inches. Excellent original condition. $300-400

348 Rare and handsome Pisgah Forest (Stephen Pottery) lidded teapot with cameo "Covered Wagon" scene made in 1953 by Walter Stephen. The base is marked with the embossed "Cameo Stephen LongPine Ardenne" logo and the date. The name "Stephen" is written in cameo slip as part of the scene. Height 4½ inches. Covered pieces by Stephen are not common and this one is in excellent original condition. $500-700

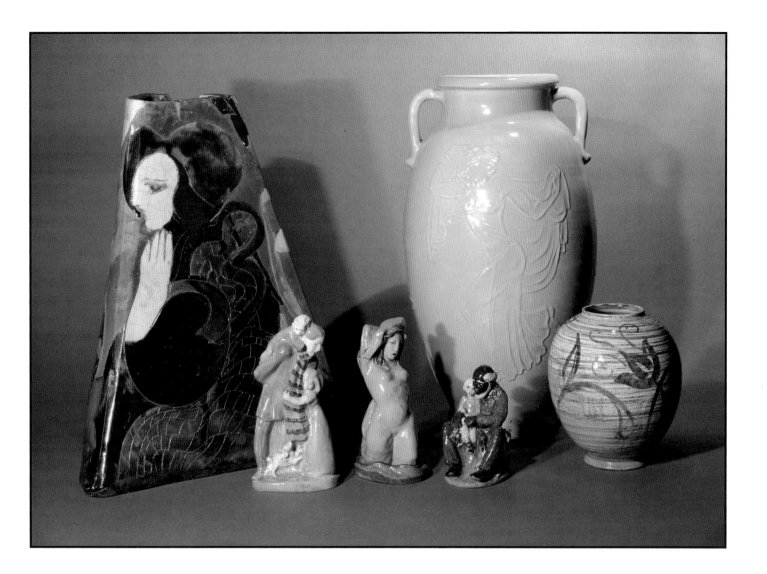

349 Fascinating three sided floor vase with several exotic female figures, incised and painted in mat, gloss and metallic glazes by Susan and Steven Kemenyffy in 1972. The base is signed "Kemenyffy 1972" near the base. Height 20 inches. There are some small chips to the rim and base. $1500-2000

350 Polychromed Edris Eckhardt figural piece showing a father, son, daughter and family dog at Christmas time, made circa 1937. The father appears to have just arrived home and has a doll, a rocking horse and other toys hidden behind his back. The piece is signed "Edris Eckhardt" in blue slip on the base and has the name "Edris Eckhardt # 2" incised inside the piece. Also painted in blue slip inside the figure is the notation, "Federal Art Project Cleveland Ohio". Height 8⅞ inches. A small chip on the father's right elbow has been professionally repaired. This is one of the most pleasant and colorful Eckhardt pieces we have seen. $1250-1750

351 Edris Eckhardt Mermaid figure made in Cleveland, Ohio about 1940. The piece is incised "Edris Eckhardt" on the base and stands 7⅞ inches tall. A ½ inch glaze loss on the Mermaid's right elbow has been professionally repaired. $1000-1500

352 Colorful Edris Eckhardt "Uncle Remus" figure made in Cleveland, Ohio circa 1937. The piece has the incised signature "Edris Eckhardt" on the base and again inside. Height 5⅝ inches. Excellent original condition. $1250-1500

353 Monumental two handled vase with Art Deco figures in relief, made by Paul Freigang, of Jamaica, New York in 1929. One side shows a figure playing a lyre while on the other a nude dances with veils ala Salome'. The base is marked with Freigang's monogram, both incised and in black slip and has the date incised. Height 20¾ inches. Freigang is a rather obscure studio potter who belonged to the Ceramic Society of New York and the New York Craftsmen Society. Freigang won a gold medal in 1937 at the Exposition Internationale des Arts et des Techniques in Paris. There are some small glaze flaws but overall, the piece is in great shape. We have some interesting photocopies of information on Freigang for the purchaser. $1000-1500

354 Rare decorated Cowan lamp vase done with floral sprays and covered with a clear high glaze. A hole is cast into the base, and the base is stamped with the Cowan logo and the notation "Cowan". Height 8⅛ inches. Excellent original condition. $800-1000

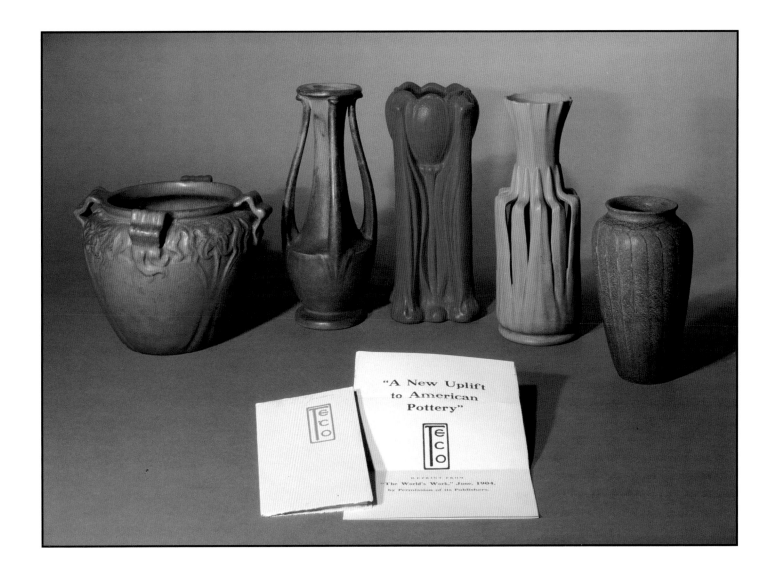

355 Unusual green mat glaze vase with embossed floral designs and four flat strap handles made circa 1910, most likely by Weller. The piece is unmarked. Height 7¼ inches. Very clean. $200-300

356 Handsome Teco four handled vase in classical form made early in this century. The base is marked with the Teco name twice and shape number 89. Height 12 inches. In excellent original condition, this vase has a wonderful green-black mottled glaze which has a great deal of character. $1500-2000

357 Early Teco advertising booklet and Teco ad piece, both from 1904. The sixteen page booklet pictures 61 different pieces including lamps, vases, ewers and jardinieres and has prices at the end. The ad piece is a four page folded sheet, a reprint of "A New Uplift to American Pottery" published in "The World's Work". The booklet is in like new condition with the exception of a pencil signature on the front cover. The ad piece is folded in thirds and has some wear at the folds. $300-400

358 Very rare Teco vase with unusual blue mat glaze made in the form of a stylized tulip with buttress supports. The base is stamped "Teco" twice and the piece stands 11⅝ inches tall and is very heavy. There are two short and tight lines at the rim and one at the base but none are easy to find and all seem very solid. $900-1200

359 Handsome Teco vase with 12 leaves which rise from the base only to turn in toward the neck and attach near the top. Designed by William J. Dodd and made in the first quarter of this century. The base is twice stamped with the name "Teco". Height 11⅜ inches. Two small glaze flakes off the rim have been professionally repaired and there is a small stilt pull off the base. $2500-3500

360 Grueby vase with overlapping leaf decoration covered with a thick rich leathery mat green glaze. The base is stamped with the "Grueby Pottery Boston USA" logo. Height 7⅜ inches. Drilled and having minor grinding chips on the base. $700-900

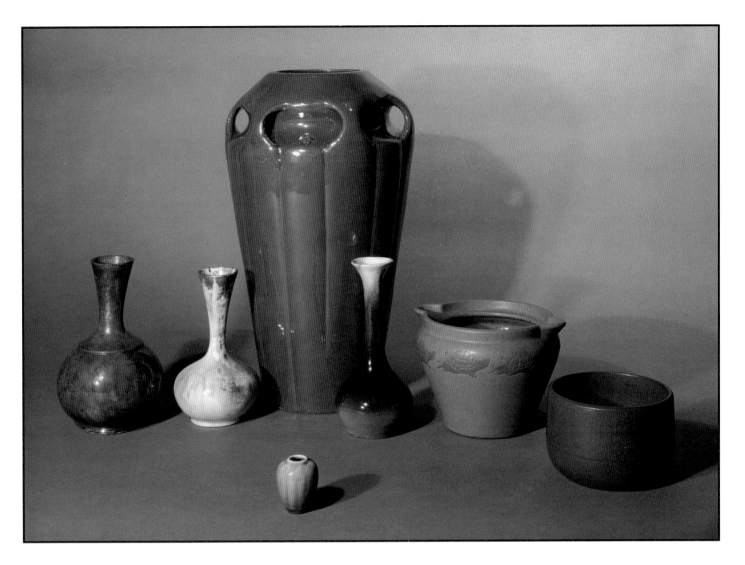

361 Rare Middle Lane Pottery "Flame" glazed vase in rich iridescent colors, made by T.A. Brouwer circa 1900. $3500-4000
Brouwer exposed his vases to open flame in the kiln, achieving sometimes wonderful and often unexpected
results with his unorthodox techniques. The base has the incised notations "Flame". "31" and the incised
whalebone marks. Height 7⅞ inches. Fine original condition.

362 Rare brightly colored Middle Lane Pottery vase made by T.A. Brouwer circa 1905. The glaze, most likely the $1500-2000
result of Brouwer's "Iridescent Fire Painting" technique, ranges in color from gold to cream to brown to lime
green. The base is marked with the M inside a whalebone logo. Height 7⅛ inches. Great color and excellent
condition.

363 Rare Robineau porcelain cabinet piece, done in a slightly crystalline green-yellow high glaze. The piece is $800-1000
marked with the partially obscured AR incised logo. Height 2⅛ inches. Excellent original condition.

364 Rare Wannopee Pottery "Scarabronze" six handled vase made in New Milford, Connecticut circa 1902. The vase $2000-2500
is supposedly modeled after ancient Egyptian vessels but still manages to have a good Arts & Crafts look. The
glaze, perhaps Wannopee's greatest achievement, has a wonderful slightly iridescent coppery look which is
unique to American art pottery. The base is stamped with the Lang & Osgood logo and shield (see Evans page
322) and the numbers, "124 H" and "17". Stamped inside the rim is the number "21". Cast into the vase between
two handles is a small scarab, a Wannopee trademark. Height 16½ inches. There is a spider crack in the base
which comes up the side about one inch and a tight line at the rim which is hard to see.

365 Rare Brauchman Art Pottery vase in shades of white, blue and green, covered in a clear high glaze. Cornelius $800-1000
Brauckman made Grand Feu Pottery in Los Angeles circa 1912 and later made pieces marked with the name,
Brauchman Art Pottery. This piece is so marked and thought to have been made circa 1916. Height 8 inches.
Excellent original condition.

366 Rare and important Marblehead planter-jardiniere with painted and incised alligator snapping turtles, decorated $3000-3500
by and possibly designed by Arthur Irwin Hennessey, circa 1909. The base is marked with the stamped
Marblehead logo the incised initial "H" and the notation "* Irrigator * Pat. Apr. 20, 1909". The Irrigator was
designed to hold a simple clay pot with flowers or bulbs which need to be watered from the bottom. The two
spouts on either end allow for pouring water between the two vessels, rather than onto the flowers and earth in
which they grow. Dimensions are 5¼ x 8⅛ inches. Excellent original condition.

367 Mat glaze Marblehead straight sided vase with complex repeating designs encircling the upper half of the piece, $500-700
incised and lightly tinted by Hannah Tutt. The base is stamped with the Marblehead logo and the incised initials
of the artist. Height 3¾ inches.

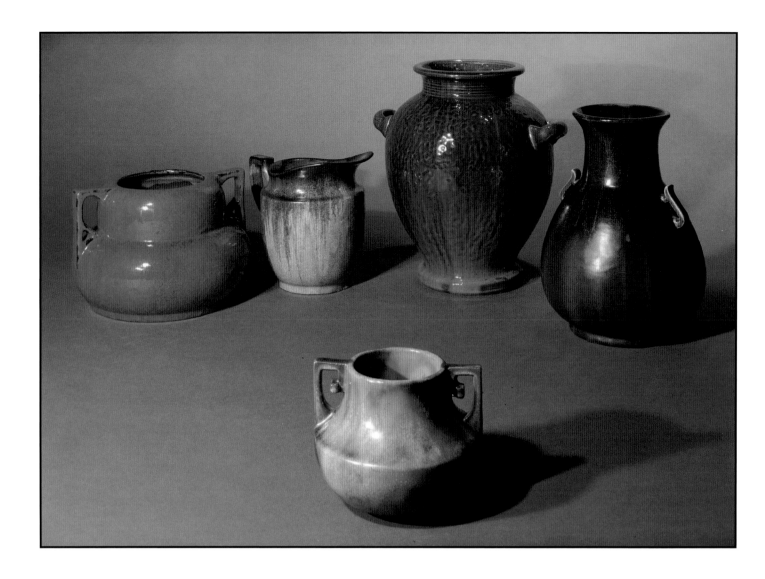

368 Handsome Fulper vase having two angular handles covered with a wonderful mirror blue over cobalt blue $600-800
crystalline glaze. The base is marked with a faded Fulper paper label and has the vertical incised Fulper logo.
Height 6⅛ inches. Very clean and quite nice.

369 Fulper pitcher covered in a mirror black crystalline over mustard glaze. The base is marked with the inkstamped $500-700
oval Fulper logo. Height 7¼ inches. Typical grinding flakes on the base.

370 Fulper two handled vase done in a two shades of green crystalline mat glaze. The base is marked with rectangular $250-350
Fulper inkstamped logo. Height 4¾ inches. Excellent original condition.

371 Tall and impressive two handled Fulper vase covered with a medium blue crystalline glaze over a mottled green. $800-1000
Marks on the base include the number "490" and the horizontally stamped name "FULPER". Height 12 inches.
Typical minor grinding chips off the base.

372 Handsome Fulper vase with two small handles covered with a slightly crystalline mirror black glaze over a rose $800-1000
ground. The base is marked with the raised oval Fulper logo. Height 10¾ inches. A very nice example in perfect
original condition.

SATURDAY
JUNE 11TH
1994
SECOND ROOKWOOD SESSION
LOTS 373-654

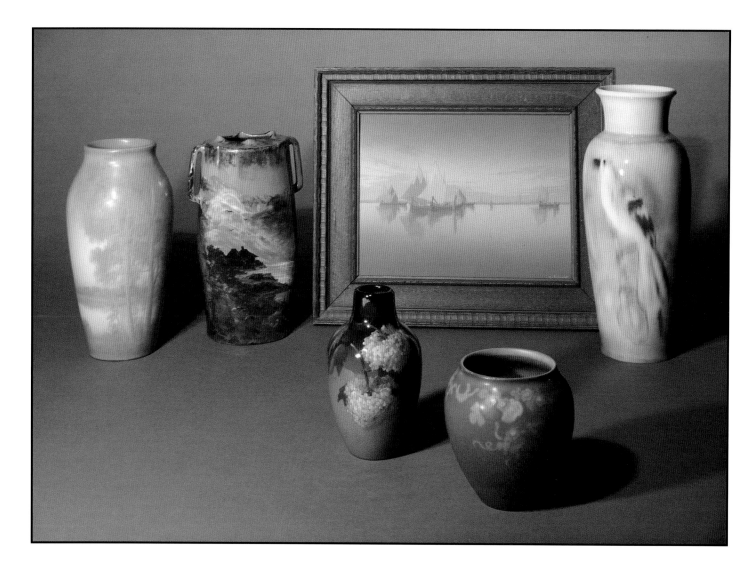

373 Nicely detailed Vellum glaze autumn landscape vase painted in 1929 by Ed Diers. Marks on the base include the $2000-3000
Rookwood logo, the date, shape number 925 C, an incised V for Vellum glaze and the artist's initials. Height 10¼
inches. There are a few small unobtrusive dimples in the glaze but the piece is uncrazed and very crisp.

374 French Crushed vase done in Limoges style glaze by Maria Longworth Nichols in 1882. One side of the vase $1000-1500
shows a web occupied by several spiders and the other side a small Japanese seaside village with several small
gulls flying overhead. Marks on the base include Rookwood in block letters and the date. The artist's initials are
stamped in block letters low on the side of the vase. Height 10¼. One handle has been broken off and
professionally repaired. There is also a small flat chip off the base which is barely visible from the side.

375 Vellum glaze Venetian harbor scene plaque painted by Carl Schmdit in 1921. The artist's name appears in the $4000-6000
lower right hand corner. Marks on the back include the Rookwood logo and the date. Size is 8⅞ x 11⅞ inches.
Original frame.

376 Nicely painted Standard glaze vase with hydrangea flowers, leaves and branches, done in 1902 by Irene Bishop. $400-500
Marks on the base include the Rookwood logo, the date, shape number 905 E and the artist's initials. Height 6⅛
inches.

377 Vellum glaze vase with repeating floral designs around the shoulder, done in 1923 by Lenore Asbury. The interior $500-700
is lined with a deep rose color. Marks on the base include the Rookwood logo, the date, shape number 1343, V
for Vellum glaze, P for porcelain body and the artist's initials. Height 4⅞ inches. Uncrazed.

378 Tall high glaze vase decorated by Jens Jensen circa 1946. The art work consists of Jensen's beloved magnolia $1000-1500
blossoms and a mocking bird perched on a branch. Marks on the base include the Rookwood logo, the number
8689 in red slip and the artist's monogram also in red slip. A neat drill hole obscures most of the date and all of
the shape number. Height 12⅞ inches. Uncrazed.

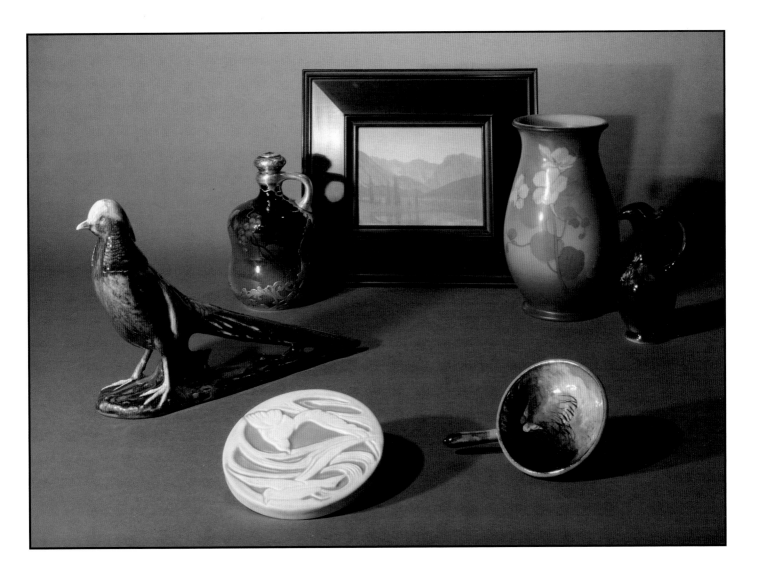

379 Interesting polychromed high glaze pheasant done with some striking colors in 1926 by William Hentschel. $600-800
Marks on the base include the Rookwood logo, the date, shape number 2832, the number "6941 in brown slip
and the artist's monogram also in brown slip. Height 9 inches. Polychromed pheasants are fairly unusual and to
find one signed by one of the regular artists is very different. This lot and another in the sale cost $36.05 each
when finally purchased from the Loring Andrews Company, a Rookwood retailer here in Cincinnati. Photocopies
of the original sales receipt are available to the purchaser of this lot.

380 Good Standard glaze stoppered whiskey jug with colorful grape decor, painted by Louella Perkins in 1896, and $3500-4500
lavish silver overlay by Gorham. The grapes painted on the jug are in a bright blue-green and the grape theme is
carried out in the silver, even on the overlaid stopper. Marks on the base include the Rookwood logo, the date,
shape number 674 and the artist's initials. The silver is marked with Gorham hallmarks and the notation,
"999/1000 R 2536 Spaulding & Co.". Spaulding & Co. was a retailer in Chicago which specialized in Gorham
products. Height 8 inches. This is one of the nicest silver overlay jugs we have seen.

381 Polychromed mat glaze circular trivet with white gulls flying over undulating waves, made at Rookwood in 1929. $300-400
Marks on the base include the Rookwood logo and shape number 2350. Diameter is 6 inches. Uncrazed.

382 Vellum glaze scenic plaque painted in 1913 by Carl Schmidt. Marks on the back include the Rookwood logo, the $1250-1750
date, V for Vellum glaze, three small incised dots and a penciled in title, "Among the Rockies". The artist's name
appears in the lower right hand corner. Size is 5¾ x 7½ inches.

383 Limoges style shallow dish with three feet and a handle, decorated with oriental grasses and a single butterfly by $150-175
M.A. Daly in 1883. Marks on the base include Rookwood in block letters, the date, G for ginger clay, an
impressed anchor mark and the artist's initials. Largest distance across is 6¼ inches.

384 Vellum glaze vase with nasturtium decoration outlined in black, painted in 1925 by Ed Diers. Marks on the base $800-1000
include the Rookwood logo, the date, shape number 27 V for Vellum glaze, a wheel ground x and the artist's
monogram. Height 10 inches. Uncrazed. A small base chip has been professionally repaired.

385 Standard glaze ewer with white clover decoration, painted in 1898 by Katharine Hickman. Marks on the base $300-500
include the Rookwood logo, the date, shape number 639 D and the artist's monogram. Height 6⅜ inches. Slight
underglaze color loss on the handle.

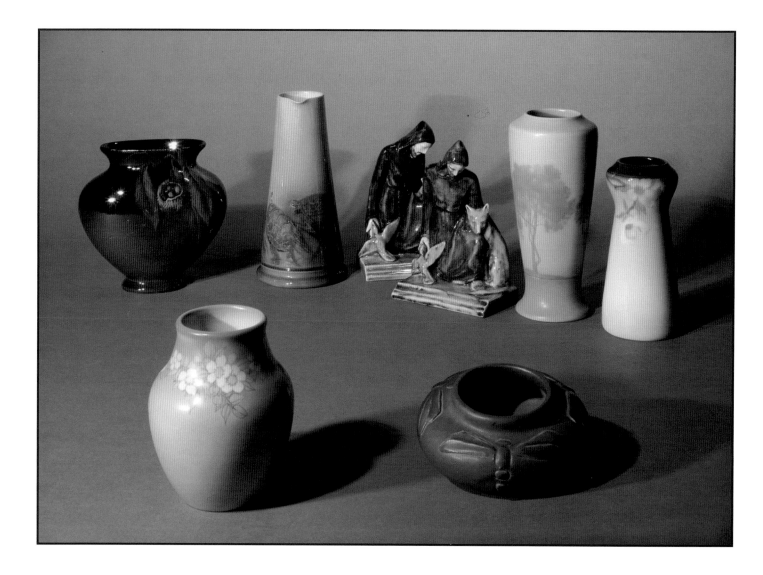

386 Standard glaze pillow vase with Ohio Buckeye decoration, painted in 1899 by Rose Fechheimer. Marks on base include the Rookwood logo, the date, shape number 797, a wheel ground x and the artist's monogram. Height 6⅝ inches. Glaze flaws at the rim and glaze scratches. $250-350

387 Very clean Vellum glaze vase with cherry blossoms outlined in black, painted in 1928 by Lenore Asbury. Marks on the base include the Rookwood logo, the date, shape number 914 E, V for Vellum glaze and the artist's initials. Height 5⅝ inches. Uncrazed. $1000-1250

388 Standard glaze tankard with turtles walking through grass, painted in 1894 by Kataro Shirayamadani. Marks on the base include the Rookwood logo, the date, shape number 564 D, W for white clay and the artist's cypher. Height 8⅛ inches. Tiny flake on spout and tight two inch line descending from the rim. $800-1000

389 Commercial polychromed St. Francis bookends made at Rookwood in 1945 and covered with a clear high glaze. Marks on the base include the Rookwood logo, the date and shape number 6883. Height 7⅛ inches. Uncrazed. $500-600

390 Arts & Crafts mat glaze bowl by William Hentschel with three large and deeply carved dragonflies encircling the shoulder. Marks on the base include the Rookwood logo, the date, shape number 1109, a triangular shaped esoteric mark and the artist's monogram. Diameter is 6 inches. $500-700

391 Very stylized Vellum glaze vase done with Arthur Conant's usual flair. The artwork consists of three flatly painted trees, each slightly varied, which surround the vase. The bottom of the vase is a solid green band with an incised line at the horizon. Purple hills rise slightly in the distance and the tree trunks are done in a tan color. Marks on the base include the Rookwood logo, the date, shape number 1356 D, V for Vellum glaze body, V for Vellum glaze and the artist's monogram. Height 8¼ inches. There are a very few glaze pits but the piece is uncrazed. $3000-3500

392 Banded Iris glaze vase with trailing cherry blossoms, painted in 1911 by Lenore Asbury. Marks on the base include the Rookwood logo, the date, shape number 1659 E, W for white (Iris) glaze and the artist's initials. Height 7⅛ inches. $750-1000

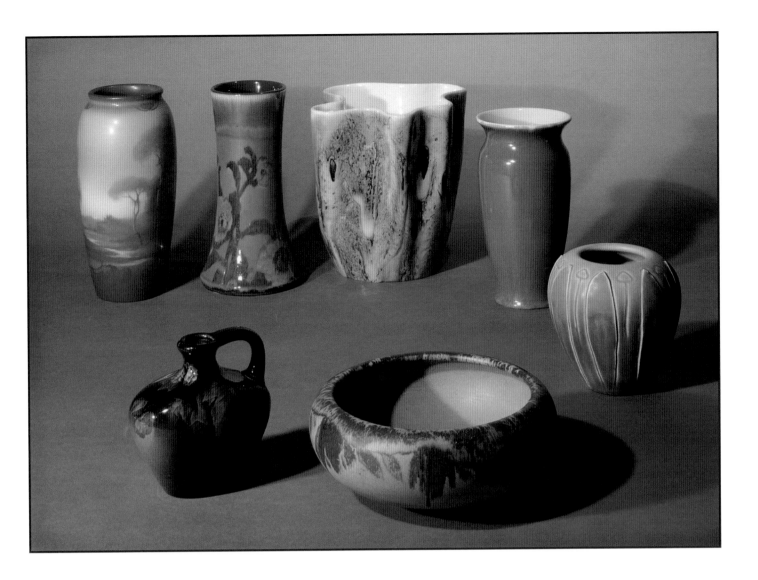

393 Crisp and clean Vellum glaze scenic vase showing a small stream flowing through a wooded meadow, painted in 1923 by Fred Rothenbusch. An unusual touch are the dark outlines of vines and leaves in the foreground near the base and just below the rim. Marks on the base include the Rookwood logo, the date, shape number 892 C, V for Vellum glaze and the artist's monogram. Height 9 inches. Uncrazed. $2500-3000

394 Standard glaze flat sided whiskey jug with hops decoration, painted in 1896 by Elizabeth Lincoln. Marks on the base include the Rookwood logo, the date, shape number 706 and the artist's initials. height 4½ inches. $300-400

395 Handsome Black Opal glaze vase with exotic floral decoration, done in 1923 by Sara Sax. The interior is glazed in a rich, deep green. Marks on the base include the Rookwood logo, the date, shape number 1358 D and the artist's monogram. Height 8¼ inches. Uncrazed. $2000-3000

396 Rookwood Commercial Bengal Brown linen fold vase made in 1953. Marks on the base include the Rookwood logo, the date and shape number 7073. Height 7¼ inches. $300-400

397 Mat glaze bowl with vine and leaf decoration by William Hentschel, done in 1921. Marks on the base include the Rookwood logo, the date, shape number 957 C, a wheel ground x and the artist's monogram. Diameter is 8 inches. There are many glaze blisters but most are not very noticeable. $250-350

398 Tall "1932" porcelain bodied vase covered with a striated honey brown over blue glaze. Marks on the base include the Rookwood logo, the date and S for Special shape. Height is 7⅞ inches. $200-300

399 Arts & Crafts carved mat glaze vase with stylized flowers and leaves in relief, done in 1910 by William Hentschel. Marks on the base include the Rookwood logo, the date, shape number 1120, V for Vellum glaze body and the artist's initials. Height 4¾ inches. $600-800

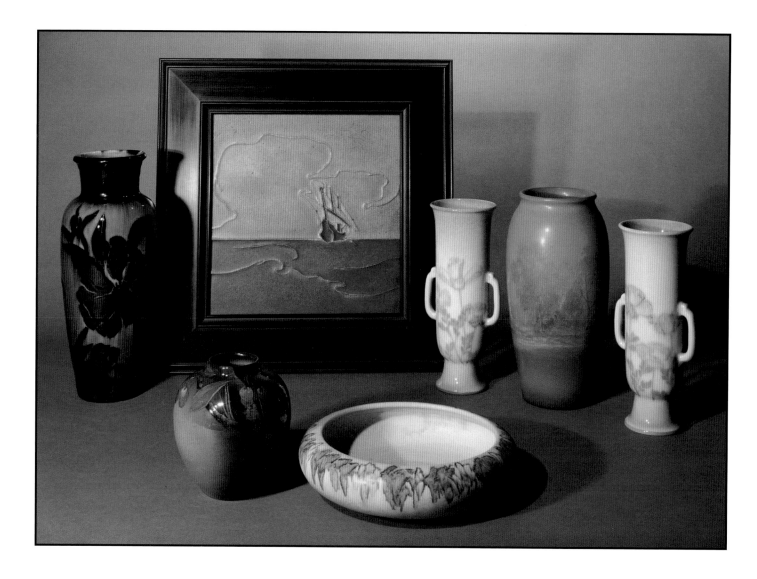

400 Tall vase with floral decoration done in heavy slip by Kay Ley in 1946 and covered with Rookwood's Wine Madder glaze. Marks on the base include the Rookwood logo, the date, shape number 2785, the incised number "4345" and the incised artist's last name. Height 13⅛ inches. Minor glaze bubbles. $700-900

401 Standard glaze vase with bright red cherry decor, done in 1896 by John Dee Wareham. Marks on the base include the Rookwood logo, the date, shape number 531 E and the artist's initials. Height 5⅝ inches. Minor glaze scratches and one small glaze bubble. Exhibited: "Rookwood Pottery" The Yuma Art Center, 1978, catalog number 33. $300-400

402 Arts & Crafts Rookwood Architectural Faience tile showing a sailing vessel on the open seas. The back is marked "Rookwood Faience" in block letters and "1251 Y". Size is 12 x 12 inches. $1000-1250

403 Mat glaze bowl with floral decoration by Charles Klinger, done in 1925. Marks on the base include the Rookwood logo, the date, shape number 2106 C, a wheel ground x and the artist's monogram. Diameter is 10 inches. Minor glaze discoloration. $250-350

404 Stylish two handled high glaze vase with yellow poppy decoration painted in 1936 by Kataro Shirayamadani. The top of the vase is shaded with a soft mauve color and the foot with a mottled green-gray. Marks on the base include the Rookwood logo, the date, shape number 6614 and the artist's cypher in black slip. Height 10¼ inches. Uncrazed and very clean. The purchaser of this lot will be allowed to buy lot 406 for the same price. $1250-1750

405 Interesting Vellum glaze scenic vase painted by Ed Diers in 1916. The dark sky on this piece reminds us of a coming storm, somewhat ominous but nonetheless beautiful. Marks on the base include the Rookwood logo, the date, shape number 892 B, V for Vellum glaze body and the artist's monogram. Height 11⅛ inches. There is a ¹⁄₁₆ x ½ inch glaze flake off the very bottom edge which is hardly noticeable. $2250-2750

406 Stylish two handled high glaze vase with yellow poppy decoration painted in 1936 by Kataro Shirayamadani. The top of the vase is shaded with a soft mauve color and the foot with a mottled green-gray. Marks on the base include the Rookwood logo, the date, shape number 6614 and the artist's cypher in black slip. Height 10¼ inches. Uncrazed and very clean with the exception of a pin point sized glaze blister. The purchaser of lot 404 will be allowed to buy this lot for the same price. $1250-1750

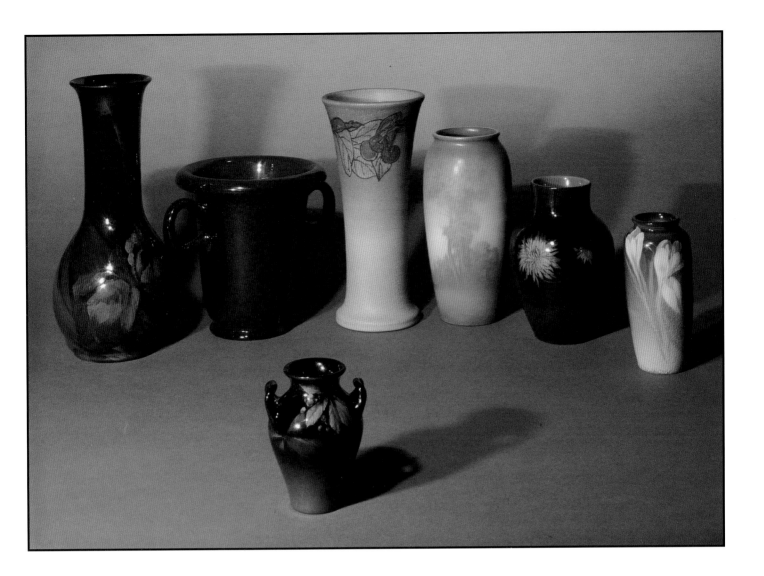

407 Tall Standard glaze vase with red parrot tulips, painted in 1900 by Fred Rothenbusch. Marks on the base include the Rookwood logo, the date, shape number 846 B, a wheel ground x and the artist's monogram. Height 12¾ inches. A small glaze blister and minor glaze flaw may account for the "x". $700-900

408 Showy Commercial two handled vase made at Rookwood in 1921 and covered with a fabulous purple porcelain type glaze. Marks on the base include the Rookwood logo, the date and shape number 2197. Height 8 inches. Uncrazed. $300-400

409 Standard glaze two handled vase decorated with Virginia creeper decor, done in 1898 by Fred Rothenbusch. Marks on the base include the Rookwood logo, the date, shape number 583 F and the artist's monogram. Height 4⅝. There is a tiny stilt pull on the base. $300-400

410 Tall mat glaze vase with unusually detailed cherry decoration, done in 1926 by Sallie Coyne. Marks on the base include the Rookwood logo, the date, shape number 1357 C and the artist's monogram. Height 11¼ inches. $800-1000

411 Softly colored scenic Vellum glaze vase painted in 1923 by Lenore Asbury in her usual subtle manner. Marks on the base include the Rookwood logo, the date, shape number 892 C, V for Vellum glaze body and the artist's initials. Height 9¼ inches. $2000-2500

412 Black Opal glaze vase with crisp white chrysanthemum decoration, painted in 1924 by Harriet Wilcox. The interior is lined with a rich orange glaze. Marks on the base include the Rookwood logo, the date, shape number 927 E and the artist's initials. Height 7¼ inches. Uncrazed. $1500-2000

413 Iris glaze vase with purple crocus decoration on a dark green ground, painted in 1902 by Constance Baker. Marks on the base include the Rookwood logo, the date, shape number 904 D and the artist's initials. Height 6½ inches. $400-600

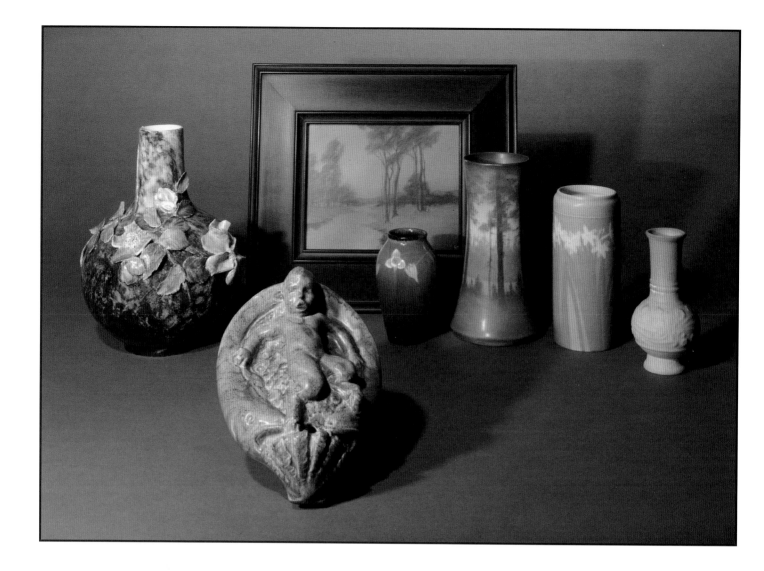

414 Rare Dallas Pottery vase with applied flowers, done in a Limoges style glaze in 1881. Marks on the base include $400-600
the stamped notation, "Dallas 1881" and the number "234" in red slip. Height 10⅝ inches. Damage to several of
the leaves and stems. Marked examples of Dallas Pottery are seldom seen, especially the Cincinnati faience
variety.

415 Rookwood Commercial wall fountain in the form of a cherub with dolphins, made in 1916 and covered with rare $600-800
Ombroso glaze. Marks on the back include the Rookwood logo, the date, P for porcelain body and shape number
2339. Size is 8⅜ x 6½ inches. Designed by Ernest Bruce Haswell, this lot has never been installed and is in
excellent original condition.

416 Colorful Vellum glaze scenic plaque painted in 1919 by Elizabeth McDermott. The artist's monogram appears in $2500-3000
the lower right hand corner. Marks on the back include the Rookwood logo and the date. Size is 7⅛ x 9⅛ inches.
Recently framed.

417 High glaze vase done with white and yellow crocuses on a purple and blue ground, painted in 1924 by Kataro $1250-1500
Shirayamadani. Marks on the base include the Rookwood logo, the date, shape number 913 F and the artist's
cypher. Height 5⅜ inches.

418 Striking Arts & Crafts scenic Vellum glaze vase painted in 1920 by Sallie Coyne. Tall conifers in the foreground $2500-3000
frame a meadow and more purple conifers in the background. Marks on the base include the Rookwood logo, the
date, shape number 1358 D, V for Vellum glaze body, a wheel ground x and the artist's monogram. Height 8⅞
inches. There are three ½ inch by ⅛ inch underglaze skips at the rim and a bit of glaze pooling at the base which
most likely are the reason for the "x".

419 Colorful Vellum glaze vase with daffodil decoration, done in 1910 by Kataro Shirayamadani. Marks on the base $2000-2500
include the Rookwood logo, the date, shape number 952 E, V for Vellum glaze body, a wheel ground x and the
artist's cypher. Height 7⅜ inches. A small glaze skip near the rim accounts for the "x" and has been professionally
repaired.

420 Unusual Rookwood Commercial vase with embossed floral designs, covered with curdled green and blue mat $150-200
glazes. Marks on the base include the Rookwood logo, the date, shape number 2990 and a fan shaped esoteric
mark. Height 6½ inches.

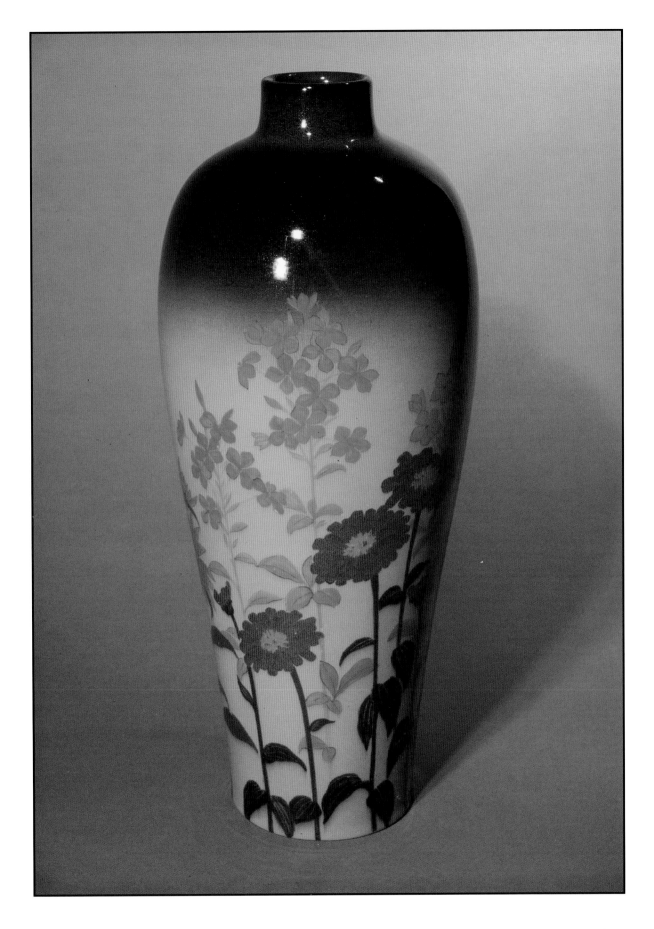

421 Large and important high glaze vase painted in 1925 by Kataro Shirayamadani. Using some of the most exotic $15000-20000
 colors available at Rookwood in the mid-20's, Shirayamadani has given us a very special flower garden
 composed of four different varieties on a black to greenish gray ground. The deep maroon used in some of the
 flowers also lines the interior. Marks on the base include the Rookwood logo, the date, shape number 2368 and
 the artist's cypher. Height 16⅜ inches.

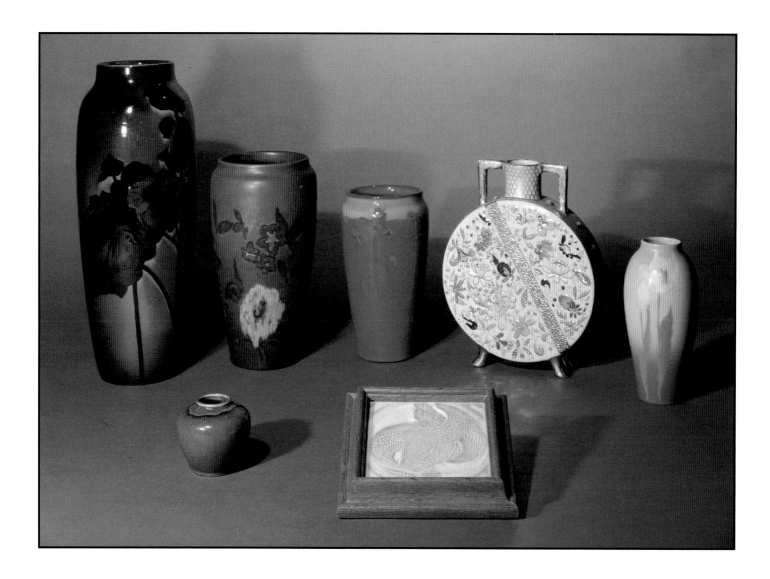

422 Tall Standard glaze vase with red hollyhock decoration, done 1n 1899 by Sallie Toohey. Marks on the base $2000-3000
include the Rookwood logo, the date, shape number 907 B, a wheel ground x and the artist's monogram. Height
16¼ inches. There are some glaze and underglaze flaws and minor scratches. Also a mid body horizontal firing
crack of about 5 inches can be seen with difficulty both inside and out.

423 Colorful "1932" glaze vase with purple over brown over blue, made at Rookwood in 1932. Marks on the base $200-300
include the Rookwood logo, the date and shape number 6307 F. Height 3 inches. Uncrazed.

424 Tall mat glaze vase with colorful floral decoration in very heavy slip, painted in 1925 by an unidentified artist. $800-1000
Marks on the base include the Rookwood logo, the date, shape number 1369 C, a wheel ground x and the artist's
monogram. The monogram is listed in Virginia Cummins book, "Rookwood Pottery Potpourri" on page 85 but the
identity of its maker is still unknown. Height 11¼ inches. The vase has been drilled and shows small patches of
glaze run and glaze skip.

425 Blue tinted high glaze vase with wild violet decoration done in 1925 by Fred Rothenbusch. Marks on the base $800-1000
include the Rookwood logo, the date, shape number 1369 D, P for porcelain body, B, most likely for blue tinted
glaze and the artist's monogram. Height 9⅛ inches.

426 Rookwood Commercial Vellum glaze cockatoo trivet made in 1930. Marks on the back include the Rookwood $300-400
logo, the date and shape number 2043. Size is 5½ x 5½ inches. Minor glaze pitting. Uncrazed and recently
framed.

427 Tall two handled pilgrim flask resting on four feet, most likely the work of Cincinnati Art Pottery, an example of $350-450
their "Hungarian Faience", made circa 1885. The decoration consists of embossed floral designs highlighted in
pastel colored slip and fired on gold. The piece appears to be unmarked. Height 11⅛ inches. There are chips on
two of the feet.

428 Vellum glaze vase with white tulip decoration painted in 1915 by Elizabeth McDermott. The base carries the $350-450
Rookwood logo, the date, shape number 901 D, V for Vellum glaze body and the artist's monogram. Height 7⅞
inches. Minor glaze pitting.

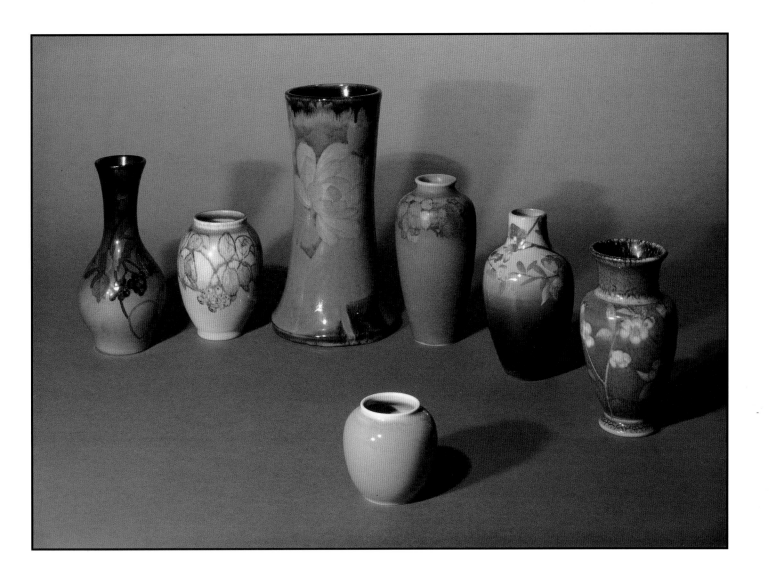

429 Standard glaze vase with leaf and berry decoration by Lena Hanscom, painted in 1903. Marks on the base include the Rookwood logo, the date, shape number 908, a wheel ground x and the artist's initials. Height 8 inches. Minor glaze scratches. Exhibited: "Rookwood Pottery" The Yuma Art Center, 1978, catalog number 61. $350-450

430 Mat glaze vase with leaf and berry decor painted in 1929 by Janet Harris. Marks on the base include the Rookwood logo, the date, shape number 2191 and the artist's monogram. Height 5⅛ inches. $350-450

431 High glaze vase with very colorful lotus decoration, painted in 1924 by Kataro Shirayamadani. The blossoms are done in a soft pink while the rest of the flower and pad are in a pale purple. The background color is deeper purple and the interior is covered with a deep blue glaze. Marks on the base include the Rookwood logo, the date, shape number 1358 C, a wheel ground x and the artist's cypher. Height 10⅝ inches. Minor glaze runs. $2000-2500

432 Two colored "1932" glaze vase done in a crystalline blue over yellow at Rookwood in 1932. Marks on the base include the Rookwood logo, the date and shape number 6319 F. Height 3 inches. $200-250

433 Mat glaze vase with a band of multicolored leaves and berries at the shoulder, painted in 1926 by Katherine Jones. Marks on the base include the Rookwood logo, the date, shape number 614 F and the artist's initials. Height 7 inches. $350-450

434 Pretty Iris glaze vase with red cherry blossoms on a ground shading from pale green to almost black, done in 1900 by Harriet Wilcox. Marks on the base include the Rookwood logo, the date, shape number 905 E, W for white (Iris) glaze and the artist's initials. Height 6½ inches. $1000-1250

435 Attractive high glaze vase with cherry blossom decoration, done in 1934 by Kataro Shirayamadani. The interior, collar and foot are covered with a mottled gray-brown glaze with iridescent highlights. Marks on the base include the Rookwood logo, the date, S for Special shape and the artist's cypher. Height 6½ inches. Uncrazed. $1250-1500

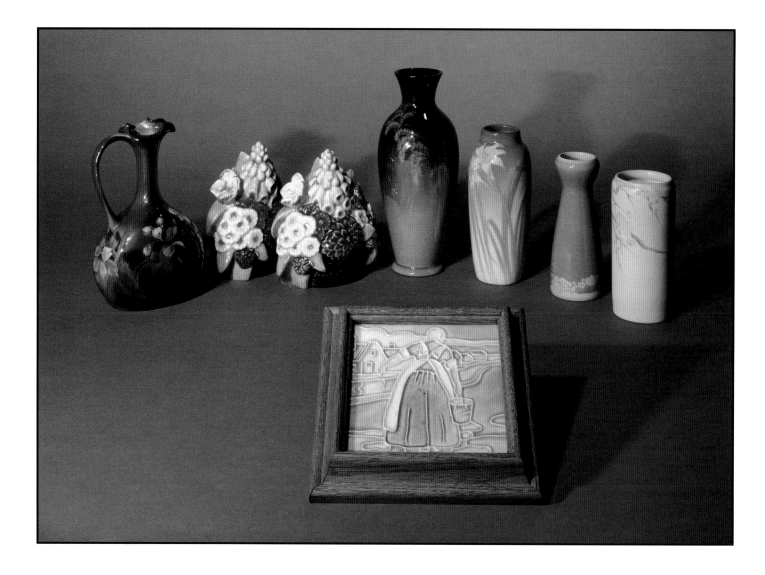

436 Flat sided Standard glaze ewer with apple blossom decoration painted in 1894 by Kate Matchette. Marks on the base include the Rookwood logo, the date, shape number 716 CC, W for white clay and the artist's initials. Height 8⅛ inches. The apple blossoms sprout from a thick limb and the artwork is done in heavily applied slip. $400-500

437 Commercial polychromed bookends in the form of flower baskets holding a variety of flowers. Marks on the base include the Rookwood logo, the date (1927) and shape number 2837. Height 6⅛ inches. Small grinding chips off the base. $400-600

438 Standard glaze vase with goldenrod decoration, done in 1897 by Olga Geneva Reed. Marks on the base include the Rookwood logo, the date, shape number 562, a diamond shaped esoteric mark and the artist's initials. Height 9⅜ inches. $400-600

439 Rookwood Commercial Vellum glaze Dutch girl trivet made in 1921. Marks on the base include the Rookwood logo, the date, shape number 1819 and a wheel ground x. Size is 5½ x 5½ inches. Minor glaze pitting. Uncrazed and recently framed. $300-400

440 Iris glaze vase with yellow jonquils on a green background, done in 1904 by Josephine Zettel. Marks on the base include the Rookwood logo, the date, shape number 907 E, W for white (Iris) glaze, a wheel ground x and the artist's monogram. Height 7 inches. $700-900

441 Unusual Iris glaze vase with incised and painted fruit blossom decoration at the base, done in 1911 by Katherine Van Horne. Marks on the base include the Rookwood logo, the date, shape number 1656 F, V for Vellum glaze body, V for Vellum glaze and the artist's monogram. Height 6¼ inches. Despite marks for Vellum, someone in the glaze department at Rookwood obviously decided to go with the Iris instead. $400-600

442 Vellum glaze vase with cherry blossoms done in an oriental manner by Lorinda Epply in 1907. Marks on the base include the Rookwood logo, the date, shape number 952 F, V for Vellum glaze body, V for Vellum glaze and the artist's monogram. Height 6 inches. $400-600

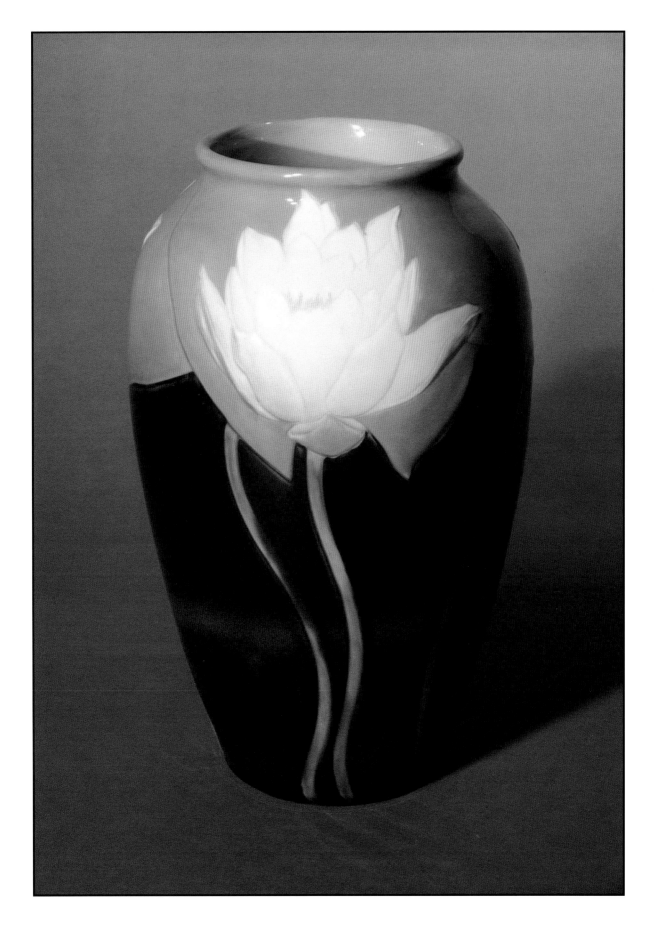

443 Spectacular and important carved Black Iris glaze vase with white lotus blossoms floating in cobalt blue water, $15000-20000
 posed against taupe colored lotus pads. Done in 1900 by William McDonald, this piece would have been
 described by Rookwood as a Relief Dark Iris or Relief Black Iris because of the carving and incising which give a
 three dimensional quality to the flowers and stems and the remarkable cobalt ground. Marks on the base include
 the Rookwood logo, the date, shape number 531 D and the artist's monogram. Height 11 inches. The vase is
 virtually uncrazed with only one or two tight firing flaws where the applied clay is thickest. There are also some
 very minor glaze scratches.

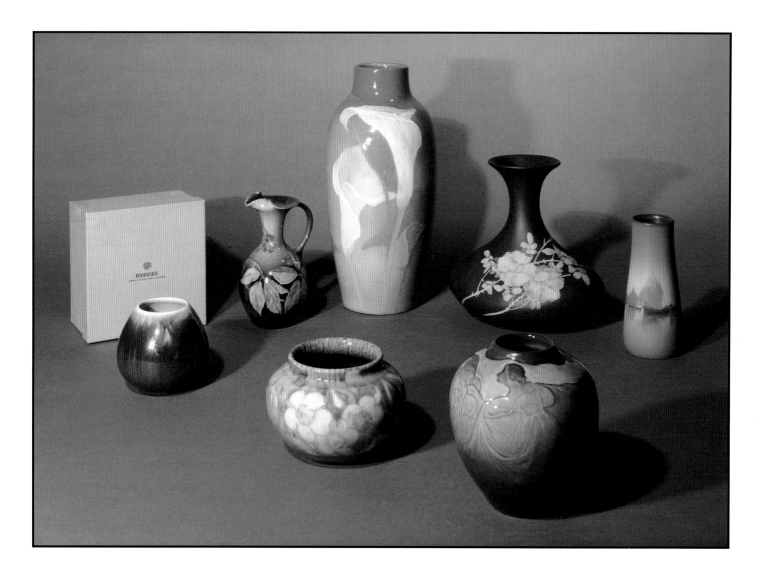

444 Rookwood Commercial vase made in 1952 and covered with an unusual variegated high glaze in shades of blue, $150-200
dark brown and cream. Marks on the base include the Rookwood logo, the date and shape number 6514. Height
3⅝ inches. Uncrazed. Comes with its original Rookwood sales room cardboard box which is in excellent
condition.

445 Standard glaze ewer with leaf, berry and vine decoration, done in 1893 by Sallie Coyne. Marks on the base $300-500
include the Rookwood logo, the date, shape number 685, W for white clay and the artist's initials. Height 6½
inches. Minor glaze scratches.

446 Colorful high glaze vase with Art Deco floral decoration painted in 1925 by William Hentschel. The interior of $400-600
the piece is lined with a variegated gray, black and brown glaze which drips over the outside rim a half inch or
so. Marks on the base include the Rookwood logo, the date, shape number 1110 and the artist's monogram in
brown slip. Height 3¾ inches. Uncrazed.

447 Tall Iris glaze vase with white calla lilies and green leaves on a green to yellow ground, painted in 1903 by Sara $4000-6000
Sax. Marks on the base include the Rookwood logo, the date, shape number 940 B, W for white (Iris) glaze, a
wheel ground x and the artist's monogram. Height 12⅝ inches. Minor glaze pooling at the base.

448 Most unusual flat sided vase with flared rim painted in 1893 by Albert Valentien. The wild rose decoration is $1000-1500
done in white slip on a very dark blue ground and glazed in Rookwood's dull finish. The palate and date suggest
an early Aerial Blue experiment. Marks on the base include the Rookwood logo, the date, shape number 684, W
for white clay, W for white (Iris or Cameo) glaze and the artist's initials. Although Valentien has marked the piece
to receive a clear high glaze, either Cameo or Iris, the covering is clearly dull finish. The coloring is certainly that
of Aerial Blue and to paraphrase Shakespeare, a wild rose by any other name would smell as sweet. Height 8
inches.

449 Rare carved Sea Green glaze vase done by Harriette Strafer in 1898. Strafer has created a scene in which an Art $3000-4000
Nouveau woman wearing a flowing gown is seen reaching toward a small tree. There are more trees and hills on
the reverse side and dark clouds surround the rim. Marks on the base include the Rookwood logo, the date,
shape number 531 E, G for Sea Green glaze and the artist's initials. Height 5½ inches. There are two tiny flakes
off the rim and another off a very high spot on the back side. These have been professionally repaired. A "before"
photo is available.

450 Small but very nicely painted Venetian harbor scene done in 1920 by Carl Schmidt and covered with Vellum $1500-2000
glaze. Marks on the base include the Rookwood logo, the date, shape number 950 F, V for Vellum glaze and the
artist's monogram. Height 6¼ inches.

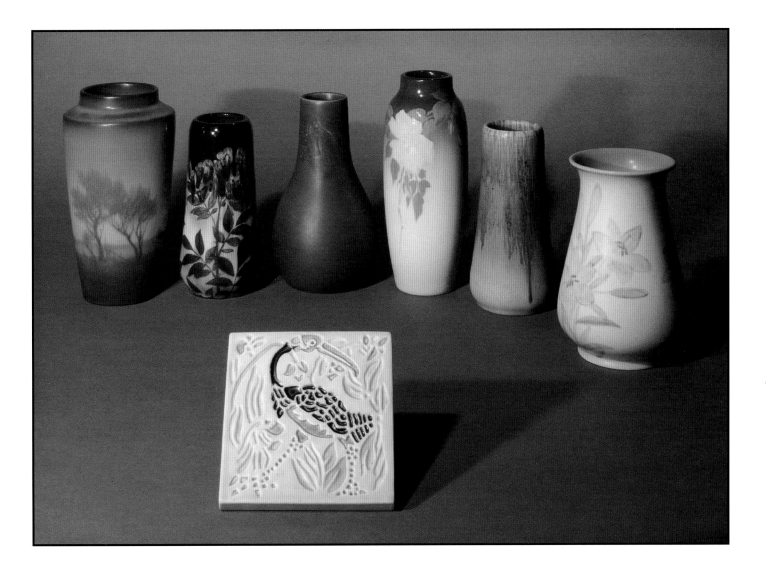

451 Interesting Vellum glaze twilight scenic vase painted in 1919 by E.T. Hurley. Done in a tonalist fashion, the vase has good depth and nice use of color. Marks on the base include the Rookwood logo, the date, shape number 1918, V for Vellum glaze and the artist's initials. Height 8¾ inches. $1500-1750

452 High glaze vase with colorful floral decoration by Kataro Shirayamadani, painted in 1925. The interior is lined with a rich purple glaze, a signature of Shirayamadani's work in this period. Marks on the base include the Rookwood logo, the date, shape number 2066, a wheel ground x and the artist's cypher. Height 7⅜ inches. A moderate rim chip has been professionally repaired and is quite invisible. $1500-2000

453 Commercial polychromed trivet showing a long beaked bird walking through a patch of pink irises, made at Rookwood in 1940. Marks on the back include the Rookwood logo, the date and shape number 6778. Size is 5⅜ x 5⅜. Uncrazed. $300-400

454 Arts & Crafts mat glaze vase with carved and painted floral patterns around the neck, done in 1911 by William Hentschel. Marks on the base include the Rookwood logo, the date, shape number 989 D and the artist's monogram. Height 8⅛ inches. $500-700

455 Pretty Iris glaze vase decorated by Lenore Asbury with pink wild roses in 1911. The delicate ground shades from dark gray to cream to pink. Marks on the base include the Rookwood logo, the date, shape number 907 E, W for white (Iris) glaze and the artist's initials. Height 9¼ inches. $2750-3250

456 Mat glaze vase with abstract multicolored decoration painted in 1928 by Sallie Coyne. Marks on the base include the Rookwood logo, the date, shape number 2066, a wheel ground x and the artist's monogram. Height 7½ inches. There is an unobtrusive glaze skip near the base. $300-400

457 Mat glaze vase with yellow day lily decoration painted in 1943 by Kataro Shirayamadani. Marks on the base include the Rookwood logo, the date, shape number 6359 and the artist's initials. Height 7⅜ inches. $1250-1500

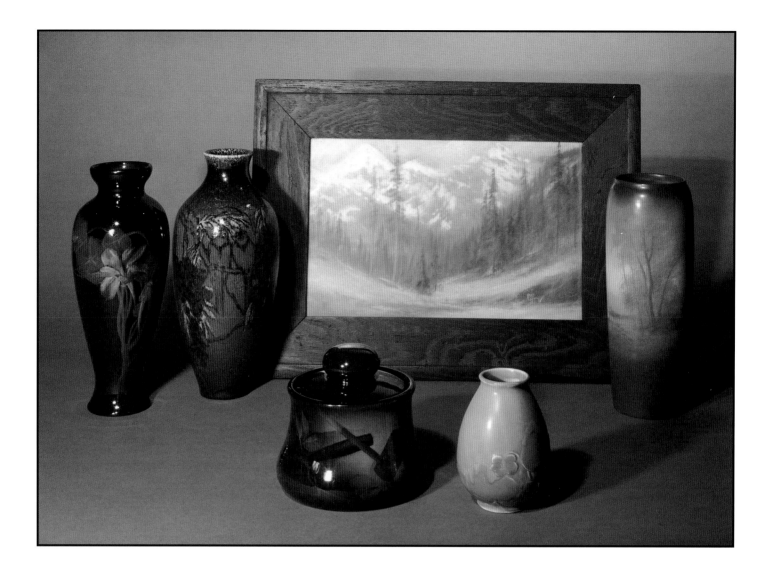

458 Standard glaze vase with an Art Nouveau treatment of nasturtiums painted in 1902 by E.T. Hurley. Marks on the $500-700
base include the Rookwood logo, the date, shape number 792 C and the artist's initials. Height 11⅛ inches.

459 Colorful high glaze vase with two pairs of birds perched in very exotic foliage, painted by E.T. Hurley in 1922. $2500-3000
Marks on the base include the Rookwood logo, the date, shape number 170 and the artist's initials. Height 11½
inches. Uncrazed. Small grinding chips on the base.

460 Large and impressive Vellum glaze scenic plaque done by Ed Diers in 1915. The painting shows Mount Sir $6000-8000
Donald in British Columbia. Diers' monogram appears in the lower left hand corner. Marks on the back include
the Rookwood logo and date impressed three times and an incised V for Vellum glaze. Affixed to the frame is an
original Rookwood label with the notation, "Mt. Sir Donald Ed Diers". Size is 9¼ x 14½ inches. Minor glaze
pitting.

461 Handsome Standard glaze humidor with decoration of two cigars, a pipe and some sort of vining plant, painted in $500-800
1900 by Fred Rothenbusch. Marks on the base include the Rookwood logo, the date, shape number 858 and the
artist's monogram. The lid also bears the artist's monogram. Height 5½ inches. There is a small, tight line on the
interior rim which is not visible on the outside.

462 Unusual Commercial vase made in 1935 with embossed floral decoration covered with a purple over greenish $200-250
blue glaze. Marks on the base include the Rookwood logo, the date and shape number 6544. Height 4⅞ inches.
Uncrazed

463 Tall and nicely colored Vellum glaze woodland scenic vase painted in 1921 by Ed Diers. Marks on the base $2500-3000
include the Rookwood logo, the date, shape number 951 C, V for Vellum glaze body and the artist's monogram.
Height 10¾ inches.

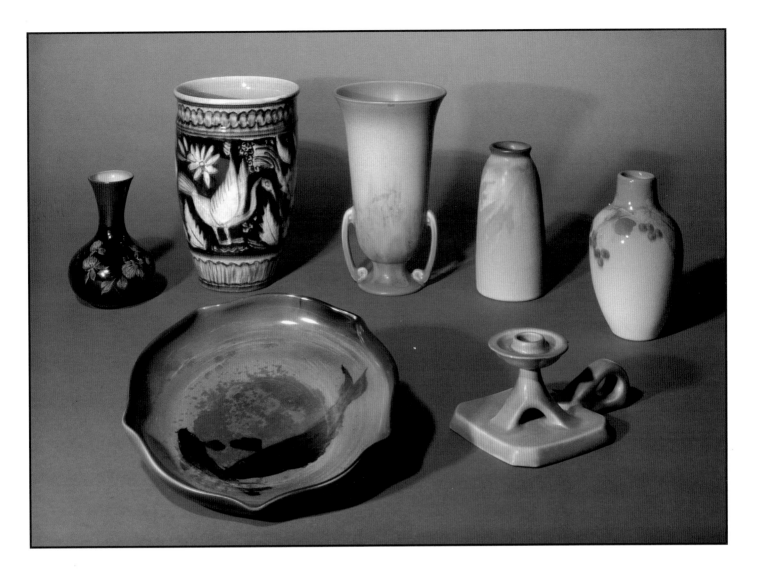

464 Standard glaze vase with detailed red clover decoration, done in 1889 by Grace Young. Marks on the base $250-350
include the Rookwood logo, the date, shape number S 850, S for sage green clay, L for light Standard glaze and
the artist's monogram. Height 5½ inches.

465 Colorful and unusual high glaze vase painted in 1944 by Elizabeth Barrett. Decoration consists of exotic birds $1250-1500
and sunflowers in yellow on a black ground with polychromed borders at top and bottom. Marks on the base
include the Rookwood logo, the date, shape number 2187 and the artist's incised monogram. Height 8¼ inches.

466 Sea Green glaze coupe plate with undersea fish decoration, done in 1900 by Fred Rothenbusch. Marks on the $200-300
back include the Rookwood logo, the date, shape number 205 B, G for Sea Green glaze, two wheel ground x's
and the artist's monogram. Diameter is 9¼ inches. Glaze flaws have been repaired.

467 Mat glaze two handled vase with floral decoration done in 1935 by Kataro Shirayamadani. Marks on the base $600-800
include the Rookwood logo, the date, S for Special shape and the artist's cypher. Height 8⅝ inches.

468 Vellum glaze vase with colorful autumn leaves, painted in 1912 by Edith Wildman. Marks on the base include $250-350
the Rookwood logo, the date, shape number 1658 F, V for Vellum glaze body, V for Vellum glaze and the artist's
monogram. Height 6⅛ inches.

469 Unusual Commercial mat glaze candlestick made at Rookwood in 1906. Marks on the base include the $200-300
Rookwood logo, the date and shape number 1250. Height 3⅛ inches. Pinhead nick on rim.

470 Iris glaze vase with leaf, vine and berry decoration by Clara Lindeman, painted in 1904. Marks on the base $800-1200
include the Rookwood logo, the date, shape number 905 E, W for white (Iris) glaze and the artist's initials. Height
6⅜ inches.

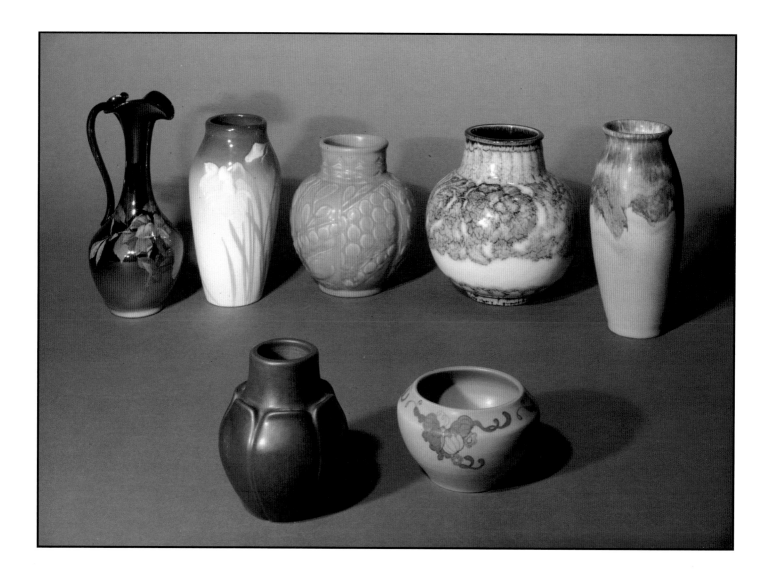

471 Standard glaze ewer with nicely detailed wild rose decor painted in 1901 by Fred Rothenbusch. Marks on the base include the Rookwood logo, the date, shape number 557 and the artist's monogram. Height 9¼ inches. One small glaze bubble. $400-600

472 Iris glaze vase decorated with yellow jonquils by Irene Bishop in 1907. Marks on the base include the Rookwood logo, the date, shape number 925 D, W for white (Iris) glaze and the artist's monogram. Height 7⅞ inches. $800-1200

473 Arts & Crafts Commercial vase made at Rookwood in 1917 and covered in a rich green mat glaze. Marks on the base include the Rookwood logo, the date and shape number 2095. Height 4⅝ inches. $200-300

474 Commercial mat glaze vase made at Rookwood in 1937. Marks on the base include the Rookwood logo, the date and shape number 6147. Height 6½ inches. $150-200

475 Very pretty Vellum glaze floral vase done in rich and varied colors by Lenore Asbury in 1922. Marks on the base include the Rookwood logo, the date, shape number 955, V for Vellum glaze and the artist's initials. Height 2¾ inches. Uncrazed. $1000-1250

476 Butterfat glaze vase with floral decoration by Lorinda Epply, painted in 1926. The interior is lined with a slightly iridescent glaze which extends onto the rim. Marks on the base include the Rookwood logo, the date, shape number 2969 and the artist's monogram. Height 7 inches. $1000-1250

477 Mat glaze with floral decoration painted in 1927 by Sallie Coyne. Marks on the base include the Rookwood logo, the date, shape number 233 and the artist's monogram. Height 8¼ inches. Uncrazed. $600-800

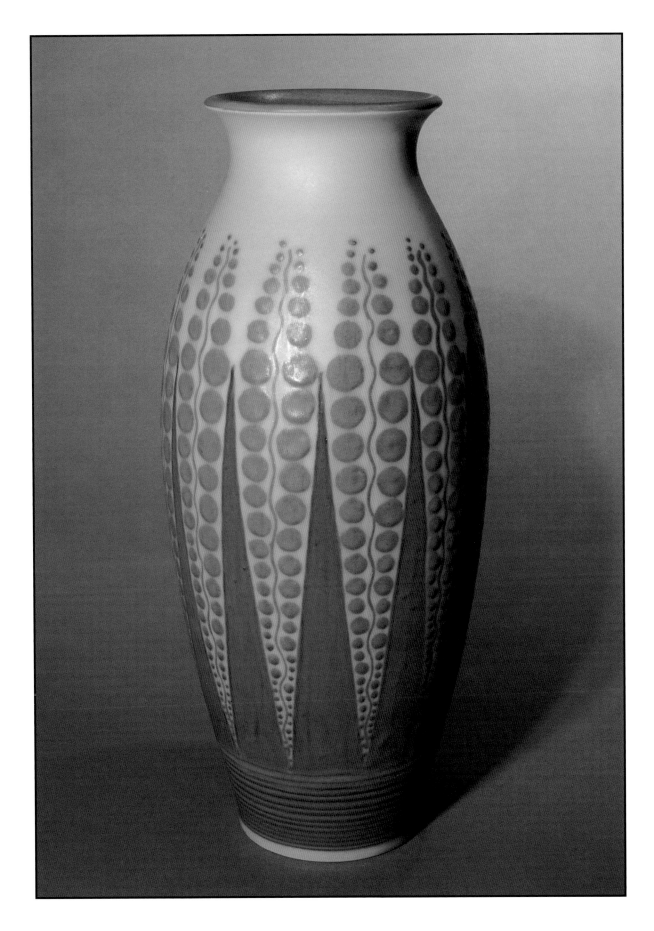

478 Monumental Art Deco Mat glaze vase decorated by William Hentschel in 1927. The highly stylized floral decor $7000-9000
is mostly applied by slip trailing, a method Hentschel and Elizabeth Barrett frequently employed. Marks on the
base include the Rookwood logo, the date, shape number 2523 and the artist's monogram. Height 17½ inches.
There is a tiny grinding nick on the base. Exhibited and illustrated as item 97 in "Rookwood Pottery The Glorious
Gamble" Anita J. Ellis, Cincinnati Art Museum, 1992-1993, catalog published by Rizzoli in 1992 (color plate,
page 162).

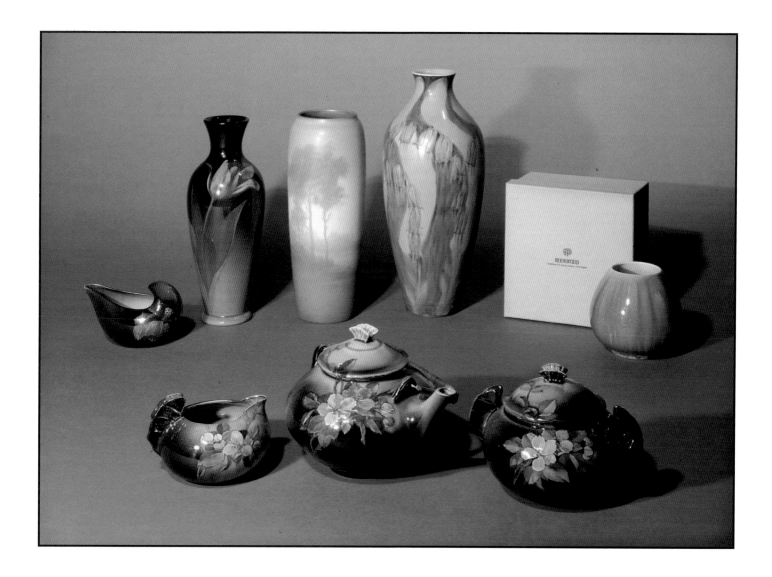

479 Standard glaze salt cellar with floral decoration done in 1891 by Harriette Strafer. Marks on the base include the Rookwood logo, the date, shape number 527, W for white clay, L for light Standard glaze and the artist's initials. Height 2¾ inches. $250-350

480 Standard glaze vase decorated with yellow tulips by Carl Schmidt in 1899. Marks on the base include the Rookwood logo, the date, shape number 562 and the artist's monogram. Height 9⅜ inches. Minor glaze scratches. $400-600

481 Three piece Standard glaze tea set with sharply detailed wild rose decoration, painted in 1890 by Kataro Shirayamadani. All three pieces have butterfly handles and the wild rose decor on the sides of the sugar bowl and teapot continues on the lids. Marks on the base of each piece include the Rookwood logo, the date, S for sage green clay, L for light Standard glaze and the artist's cypher. The creamer and lidded sugar bowl are shape number 329 and the lidded teapot is shape number 404. Height of the tallest piece is 4½ inches. Remarkably, all three pieces are in excellent original condition with the exception of the wicker handle on the teapot which needs to be re-wound. $1000-1500

482 Vellum glaze scenic vase done in soft shades of green, brown, blue and cream, painted in 1919 by E.T. Hurley with his usual great sense of depth and perspective. Marks on the base include the Rookwood logo, the date, shape number 951 D, V for Vellum glaze body and the artist's initials. Height 9½ inches. $2000-2500

483 Mat glaze vase with incised and painted floral decoration, done in 1921 by C.S. Todd. Marks on the base include the Rookwood logo, the date, a wheel ground x and the artist's initials. Height 11⅛ inches. The piece has been drilled and has an unobtrusive glaze skip near the base. $600-800

484 Rookwood Commercial vase made in 1957, covered with an unusual variegated high glaze in shades of blue, brown, gray and white. Marks on the base include the Rookwood logo, the date, the obscured shape number 6514 and the notation, "Rookwood Cinti.O.". Height 3½ inches. Uncrazed. Comes with its original Rookwood sales room cardboard box which is in excellent condition. $150-200

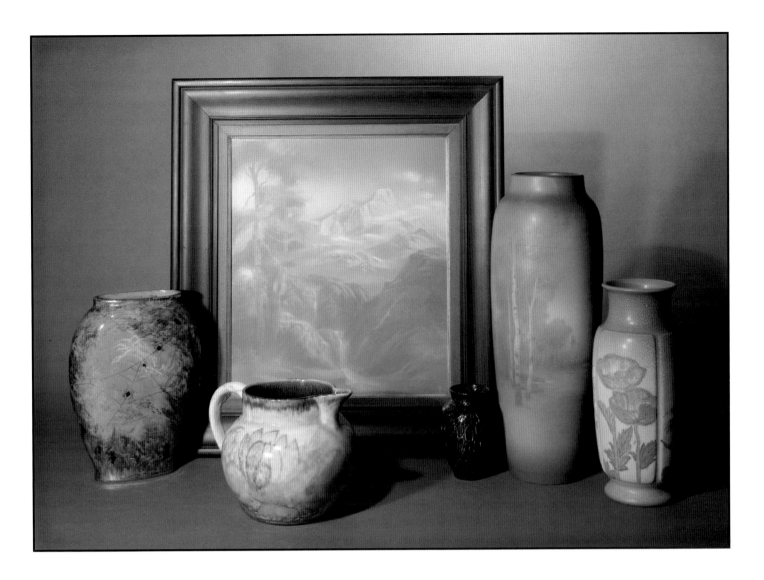

485 Early Limoges style pillow vase painted in 1882 by Maria Longworth Nichols. On one side are found several $2250-2750
spiders in a web while the other side shows a branch with berries in different colors done in very heavy slip, the
whole enhanced with fired on gold. The base is marked with the words "Rookwood Pottery" in raised letters, the
stamped in date and Mrs. Nichols' initials in fired on gold. Height 10⅛ inches. Three of the berries have minor
glaze abrasions or flakes.

486 High glaze pitcher with floral decoration and slightly iridescent blue, brown and gray lining, done in 1924 by $600-800
William Hentschel. Marks on the base include the Rookwood logo, the date, shape number 13 and the artist's
monogram. Height 6⅞ inches. Uncrazed.

487 Monumental Vellum glaze scenic plaque, possibly of Long's Peak, Colorado, painted in 1928 by Fred $10000-12500
Rothenbusch. Marks on the back include the Rookwood logo and the date. The artist's monogram appears in the
lower right hand corner. Size is 16⅛ x 14⅛ inches. This is an unusually large and well defined plaque, a
combination seldom seen. Of the largest plaques to have surfaced over the last 25 years, most were done by
Rothenbusch, a testament to Rookwood's faith in his ability. This plaque is uncrazed and appears to be in its
original frame.

488 Commercial vase with spectacular copperdust crystalline glaze made at Rookwood in 1937. Marks on the base $300-400
include the Rookwood logo, the date and shape number 6510. Height 5 inches.

489 Tall and very clean Vellum glaze landscape vase, painted in 1923 by Lenore Asbury. The decoration is of a lake $5000-7000
seen through a birch forest in blues and greens with strong hints of pink. Marks on the base include the
Rookwood logo, the date, shape number 907 B, V for Vellum glaze, P for porcelain body and part of the artist's
initials. Height 17⅜ inches. There is a neat drill hole in the base. This is an unusually large and extremely clean
Vellum scenic vase which is completely uncrazed and has hardly a blemish.

490 Very showy mat glaze vase divided into four panels by cast in vertical lines. Decorated in 1939 by Kataro $3000-4000
Shirayamadani, the panels are decorated with poppies, daisies, irises and dogwood, a different flower in each.
Marks on the base include the Rookwood logo, the date, shape number 2933 and the artist's cypher. Height 11⅜
inches. This is one of the nicest 30's pieces by Shirayamadani we have seen. It is extremely clean and well
executed.

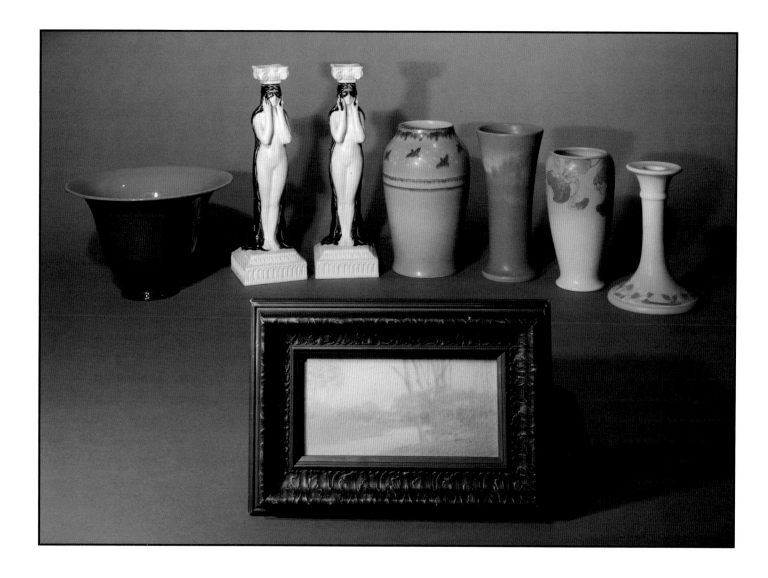

491 Rookwood Commercial vase with flared rim made in 1921 and covered with a rich purple porcelain glaze lined with medium blue. Marks on the base include the Rookwood logo, the date and shape number 2260 C. Height 6¼ inches. $300-400

492 Vellum glaze scenic plaque in warm shades of brown and cream, painted in 1913 by Lorinda Epply. The artist's monogram appears in the lower right hand corner. Marks on the back include the Rookwood logo, the date and V for Vellum glaze body. Affixed to the back are an original Rookwood paper logo and an original Rookwood paper label with the notation, "Summer Idyl Lorinda Epply". Size is 3¾ x 7⅝ inches. $1000-1250

493 Very unusual Art Deco candlesticks designed by Louise Abel and made at Rookwood in 1924. Both pieces are covered in a white mat glaze while the nude's floor length hair and mask are done in high glaze black. Marks on the base include the Rookwood logo, the date, shape number 2524 and the cast in monogram of the artist. Height 12⅜ inches. $800-1000

494 Banded Vellum glaze vase with birds and flowers repeating around the shoulder, painted in 1918 by Charles Klinger. Marks on the base include the Rookwood logo, the date, shape number 1044, a wheel ground x and the artist's monogram. Height 8¾ inches. Some small areas of glaze loss at the base account for the "x". $500-700

495 Banded scenic Vellum glaze vase with trees and flying birds painted in 1910 by Fred Rothenbusch. Marks on the base include the Rookwood logo, the date, shape number 1357 D, V for Vellum glaze body, V for Vellum glaze and the artist's monogram. Height 8⅝ inches. Two long craze lines on the interior are just that, craze lines. They do not correspond with anything on the outside. Although a pleasant piece, the decoration is a bit fuzzy. Exhibited: "Rookwood Pottery" The Yuma Art Center, 1978, catalog number 67. $700-900

496 Very crisp and clean Vellum glaze vase with detailed nasturtium decoration outlined in black, done in 1929 by Fred Rothenbusch. Marks on the base include the Rookwood logo, the date, shape number 1779, V for Vellum glaze and the artist's monogram. Height 7⅝ inches. Uncrazed. $1750-2250

497 Vellum glaze candlestick with wild rose decoration done in 1909 by Edith Noonan. Marks on the base include the Rookwood logo, the date, shape number 822 C, V for Vellum glaze body, V for Vellum glaze and the artist's initials. Height 7½ inches. Moderate glaze peppering. $200-300

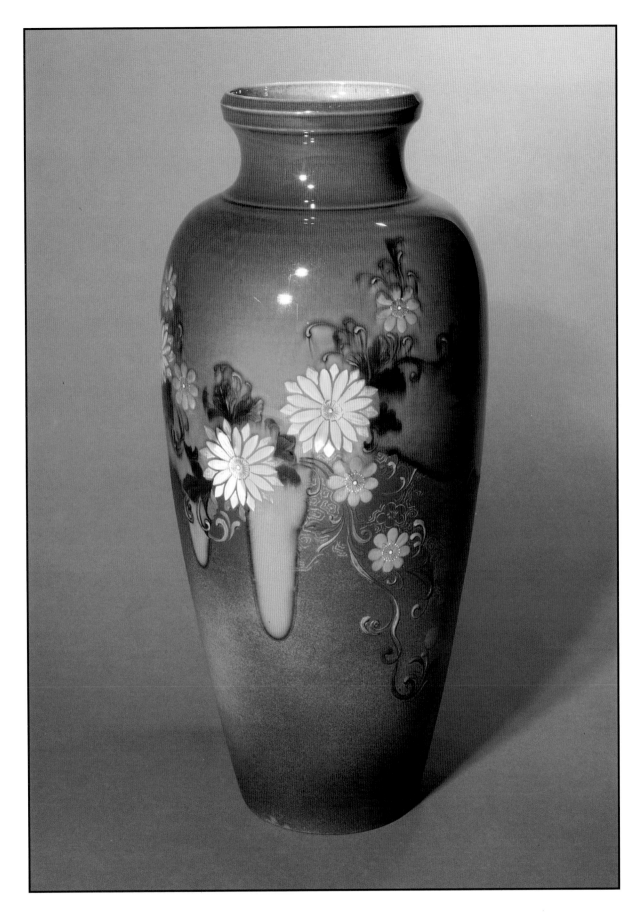

498 Large and important vase painted in 1887 by Albert Valentien. This unusual combination of techniques features a $25000-35000
light Standard glaze over what may be Rookwood's dull finish, allowing us an unusual glimpse at how slip
decoration was applied and augmented. The stylized flowers, done in a Japanesque manner, are in heavy slip
while Valentien has incised other flowers and vines on the ground which take on a completely different look
when covered with the thick Standard glaze. Hints of Tiger Eye can be seen, particularly around the shoulder of
the vase. Marks on the base include the Rookwood logo, the date, shape number 378 B, S for sage green clay, L
for light Standard glaze and the artist's initials. Height 15⅞ inches. Exhibited and illustrated as item 4 in
"Rookwood Pottery The Glorious Gamble" by Anita J. Ellis, Cincinnati Art Museum, 1992-1993, catalog
published by Rizzoli in 1992 (color plate, page 69).

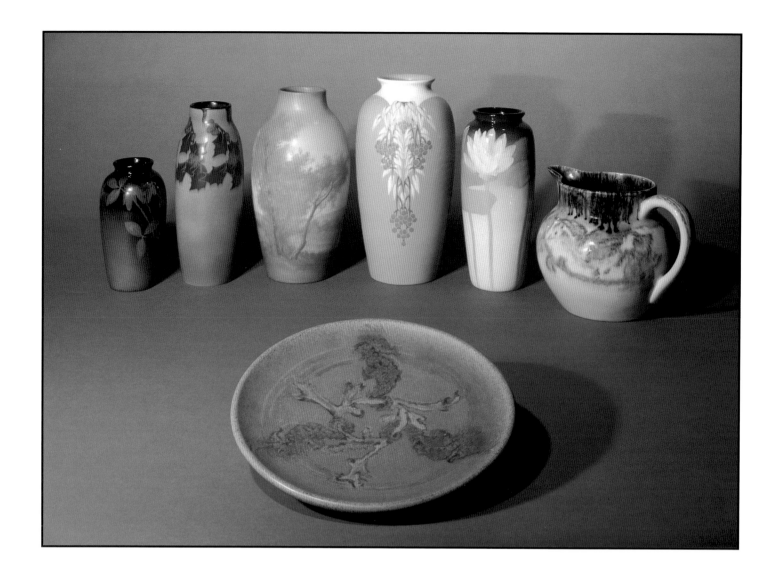

499 Standard glaze vase with red clover decor, done in 1901 by Marianne Mitchell. Marks on the base include the Rookwood logo, the date, shape number 922 D and the artist's monogram. Height 6⅞ inches. Exhibited: "Rookwood Pottery" The Yuma Art Center, 1978, catalog number 54. $350-450

500 Very unusual and colorful Vellum glaze vase with five sprigs of stylized holly trailing down from the rim, done in 1917 by Sara Sax. The holly, black leaves and stems and red berries are shown over a vivid purple ground. Marks on the base include the Rookwood logo, the date, shape number 932 D and the artist's mongram. Height 9¾ inches. $2250-2750

501 Vellum glaze scenic landscape vase painted in 1919 by Ed Diers. Marks on the base include the Rookwood logo, the date, shape number 940 C, V for Vellum glaze body and the artist's monogram. Height 10½ inches. Tight ½ inch line at the rim has been professionally repaired. $1000-1500

502 Classic Arts & Crafts mat glaze charger with three seahorses, their tails entwined in seaweed, symmetrically spaced around the center of the piece, done in 1903 by Sallie Toohey. Marks on the back include the Rookwood logo, the date, shape number 678 Z and the artist's monogram. Diameter is 11 inches. $800-1000

503 Vibrant Vellum glaze vase slip painted with three repeating groups of hanging white flowers and maroon berries on a lime green ground. The symmetrical Art Nouveau style is the work of Sara Sax in 1915. Marks on the base include the Rookwood logo, the date, shape number 922 B, V for Vellum glaze body, V for Vellum glaze and the artist's monogram. Height 11¼ inches. $1750-2250

504 Iris glaze vase painted by Sara Sax, circa 1906. Decoration consists of colorful lotus blossoms, buds and pads which rise up from the bottom of the vase. Marks on the base include the Rookwood logo, the date, shape number 904 CC, W for white (Iris) glaze and the artist's monogram. Height 9⅝ inches. $3000-3500

505 High glaze pitcher with floral decoration and slightly iridescent blue, brown and gray lining, done in 1929 by Lorinda Epply. Marks on the base include the Rookwood logo, the date, shape number 13 and the artist's monogram. Height 6⅞ inches. Uncrazed. $600-800

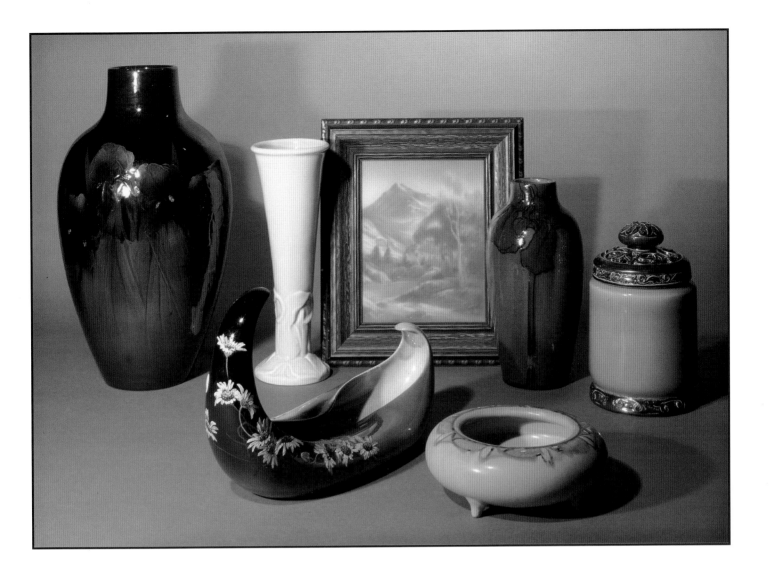

506 Monumental Standard glaze vase with nicely detailed iris decoration, done by Kataro Shirayamadani in 1900. $5000-7000
The yellow and blue irises are in full bloom and completely encircle the vase. Marks on the base include the
Rookwood logo, the date, shape number 905 A and the artist's cypher. Height 17½ inches. There are a very few
small glaze scratches.

507 Classically Victorian Standard glaze flower boat with very detailed and beautifully painted daisies, done in 1891 $800-1000
by William McDonald. Marks on the base include the Rookwood logo, the date, shape number 374, W for white
clay, L for light Standard glaze and the artist's initials. Remnants of an original Rookwood salesroom label are
still affixed to the base. Height 9 inches, length 15⅜ inches.

508 Tall Commercial vase with embossed calla lily decor, made at Rookwood in 1915. 1915 was the first year for $300-400
porcelain and porcelain compatable glazes and this is a great example of "rich, heavy, single-color glaze(s)
flowing over forms perfectly plain or enriched with subtle low relief modeling...". Marks on the base include the
Rookwood logo, the date and shape number 2010. Height 13⅛ inches. Uncrazed.

509 Clean and crisply painted Vellum glaze mountain scenic plaque done in 1929 by Fred Rothenbusch. The artist's $4000-6000
monogram appears in the lower left hand corner. Marks on the back include the Rookwood logo and the date.
Affixed to the frame is an original Rookwood paper logo and an original Rookwood paper label with the
notation, "A Peak F. Rothenbusch.". Size is 9⅝ x 7¾ inches. There are one or two small bubbles in the glaze but
the piece is uncrazed.

510 Mat glaze bowl with four small feet, carved and painted in 1920 by C.S. Todd. Marks on the base include the $400-500
Rookwood logo, the date, shape number 466 B and the artist's initials. Diameter is 8 inches.

511 Very stylish vase with flatly painted blue irises outlined in black on a green ground, done in 1904 by Albert $1500-2000
Valentien. Possibly a Standard glaze the unusual style and color make this a difficult piece to identify. The glaze
has a yellow tint but the overall effect is not typically Standard. The artwork is apparently inlaid, a small glaze
skip shows how precisely the lines of the flower stems are cut into the clay. Marks on the base include the
Rookwood logo, the date, shape number 940 C, V for Vellum glaze body, a wheel ground x and the artist's
initials. Height 11⅛ inches. There are some small burst glaze bubbles in the blue flowers, minor grinding chips
on the base and glaze skips on the flower stems.

512 Rookwood Commercial humidor in gloss green and mirror brown glazes, made in 1926. Marks on the base $400-600
include the Rookwood logo, the date and shape number 2622. Height 9⅜ inches. A very complex design, the
gloss green glaze is visible below the open fretwork on the lid which is done in the mirror brown.

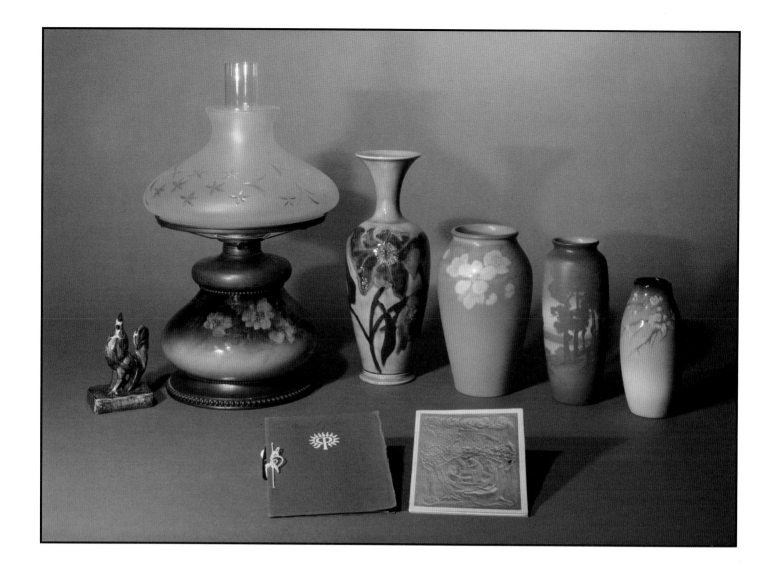

513 Polychromed high glaze rooster paperweight, done in 1946, most likely by a Junior Decorator. Marks on the base include the Rookwood logo, the date, shape number 6030 and in black slip, the number 68 W and an artist's monogram which appears to be HE. Height 5 inches. — $300-400

514 Unusual Standard glaze lamp decorated with wild roses by Lenore Asbury in 1899. Marks on the base include the Rookwood logo, the date, shape number S 1209 and the artist's initials. Height of the ceramic portion only is 4⅝ inches. This is an original lamp with a cast hole in the base and old fittings. Originally an oil lamp, it has been converted to electricity but could be returned to its first use. The shade is most likely recent. — $1500-2000

515 Rare Rookwood advertising booklet from 1904, one of only two dated publications issued by Rookwood. The "1904" catalog was an attempt to sell Rookwood by mailorder. Orders for similar pieces could be ordered on a trial basis from anywhere in the country. This booklet is blindstamped with the Rookwood logo on its cover and contains 36 pages and shows some 102 examples, 13 in color. Only a handful of these have survived in their 90 years of existence. This one is in excellent shape. Size is 7 x 5¾ inches. — $400-500

516 Tall high glaze vase with bright red flowers and green leaves in heavy slip, painted in 1944 by Loretta Holtkamp. Marks on the base include the Rookwood logo, the date, shape number 216, and the artist's monogram. Height 13⅜ inches. — $600-800

517 Rare Rookwood advertising booklet in black and white made circa 1895. Inside are photos of 37 pieces of Rookwood, mostly Standard glaze, with descriptions of glaze lines, comments on Rookwood by newspaper writers and ceramics experts and a listing of artist's signatures. Interesting are listings for Rookwood's new glazes, Sea Green, Aerial Blue and Iris which help date the booklet. Size is 6⅝ x 5¼ inches. Excellent original condition. — $200-300

518 Beautifully conceived and painted Vellum glaze vase with white apple blossom decoration, done in 1930 by Ed Diers. The artwork is very precise and the condition of the vase is pristine. Marks on the base include the Rookwood logo, the date, shape number 913 C, V for Vellum glaze and the artist's monogram. Height 9¼ inches. Uncrazed. — $2500-3000

519 Colorful Vellum glaze scenic vase, painted in 1918 by Sallie Coyne. Marks on the base include the Rookwood logo, the date, an obscured shape number, a wheel ground x and the artist's monogram. Height 9 inches. Glaze losses aground the rim account for the x and have been professionally repaired. The piece has also been drilled. — $700-900

520 Pretty Iris glaze vase with trailing apple blossom decoration, done in an oriental manner in 1910 by C.S. Todd, probably in his very first year at Rookwood. Marks on the base include the Rookwood logo, the date, shape number 939 D, W for white (Iris) glaze and the artist's initials. Height 7⅛ inches. — $1500-1700

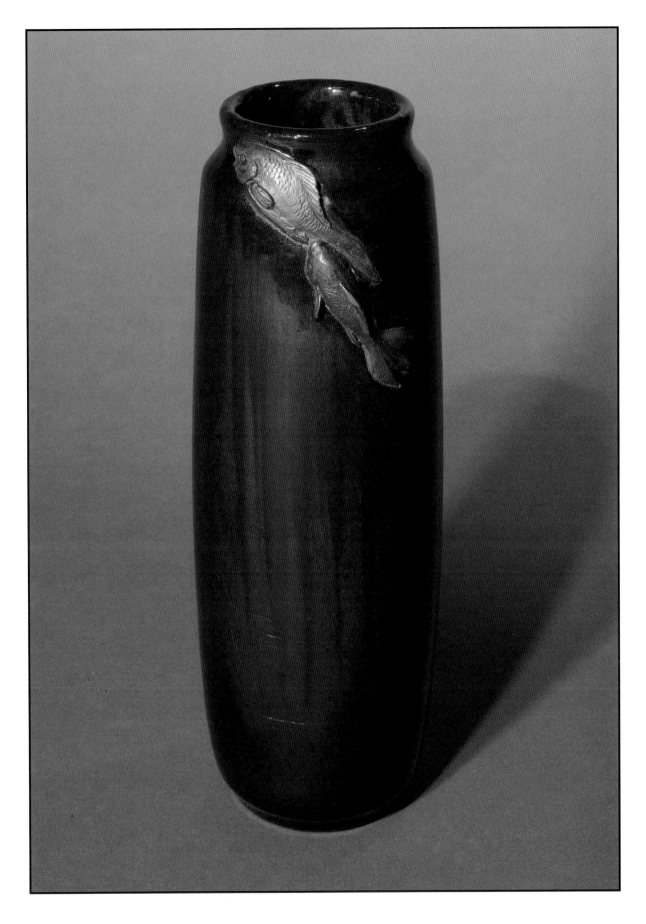

521 Rare and important Standard glaze vase with extensive Tiger Eye effect, most likely the work of Kataro $12500-17500
 Shirayamadani, made at Rookwood in 1898. Decoration consists of two extremely detailed, carved and
 electroplated fish swimming toward the rim and several other incised fish, swimming through the Tiger Eye glaze
 on the lower half of the body. Marks on the base include the Rookwood logo, the date and shape number S 1363.
 Heavy glaze obscures other marks but the style and quality of decoration point assuredly toward Shirayamadani.
 A similar example by the artist is lot 1112 of the Glover Collection Auction. Height 8⅜ inches. Exhibited and
 illustrated as item 24 in "Rookwood Pottery The Glorious Gamble" Anita J. Ellis, Cincinnati Art Museum, 1992-
 1993, catalog published by Rizzoli in 1992 (color plate, page 89).

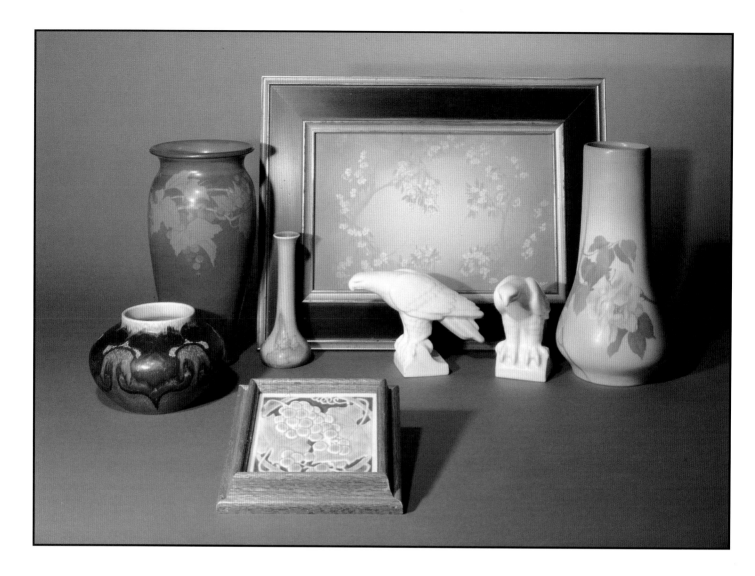

522 Brightly colored vase with repeating floral designs done in rich, thick mat glazes by C.S. Todd in 1922. Marks on the base include the Rookwood logo, the date, shape 1929 and the artist's initials. Height 4½ inches. $600-800

523 Tall and handsome Vellum glaze vase with crisply painted vines, leaves and multicolored berries all outlined in black, done in 1926 by Lenore Asbury. The interior is lined in a medium purple glaze. Marks on the base include the Rookwood logo, the date, shape number 2786, V for Vellum glaze and the artist's initials. Height 11¼ inches. Neatly drilled through the bottom but uncrazed. $2000-2500

524 Polychromed Commercial Vellum glaze trivet with red grapes and green leaves, made at Rookwood in 1929. Marks on the back include the Rookwood logo, the date and shape number 1683. Size is 5⅝ x 5⅝ inches. Uncrazed and recently framed. $300-400

525 Mat glaze bud vase with floral decoration painted by Sallie Coyne in 1931. Marks on the base include the Rookwood logo, the date, shape number 2309, a fan shaped esoteric mark and the artist's monogram. Height 7 inches. $250-350

526 Unusual plaque, most likely unglazed and in biscuit form, having apple blossom decoration painted by E.T. Hurley in 1920. The artist's initials and the date appear in the lower right hand corner. Marks on the back include the Rookwood logo and the date. Incised twice on the top edge of the plaque is the number "678". There are several firing cracks at the edges of the plaque, the most serious extending about two inches into the decoration. Glazing was most likely withheld because of the flaws, giving us a rare glimpse at underglaze decorating techniques and different look for a Rookwood plaque. Size is 9⅛ x 14½ inches. $2000-2500

527 Art Deco eagle bookends made at Rookwood in 1945 and covered with a white mat glaze. Marks on the base include the Rookwood logo, the date, shape number 6491 and the cast in monogram of designer Louise Abel. Height 5⅜ inches. A small corner chip to the base of one piece has been professionally repaired. $300-400

528 Tall and early Vellum glaze vase with white rose decoration by Ed Diers, painted in 1908. Marks on the base include the Rookwood logo, the date, shape number 1278 C, V for Vellum glaze body, V for Vellum glaze and the artist's monogram. Height 12¼ inches. There are several very tight and stable firing separations, especially in the lower portion of the vase, one of which has been professionally covered. $800-1000

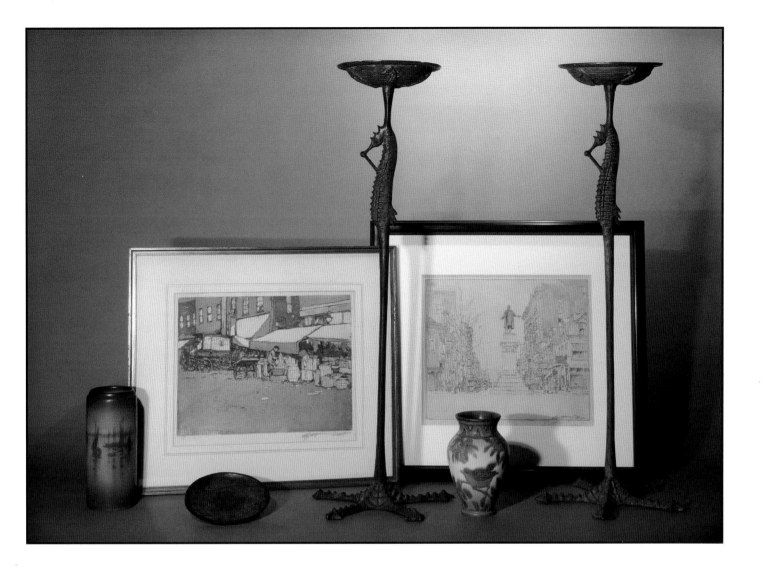

529 Vellum glaze harbor scene vase painted by E.T. Hurley in 1908. The twilight scene pictures fishing boats in a small bay. Marks on the base include the Rookwood logo, the date, shape number 952 E, V for Vellum glaze, V for Vellum glaze body and the artist's initials. Height 7½ inches. $1500-2000

530 Hand colored etching and aquatint printed by E.T. Hurley in 1920. Titled, "6th Street Market", the original plate was etched by Hurley in 1915, this print being number 8 of 50. Signed, dated and numbered in pencil in the margin. Hurley made dozens of etchings of Cincinnati scenes in addition to his work at Rookwood and his bronze work. Only a small number were hand colored and each are colored in a different manner. Image size is 10 x 12 inches. Excellent original condition. $400-600

531 E.T. Hurley bronze ashtray with fish swimming in a circular pattern made in Cincinnati circa 1925. The back is marked with Hurley's initials. Diameter is 5½ inches. Cleaned patina. $200-300

532 Hurley Bronze standing seahorse ashtray, made by E.T. Hurley circa 1925. The starfish base is marked "ETH" and "1925" and the underside of the top has seahorses radiating out from the center. Height 28⅛ inches. Hurley began working in bronze about 1905 and continued for at least 30 years producing dozens of objects, generally incorporating sea creatures into the design. Although made in quantity, Hurley Bronzes are never plentiful. Excellent original condition and patina. $1250-1500

533 Handsome hand colored etching made by E.T. Hurley in 1915. The scene is of President Garfield's statue on 8th Street in downtown Cincinnati. Signed in the plate and in pencil in the margin, "E.T. Hurley 1915-". Image size is 10 x 12 inches. Minor light staining but otherwise in very fine condition. $400-600

534 Colorful and clean mat glaze vase showing a bluebird perched in a flowering tree, painted in 1933 by E.T. Hurley. A geometric band encircles the neck and the interior is lined with a mottled brown glaze. Marks on the base include the Rookwood logo, the date, S for Special shape and the artist's initials. Height 6⅛ inches. Uncrazed. $1000-1250

535 Hurley Bronze standing seahorse ashtray, made by E.T. Hurley circa 1925. The starfish base is marked "ETH" and "1925" and the underside of the top has seahorses radiating out from the center. Height 28¾ inches. Excellent original condition and patina. $1250-1500

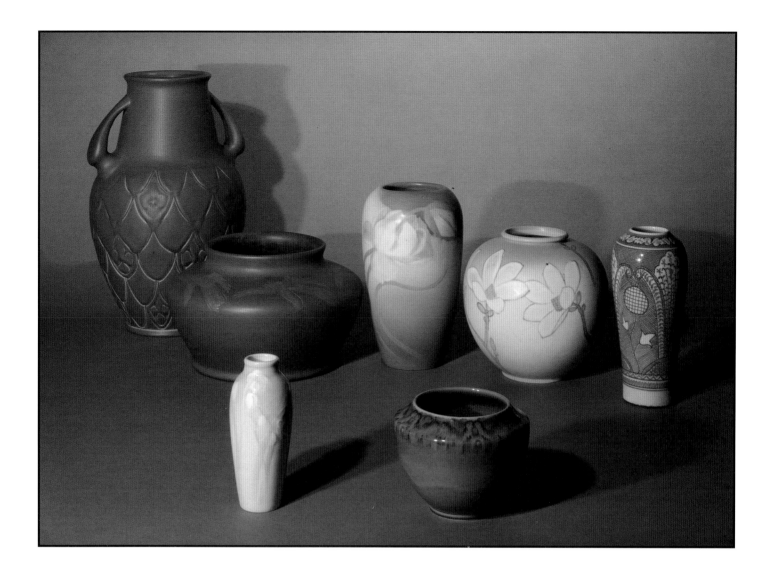

536 Large Rookwood Commercial vase with two handles, having embossed floral designs, made in 1916. Marks on $400-600
the base include the Rookwood logo, the date and shape number 339 B. Height 14⅜ inches. Small firing line
where one handle attaches is all but invisible.

537 Broad mat glaze vase with five incised and painted birds in green on a reddish ground, done in 1911 by William $700-900
Hentschel. Marks on the base include the Rookwood logo, the date, shape number 1393, V for Vellum glaze
body and the artist's monogram. Height 6⅛ inches.

538 Iris glaze vase with delicate floral decoration done in 1901 by Sara Sax. Marks on the base include the Rookwood $500-700
logo, the date, shape number 918, W for white (Iris) glaze and the artist's monogram. Height 5⅝ inches. Overall
even crazing.

539 Nicely detailed and very colorful Vellum glaze vase with lotus decoration, painted circa 1908 by Ed Diers. Marks $1000-1200
on the base include the Rookwood logo, the date, a shape number which appears to be 1126 C, V for Vellum
glaze, V for Vellum glaze and the artist's monogram. Height 9 inches. The vase is drilled but the shape is listed as
a lamp base by Rookwood.

540 Black Opal glazed vase with floral decor at the rim, done in 1924 by Sara Sax. Marks on the base include the $700-900
Rookwood logo, the date, shape number 1927 and the artist's monogram. Height 4 inches. Uncrazed.

541 Vellum glaze vase with slightly stylized magnolia blossoms painted in 1945 by Kataro Shirayamadani. Marks on $1250-1750
the base include the Rookwood logo, the date, shape number 6204 C, the number "6220" incised and the artist's
initials. Height 7⅛ inches. Uncrazed.

542 Exotic high glaze vase with what appears to be Islamic style decoration, done in 1920 by William Hentschel. $600-800
Marks on the base include the Rookwood logo, the date, shape number 2033 E, a wheel ground x and the artist's
monogram. Height 8⅛ inches. Very minor glaze dimples.

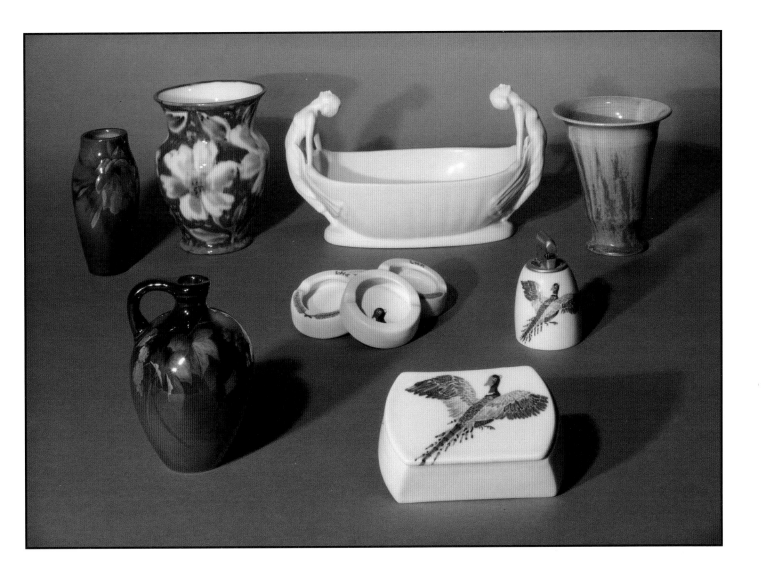

543 Sea Green vase with floral decoration painted in 1899 by Fred Rothenbusch. Marks on the base include the $1500-2000
Rookwood logo, the date, shape number 30, G for Sea Green glaze, several numbers in red paint, possibly
Cincinnati Art Museum acquisition numbers and the artist's monogram. Height 6 inches. Very little crazing.

544 Standard glaze whiskey jug with hops decoration, done in 1896 by Josephine Zettel. Marks on the base include $400-500
the Rookwood logo, the date, shape number 767 and the artist's monogram. Height 5⅝ inches.

545 Very pretty high glaze vase with overall floral decoration by Jens Jensen, painted in 1943. Marks on the base $1000-1500
include the Rookwood logo, the date, shape number 6406 and the artist's monogram. Height 7 inches. Uncrazed.

546 Unusual six piece smoking set with pheasant decoration, painted in 1945, 1946 and 1950 by Lois Furukawa and $800-1200
Loretta Holtkamp. The set consists of a lighter, cigarette box with lid and four ashtrays. Marks on the bases
include the Rookwood logo, the dates, shape numbers 6922, 6922 A, 6922 B and the artists' monograms.
Holtkamp decorated two of the ashtrays and Furukawa the rest. All of the pieces bear the notation, "L-H-K" either
on the bottom of the piece or the exterior. We can only assume the initials belong to the person for whom the
pieces were made and that the owner commissioned the pieces over a period of five years. The lighter is the
tallest piece at 3¼ inches and seems to be in working order.

547 Commercial bowl designed by Shirayamadani and Louise Abel and made at Rookwood in 1946. At each end of $400-600
the bowl are nude figures leaning backward toward each other. Marks on the base include the Rookwood logo,
the date, shape number 2923 and the cast in monogram of Louise Abel. Height 6⅞ inches.

548 Unusual "1932" vase done in crystalline brown over mustard glazes. Marks on the base include the Rookwood $175-225
logo, the date and S for Special shape. Height 6⅛ inches.

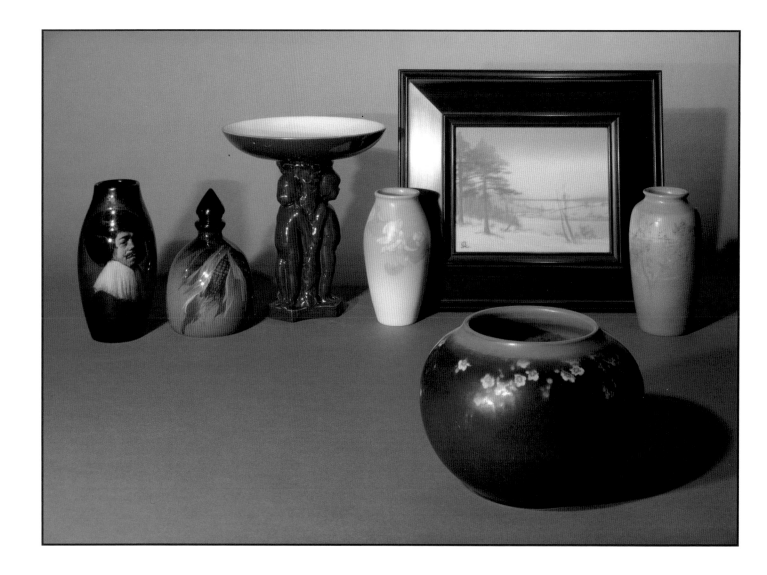

549 Standard glaze vase with the portrait of a cavalier painted in 1903 by Grace Young. Marks on the base include the Rookwood logo, the date, shape number 939 C, the notation, "-after Franz Hals-" and the artist's monogram. Height 8 inches. Small flat chip on base. $1000-1500

550 Standard glaze stoppered whiskey jug with corn decoration, done in 1902 by Howard Altman. Marks on the base include the Rookwood logo, the date, shape number 747 C and the artist's monogram. Height 7¼ inches. $500-700

551 Richly glazed Commercial compote supported by three putti, made at Rookwood in 1921. The lower portion is covered in deep purple while the bowl is lined in bright yellow. Marks on the base include the Rookwood logo, the date and shape number 2440. Height 10½ inches. $400-500

552 Vellum glaze vase with colorful floral decoration painted in 1928 by Fred Rothenbusch. Marks on the base include the Rookwood logo, the date, shape number 925 E, V for Vellum glaze and the artist's monogram. Height 7⅛ inches. Uncrazed. $800-1200

553 Arts & Crafts Vellum glaze scenic plaque painted by Sallie Coyne in 1917. The winter landscape features a frozen lake and pine trees and is signed in the lower left hand corner by Coyne. Marks on the back include the Rookwood logo, the date and V for Vellum glaze body. Size is 7¼ x 9⅛ inches. Small glaze losses on two edges of the plaque are easily covered by the new frame. $2500-3000

554 Vellum glaze bowl with fruit blossoms encircling the shoulder, done in 1916 by Charles McLaughlin. Marks on the base include the Rookwood logo, the date, shape number 1375, V for Vellum glaze body and the artist's monogram. Height 6⅛ inches. Small and very tight spider crack in bottom which does not go through and which does not come near the side of the bowl. $400-500

555 Vellum glaze scenic vase with red flowering trees in the foreground, painted in 1914 by Charles McLaughlin. Marks on the base include the Rookwood logo, the date, shape number 922 D, V for Vellum glaze and the artist's monogram. Height 7⅜ inches. $800-1000

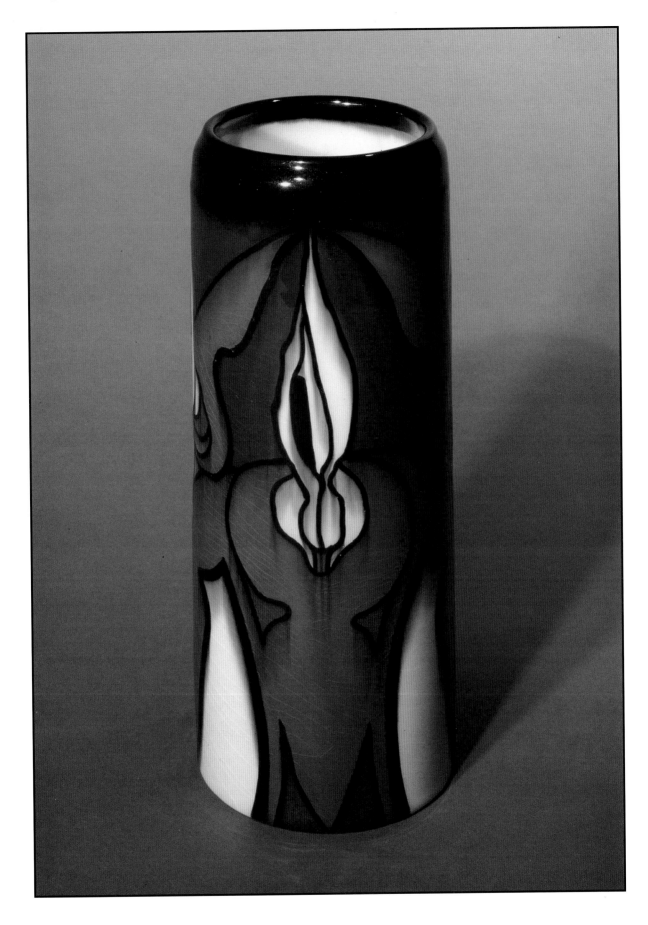

556 Rare and important Iris glaze vase done by John Dee Wareham in 1907. Four highly stylized orchids circle the $12500-15000
vase, done in black, cobalt blue, tan and light yellow with the white clay body used as a fifth color. Wareham has
fashioned a most remarkable bit of magic which presages the work of Georgia O"Keeffe by 20 years. Marks on
the base include the Rookwood logo, the date, shape number 952 C and the artist's monogram. Height 10¼
inches. Minor glaze scratches.

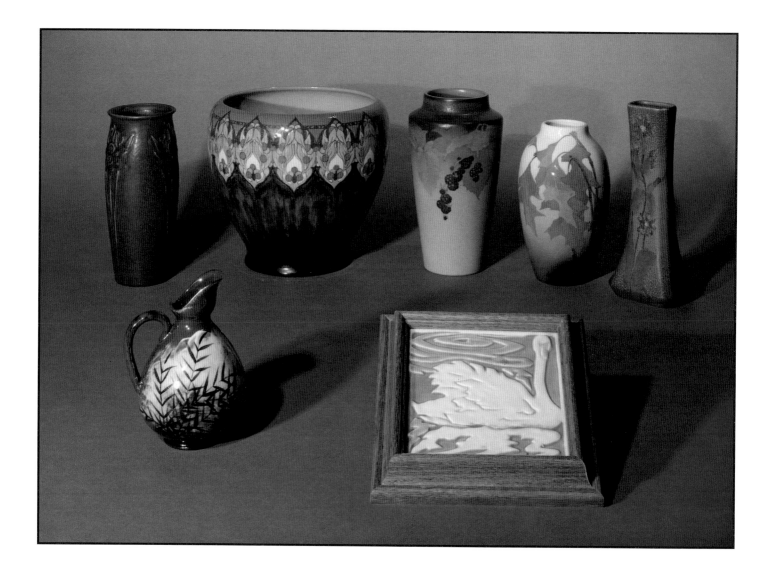

557 Unusual Rookwood Commercial vase with embossed iris designs covered with a striking purple over blue mat glaze. Marks on the base include the Rookwood logo, the date and shape number 2476. Height 8¼ inches. Small grinding chip on base. $200-300

558 Limoges style pitcher decorated with grasses against a cloudy sky by William McDonald in 1883. The rim is trimmed with fired on gold. Marks on the base include Rookwood in block letters, the date, shape number 1 R for red clay, an impressed anchor and the artist's initials. Height 5¼ inches. $350-450

559 Rare and unusual high glaze vase with elaborate repeating leaf and berry designs encircling the upper half of the body, done in 1920 by Sara Sax. Marks on the base include the Rookwood logo, the date, shape number 2466, a wheel ground x and the artist's monogram. Height 8¼ inches. There are some glaze runs in the dark blue coloring on the lower portion of the piece. $3000-4000

560 Vellum glaze vase with nicely detailed blackberry decor, painted in 1926 by Fred Rothenbusch. Marks on the base include the Rookwood logo, the date, shape number 1918, V for Vellum glaze, a wheel ground x and the artist's monogram. Height 8¾ inches. Uncrazed with even glaze burn around the collar. $700-900

561 Vellum glaze trivet with a swimming white swan, done at Rookwood in 1924. Marks on the back include the Rookwood logo, the date and shape number 3202. Size is 5⅝ x 5⅝ inches. Minor glaze pitting. Uncrazed and recently framed. $300-400

562 Iris glaze vase with colorful reddish-brown oak leaves on a black to coral to white background, painted in 1904 by Sara Sax. Marks on the base include the Rookwood logo, the date, shape number 900 C, an incised W for white (Iris) glaze and the artist's monogram. Height 7⅝ inches. $2500-3000

563 Mat glaze vase with overall floral decoration painted in 1923 by Louise Abel. Marks on the base include the Rookwood logo, the date, shape number 697 and the artist's monogram in brown slip. Height 9⅛ inches. $300-400

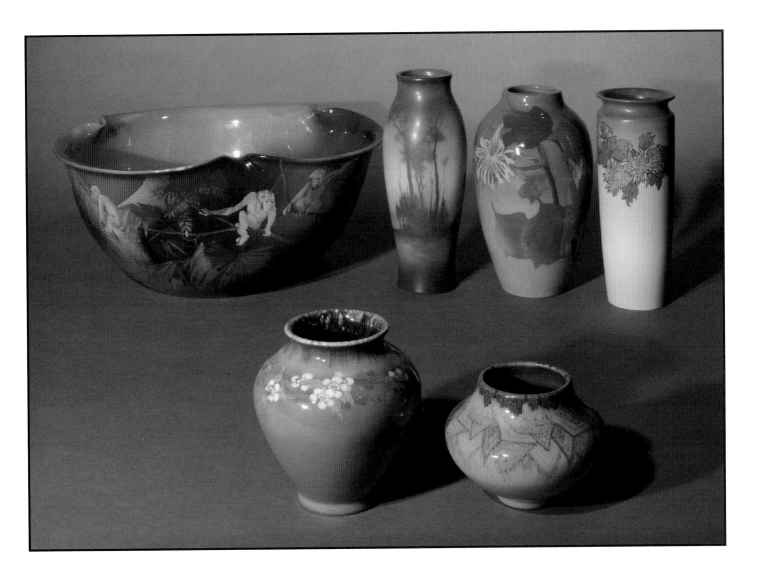

564 Rare and large Standard glaze punch bowl with an unusual scene of seven apes climbing trees and swinging on vines, painted in 1893 by Bruce Horsfall. The primates seem to be very happy and pleasant since they are all smiling. The base is marked with the Rookwood logo, the date, shape number 163 B, W for white clay and the artist's monogram. Height 7⅛ inches, largest distance across is 16¾ inches. There is a tight diagonal ½ inch rim bruise and minor glaze scratches. The interior of the bowl has a fair number of scratches, most likely from being used. No monkey business here. $4000-6000

565 Pretty yellow tinted high glaze vase with fruit blossoms encircling the shoulder, painted in 1925 by Sara Sax. The interior is glazed with a mottled gray. Marks on the base include the Rookwood logo, the date, shape number 2831 and the artist's monogram. Height 5½ inches. Uncrazed. $1000-1250

566 Very crisp and clean Vellum glaze scenic vase, painted in 1917 by Lenore Asbury. Marks on the base include the Rookwood logo, the date, shape number 937 and the artist's initials. Height 10¼ inches. Few Vellum glaze pieces prior to 1921 are uncrazed, as is this one. $2000-2500

567 Unusual and colorful yellow tinted high glaze vase with layers of geometric shapes laid one on top of the other, done in 1930 by Sara Sax. The interior is glazed with a mottled pink and black that spills over the rim. Marks on the base include the Rookwood logo, the date, shape number 1944, a fan shaped esoteric mark and the artist's monogram. Height 3¾ inches. Uncrazed. $700-900

568 Striking Iris glaze vase with colorful Tulip Poplar flowers, branches and leaves, done in 1903 by Sara Sax. Marks on the base include the Rookwood logo, the date, shape number 900 B, W for white (Iris) glaze, a wheel ground x and the artist's monogram. Height 9½ inches. $5000-7000

569 Nicely detailed Vellum glaze vase with chrysanthemum decoration, all outlined in black, painted by Ed Diers in 1918. Marks on the base include the Rookwood logo, the date, shape number 1882 and the artist's monogram. Height 9½ inches. $1750-2250

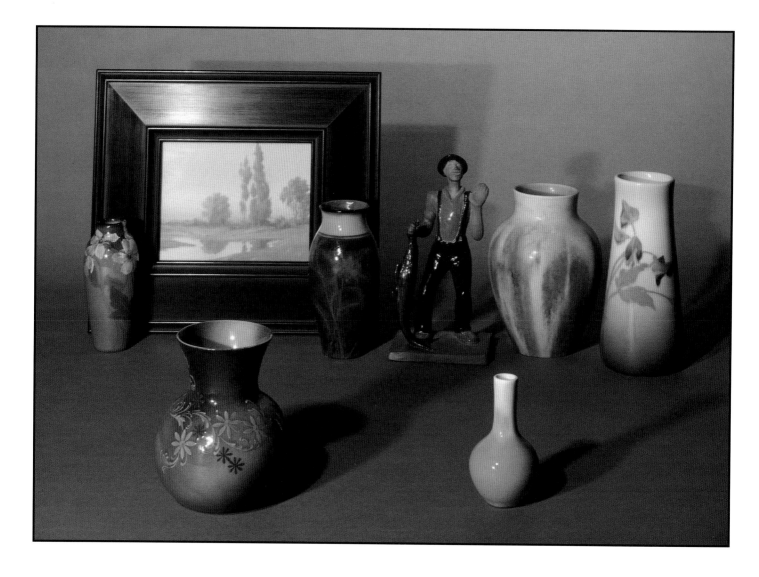

570 Standard glaze vase with pretty yellow flowers painted by Alice Willitts in 1905. Marks on the base include the Rookwood logo, the date, shape number 918 E and the artist's monogram. Height 5⅝ inches. $300-400

571 Vellum glaze scenic plaque showing trees reflected in a small pond, done in 1920 by Ed Diers. The artist's monogram appears in the lower right hand corner. Marks on the back include the Rookwood logo and the date. Penciled on the back is the notation, "Tall Sycamore by Ed Diers" which may have been the original title. Size is 5⅞ x 7⅞. Glaze losses at the top and left hand edge extend into the image about ½ inch but are neatly covered by a new frame. $1250-1750

572 Standard glaze vase with stylized floral decoration painted in 1888 by Albert Valentien. A small version of lot 498 from "Rookwood Pottery the Glorious Gamble", this piece is marked with the Rookwood logo, the date, shape number 402, S for sage green clay, L for light Standard glaze and the artist's initials. Height 5½ inches. $400-500

573 High glaze vase with floral decoration painted in 1922 by Kataro Shirayamadani. Marks on the base include the Rookwood logo, the date, shape number 356 E and the artist's cypher. Height 6½ inches. An excess of air bubbles in the glaze tend to obscure the decoration. $400-600

574 Rare and unusual Commercial fisherman figure designed by J. Reich and made at Rookwood in 1942. Only the fisherman's clothes and the fish are glazed. The plinth on which he stands and his hands and face are left in the biscuit state. Marks on the base include the Rookwood logo, the date, shape number 6808, a wheel ground x and the designer's name. Height 8⅞ inches. $800-1000

575 Slightly crystalline "1932" glaze vase in shades of blue and yellow, made at Rookwood in 1930. Marks on the base include the Rookwood logo, the date, shape number 2587 F and a fan shaped esoteric mark. Height 4⅛ inches. $150-200

576 Mat glaze vase with abstract but colorful decoration, painted in 1931 by Jens Jensen. Marks on the base include the Rookwood logo, the date, shape number 927 E, a wheel ground x and the artist's monogram. Height 7⅛ inches. $400-600

577 Crisp and clean Iris glaze vase with beautifully painted sweet pea decoration, done in 1906 by Lenore Asbury. Marks on the base include the Rookwood logo, the date, shape number 950 D, W for white (Iris) glaze and the artist's initials. Height 8¼ inches. Very little crazing. $2500-3000

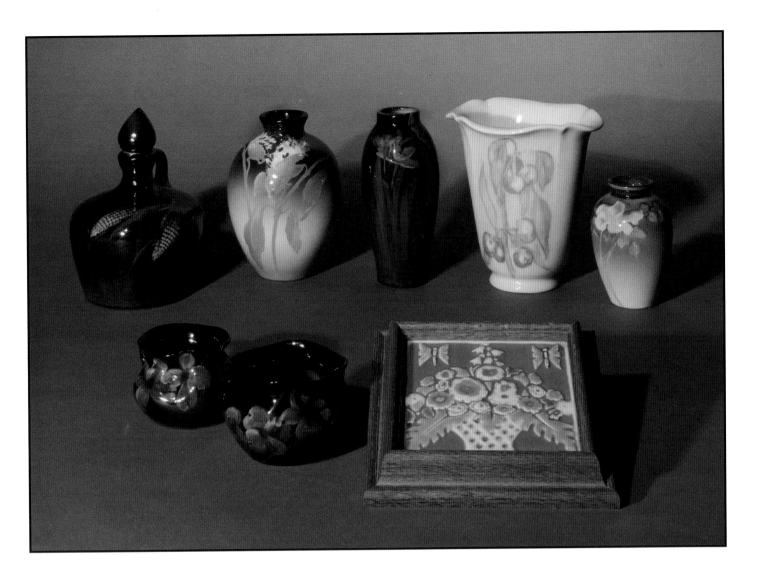

578 Standard glaze stoppered whiskey jug with corn decoration by Ed Diers, painted in 1898. Marks on the base include the Rookwood logo, the date, shape number 676 and the artist's monogram. Height 7½ inches. $600-800

579 Standard glaze creamer and sugar bowl with dogwood decoration by Jeannette Swing, painted in 1900. Marks on the two pieces include the Rookwood logo, the date, shape number 330 and the artist's monogram. Height of the sugar bowl is 2⅞ inches and the creamer is 2½ inches. $400-500

580 Iris glaze vase with nicely detailed milkweed decoration, done in 1906 by Irene Bishop. Marks on the base include the Rookwood logo, the date, shape number 902 D, W for white (Iris) glaze and the artist's monogram. Height 6⅞ inches. $1250-1750

581 Sea Green glaze vase with yellow daffodils on a deep blue ground, done by Sallie Coyne in 1902. Marks on the base include the Rookwood logo, the date, shape number 901 D, G for Sea Green glaze and the artist's monogram. Height 7⅛ inches. $1500-2000

582 Multicolored Vellum glaze trivet with flower basket and butterfly decoration, made at Rookwood in 1928. Marks on the back include the Rookwood logo, the date and shape number 3206. Size is 5⅝ x 5⅝ inches. Very minor glaze pitting. Uncrazed and recently framed. $300-400

583 High glaze flared vase with cherry decoration on two sides, done in 1946 by Clotilda Zanetta. Marks on the base include the Rookwood logo, the date, shape number 6314, the number "9014" in brown slip and the artist's monogram, also in brown slip. Height 7⅛ inches. Uncrazed. Exhibited: "Rookwood Pottery" The Yuma Art Center, 1978, catalog number 105, illustrated. $400-500

584 Iris glaze vase with delicate pink wild roses against a blue ground, done in 1901 by Ed Diers. Marks on the base include the Rookwood logo, the date, shape number 605, W for white (Iris) glaze and the artist's monogram. Height 4⅞ inches. $500-700

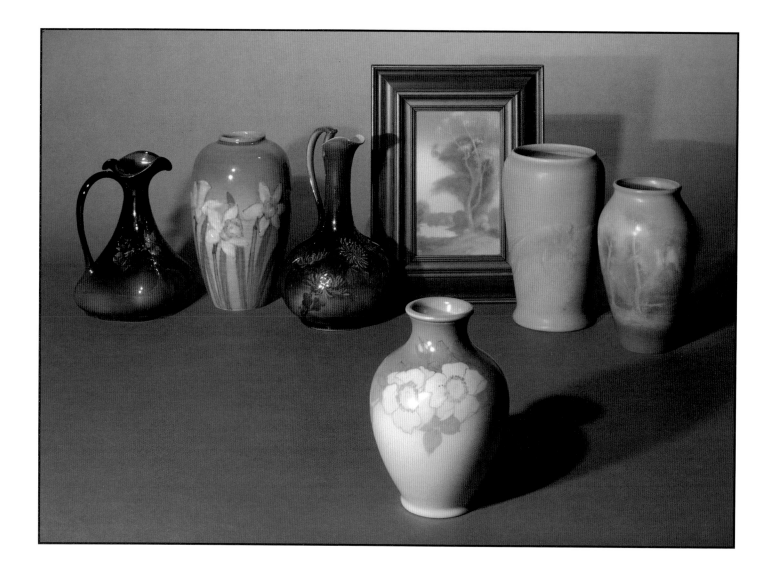

585 Standard glaze ewer with red floral decoration painted in 1895 by Lenore Asbury. Marks on the base include the Rookwood logo, the date, shape number 740, a partial paper label from a Chicago retailer and the artist's initials. Height 8⅛ inches. There are some burst glaze bubbles where the handle attaches to the top and some minor glaze scratches. — $400-600

586 Showy high glaze vase with colorful jonquils on a purple ground, painted in 1944 by Kataro Shirayamadani. Marks on the base include the Rookwood logo, the date, shape number 6869 and the artist's initials. Height 8¾ inches. — $2000-2500

587 Nicely painted Standard glaze ewer with chrysanthemum decoration by Anna Valentien, done in 1889. Marks on the base include the Rookwood logo, the date, shape number 462, S for sage green clay, L for light Standard glaze and the artist's initials. Height 9⅛ inches. There are some very minor glaze imperfections. — $700-900

588 Vellum glaze vase with detailed wild rose decoration, painted in 1928 by Ed Diers. Marks on the base include the Rookwood logo, the date, shape number 2918 E, V for Vellum glaze, a wheel ground x and the artist's monogram. Height 6¾ inches. Uncrazed. — $700-900

589 Colorful and crisp Vellum glaze scenic plaque painted in 1926 by Fred Rothenbusch. The artist's monogram appears in the lower left hand corner. Marks on the back include the Rookwood logo and the date. Affixed to the frame is an original Rookwood paper logo and an original Rookwood paper label with the title, "Path to the River, F. Rothenbusch." Size is 7⅞ x 5 inches. Uncrazed and in its original frame. — $2000-3000

590 Unusual carved mat glaze vase showing a fish swimming through seaweed done in 1912 by William Hentschel. The fish appears to be blowing bubbles as it swims. Marks on the base include the Rookwood logo, the date, shape number 1661, a wheel ground x and the artist's monogram. Height 8⅝ inches. — $800-1200

591 Very clean and pleasant scenic Vellum glaze vase painted in 1937 by Fred Rothenbusch. Typical of Rothenbusch, the vase shows nice composition and great color but is a rare late 30's example. Marks on the base include the Rookwood logo, the date, shape number 913 D, V for Vellum glaze and the artist's monogram. Height 7¾ inches. Uncrazed. — $2000-2500

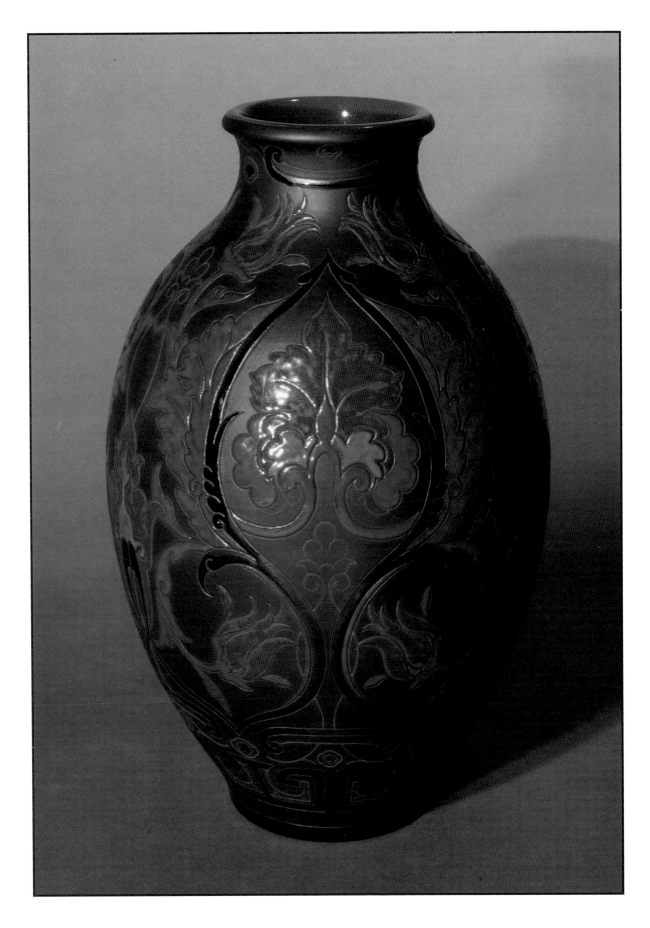

592 Rare and very important French Red vase decorated in 1923 by Sara Sax. A rare glaze line, French Red was aptly $30000-40000
 named by Jack Kircher in 1969 in his early work on Rookwood done in conjunction with Joseph and Barbara
 Agranoff. The rich red color was slip imported from France and used infrequently because of its cost. Only a
 handful of French Red pieces have surfaced, most done by Sax with the best being very complicated and
 innovative Art Deco or Arts & Crafts designs in mat and gloss glazes. This example is perhaps the Magnum Opus
 of French Red, being at once the largest example to employ intricate incised and enameled glazes over a dull
 finish ground and easily the most complex. The pattern of tulips and lilies repeats three times around the vase
 with Greek key designs around the base. Each area of color is first outlined by incising in the wet clay and the
 rich colors are then applied in heavy slip. Several other areas of decoration are simply incised. The rich French
 red color is used on many of the flowers and as a lining for the vases interior. Marks on the base include the
 Rookwood logo, the date, shape number 2246 C and the artist's monogram. Height 14⅛ inches. Uncrazed and
 extremely clean.

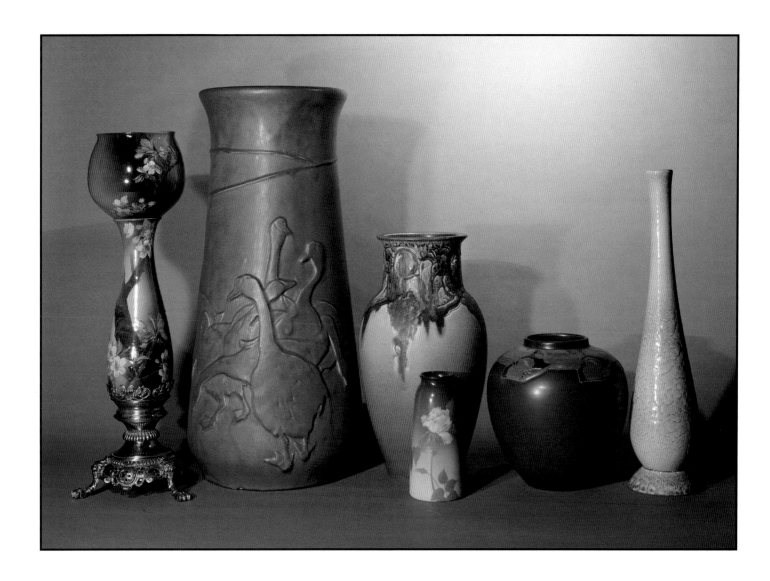

593 Rare and beautifully decorated Standard glaze oil lamp painted by an unknown artist in 1894. The two Standard glaze parts are held together with a long bolt that also secures the original brass fittings. Decoration consists of highly detailed fruit blossoms, leaves, stems and large limbs. Marks on the base of the bottom section include the Rookwood logo, the date and shape number 702. No artist's signature has been found. Height of ceramic portion only is approximately 18 inches. The original cap is missing its font and burner and though available is not pictured on the lamp. A tight line in the back of the top section has been professionally repaired. $1000-1500

594 Commercial umbrella stand, actually a product of Rookwood's Architectural Faience department, made in 1905 and decorated with embossed geese under a green mat glaze. Marks on the base include the Rookwood logo and date impressed three times, shape number 1235 AY and the number "12". Height 26⅛ inches. Excellent original condition. $1000-1500

595 Tall mat glaze vase with deeply carved fruit decoration, done in 1917 by C.S. Todd. Repeating apples, leaves, grapes and grape vines encircle the shoulder and are covered with interesting glazes. Marks on the base include the Rookwood logo, the date, shape number 324 and the artist's initials. Height 16¼ inches. Minor glaze skips on the top of the rim. $2500-3000

596 Iris glaze vase with a nicely detailed single white rose painted in 1909 by Ed Diers. Marks on the base include the Rookwood logo, the date, shape number 1658 E, W for white (Iris) glaze, a wheel ground x and the artist's monogram. Height 7⅝ inches. Glaze skips at the rim account for the "x" and have been professionally repaired. $800-1000

597 Deeply carved Vellum glaze vase done in 1914 by Sara Sax. The shoulder of the piece is encircled with carved, incised and painted Buckeye leaves, stems and pods underscored with a angular border. Marks on the base include the Rookwood logo, the date, shape number 531, V for Vellum glaze body, V for Vellum glaze and the artist's monogram. Height 9½ inches. There are one or two small glaze bubbles in the solid blue lower portion of the vase. The Buckeye is Ohio's state tree. $1250-1750

598 Very tall Commercial vase made at Rookwood in 1965 and covered with what may be Mustard Seed glaze. Marks on the base include the Rookwood logo, the date, shape number 7204, an impressed R for "Registered" and the notation, "Rookwood Pottery Starkville Miss.". Height 20⅝ inches. This is one of Rookwood's last products and near the end of the shape record list. It is also a classic "50's Modern" shape and color. $500-700

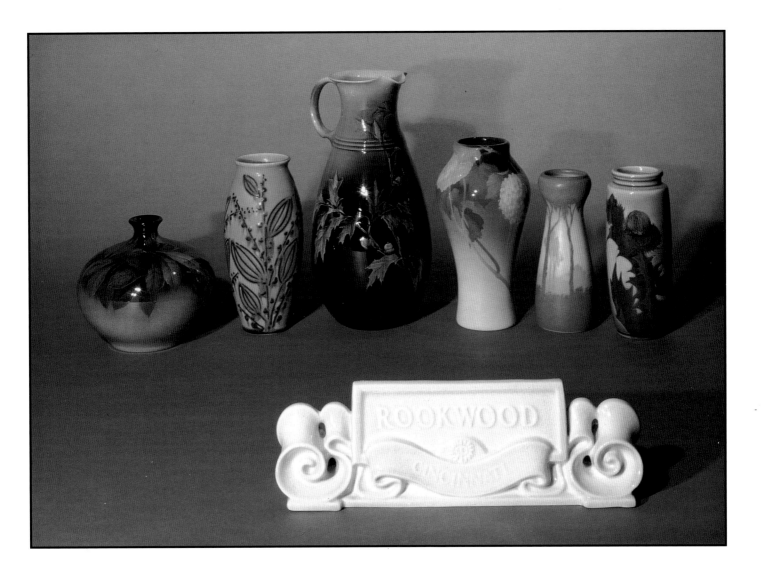

599 Handsome Standard glaze vase decorated with overlapping green leaves on its upper half, done in 1898 by Mary Nourse. Marks on the base include the Rookwood logo, the date, shape number 762 C, L for light Standard glaze and the artist's initials. Height 5⅝ inches. $600-800

600 Stylish Art Deco floral vase with slip trail outlining and a blue crystalline mat glaze for the color of the leaves, done in 1928 by Elizabeth Barrett. Marks on the base include the Rookwood logo, the date, shape number 233 and the artist's monogram. Height 8⅛ inches. $500-700

601 Tall Standard glaze pitcher decorated by Albert Valentien in 1891 with oak leaves and acorns. Marks on the base, all incised, include the Rookwood logo, the date, shape number 567, W for white clay and the artist's initials. Height 12⅛ inches. There are one or two small bubbles and scratches in the glaze. We have seen a small number of similar Rookwood pieces with all the marks incised on the base, presumably by the artist. One theory suggests the pieces were made after hours, for personal use and not stamped with the typical marks. $1000-1250

602 Rookwood high glaze double sided advertising sign made in 1947. Marks on the base include the Rookwood logo, the date, shape number 2788 and the incised number "5". Size is 3¾ x 13 inches. $1000-1250

603 Nicely painted Iris glaze vase with hydrangea decoration, done in 1902 by Fred Rothenbusch. Marks on the base include the Rookwood logo, the date, shape number 900 C, a wheel ground x, an incised W for white (Iris) glaze and the artist's monogram. Height 8⅝ inches. Two small glaze runs on the back side account for the "x". $800-1200

604 Handsome Arts & Crafts style Vellum glaze scenic vase with soft background of trees framed by the silhouettes of trees in the foreground, painted circa 1910 by Lenore Asbury. Marks on the base include the Rookwood logo, the date, shape number 1656 E, V for Vellum glaze body, V for Vellum glaze and the artist's initials. Height 7¼ inches. Two tight cracks descend from the rim. $1000-1250

605 Sea Green vase with red thistle decoration in slight relief, done in 1901 by Rose Fechheimer. Marks on the base include the Rookwood logo, the date, shape number 589 F, G for Sea Green glaze, a wheel ground x and the artist's monogram. Height 7⅝ inches. $2000-2500

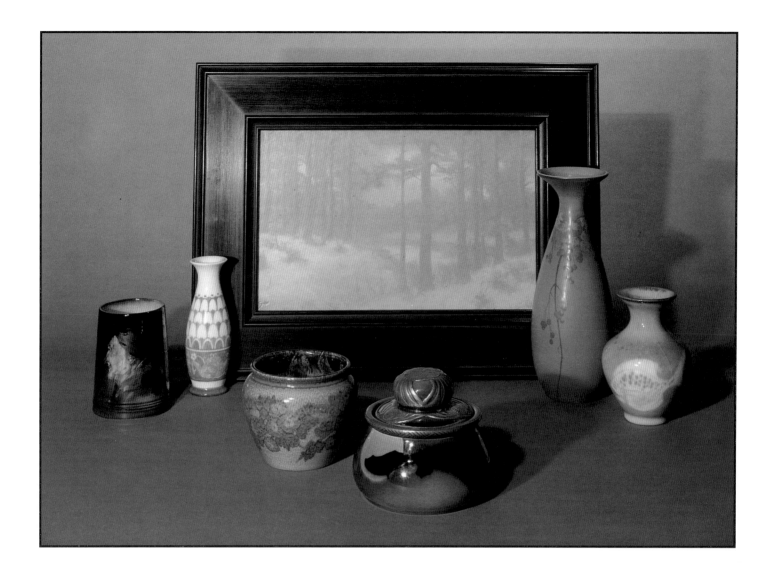

606 Standard glaze mug with the portrait of a monk painted in 1892 by M.A. Daly. Marks on the base include the Rookwood logo, the date, shape number 587, W for white clay and the artist's initials. Height 4⅛ inches. There is a tight two inch line descending from the rim. Exhibited: "Rookwood Pottery" The Yuma Art Center, catalog number 25, illustrated. — $700-900

607 High glaze vase painted in 1919 by Arthur Conant showing a band of colorful flowers and several bands of repeating arches. Marks on the base include the Rookwood logo, the date, shape number 357 F and the artist's monogram. Height 6⅛ inches. — $800-1200

608 Interesting high glaze vase with multicolored floral decoration and an unusual lining, painted in 1926 by Sara Sax. Marks on the base include the Rookwood logo, the date, shape number 964, a wheel ground x and the artist's monogram. Height 3⅞ inches. There are some burst glaze bubbles in the inside bottom of the piece. — $500-700

609 Large Vellum glaze winter scenic plaque done in very special colors by E.T. Hurley in 1921. The artist's initials appear in the lower left hand corner. Marks on the back include the Rookwood logo and the date. Affixed to the back is an original Rookwood paper label with the notation, "Winter Woods E.T. Hurley". Size is 9⅛ x 14⅛ inches. There are some areas of loose glaze in the lower left center portion of the piece and some areas of glaze loss on two of the edges which are covered by the frame. — $2500-3500

610 Rare Sea Green humidor with electroplated silver mounts applied at Rookwood in 1900. The body was decorated by Rose Fechheimer and features a bat flying in front of a full moon. The silver rim has a cross hatch pattern around the outside while the lid features circular designs which may be Japanese in origin. Marks on the base include the Rookwood logo, the date, shape number T 1230, G for Sea Green glaze and the artist's initials. The lid also bears the artist's initials. Height 4½ inches. There are tight lines in the body of the piece and in the lid (which are covered by the silver) and some pitting of the glaze on the lid. — $2000-2500

611 Pretty Vellum glaze vase with leaf, berry and vine decoration, outlined in black and painted by Lenore Asbury in 1921. Marks on the base include the Rookwood logo, the date, shape number 4 V for Vellum glaze and the artist's initials. Height 10½ inches. — $800-1000

612 High glaze vase by Jens Jensen with two tan and blue fish on a gray ground. The interior is lined with a rich brown and gray glaze and the rim is highlighted with dark blue. Done in 1943, marks on the base include the Rookwood logo, the date, shape number 6148 and the artist's monogram. Height 5⅝ inches. — $800-100

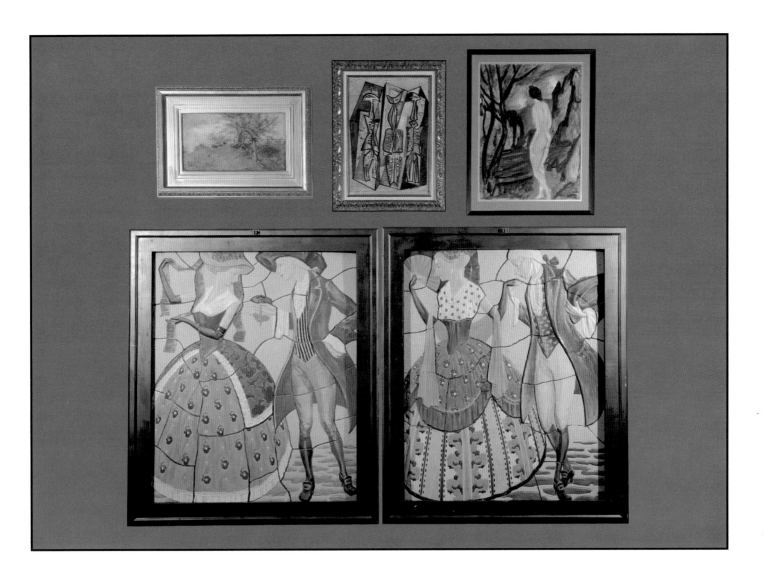

613 Rare and colorful Architectural Faience installation showing a colonial man and woman in formal attire, made at Rookwood circa 1940. Although the clothing is classic Williamsburg, the decorative treatment is Art Deco and may well be the work of William Hentschel. Unlike most Rookwood Faience, the tiles in this installation are three dimensional with many areas in deep relief which adds to the decorative quality and the overall weight. The pieces are in heavy wooden frames and we have not been able to inspect the backs for markings. Originally the property of Dr. George Sperti, owner of Rookwood in the 1940's, this plaque hung in Sperti's home until his estate was settled in 1993. Most likely never installed, the condition is very good. There are minor chips and the frame needs some touching up. Size is 50 x 41½ inches. Weight is approximately 300 pounds. The purchaser of this lot will be allowed to purchase lot 617 for the same amount. $4000-6000

614 Rare oil on canvas landscape painting by Mary Louise McLaughlin showing a cluster of apple trees on a hillside with a fence in the background. Painted in 1891 the work is signed and dated by McLaughlin in the lower right hand corner. Size is 12 x 22 inches. In good original condition, the painting has some minor paint loss on the left hand edge and probably needs to be cleaned. The frame is old and most likely original but has been covered in gold paint. This is one of the nicest paintings by McLaughlin to ever appear on the market and needs only minor restoration. $400-600

615 Abstract mixed media painting on paper done by William Hentschel circa 1945. Affixed to the frame is an older exhibition label which lists the title as "Old Soldiers" and the price as "Not for Sale". Signed in the lower right hand corner. Image size is 24 x 17 inches. Framed. $600-800

616 Oil painting on paper showing a nude in a wooded area, painted circa 1950 by Jens Jensen. Signed in the lower right hand corner. Image size is 27½ x 21½ inches. $1500-2000

617 For description, see lot 613. The purchaser of lot 613 will be allowed to buy this lot for the same amount. $4000-6000

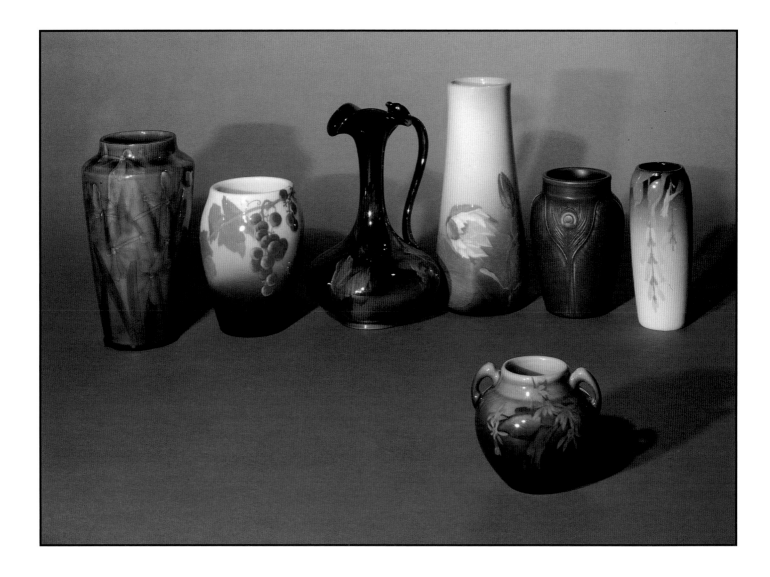

618 Very handsome high glaze vase decorated with yellow and blue flowers in 1926 by Kataro Shirayamadani. The $3000-4000
interior is glazed in a medium blue and the red background coloring has formed interesting relationships with
some of the other colors. The effect is somewhat like that of Black Opal but it is something else. Marks on the
base include the Rookwood logo, the date, shape number 1918 and the artist's cypher. Height 8¼ inches. There is
some glaze pooling at the base and grinding chips as a result.

619 Very clean and nicely detailed Iris glaze vase with colorful grape decor, done in 1903 by Irene Bishop. Marks on $2000-2250
the base include the Rookwood logo, the date, shape number 942 C, W for white (Iris) glaze, a paper label from
Davis Collamore & Co., Fifth Ave. and 37th St., New York and the artist's monogram. Height 6¼ inches.
Uncrazed.

620 Standard glaze ewer with colorful autumn leaf decor, painted in 1899 by Katharine Hickman. Marks on the base $400-500
include the Rookwood logo, the date, shape number 611 C and the artist's monogram. Height 10 inches.

621 Pretty Iris glaze vase with colorful lotus decoration, done in 1904 by Mary Nourse. Marks on the base include the $3500-4500
Rookwood logo, the date, shape number 950 C, W for white (Iris) glaze and the artist's initials. Height 10⅛
inches.

622 Two handled Sea Green vase with yellow floral decoration painted in 1901 by Sallie Coyne. Marks on the base $1000-1500
include the Rookwood logo, the date, shape number 919, G for Sea Green glaze and the artist's monogram.
Height 3¼ inches. Minor glaze scratch.

623 Unusual mat glaze vase with three stylized peacock feathers deeply carved, incised and painted in 1910 by Sara $1250-1500
Sax. Marks on the base include the Rookwood logo, the date, shape number 1123, V for Vellum glaze body and
the artist's monogram. Height 6¼ inches.

624 Iris glaze vase with pretty trailing flowers in pink and green, painted in 1907 by Katherine Van Horne. Marks on $800-1200
the base include the Rookwood logo, the date, shape number 951 E, W for white (Iris) glaze and the artist's
monogram. Height 7 inches.

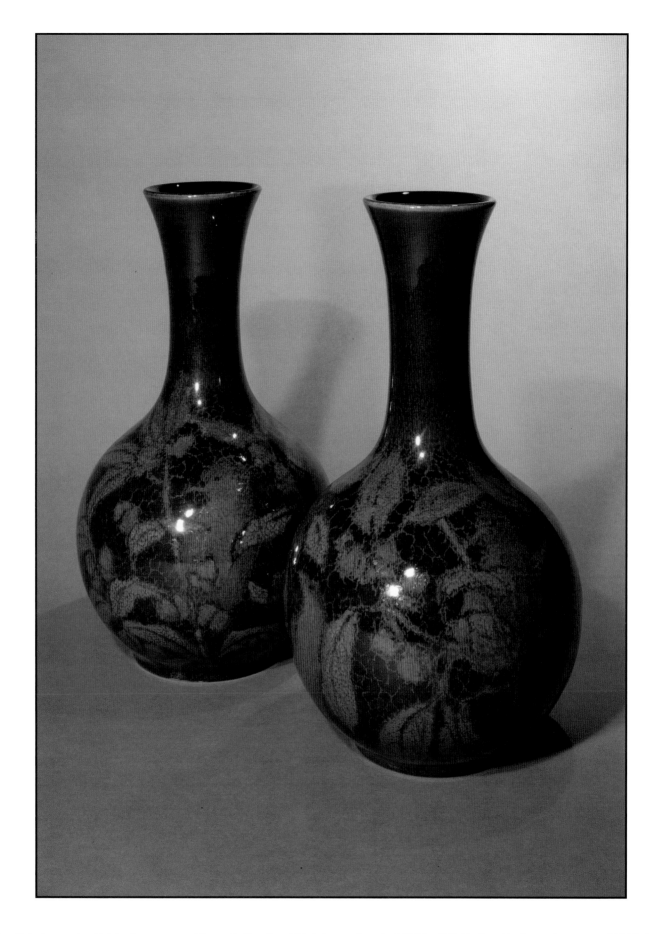

625 Fabulous pair of high glaze vases with exotic floral and bird decor, done in 1930 by E.T. Hurley. Marks on the $8000-12000
base include the Rookwood logo, the date, shape number 2983, the numbers "9731" and "9730" in black slip, a
fan shaped esoteric mark and the artist's initials in black slip. Height 15¼ and 15½ inches. Uncrazed. Exhibited
and illustrated as item 96 in "Rookwood Pottery The Glorious Gamble", Anita J. Ellis, Cincinnati Art Museum,
1992-1993, catalog published by Rizzoli in 1992 (color plate, page 161).

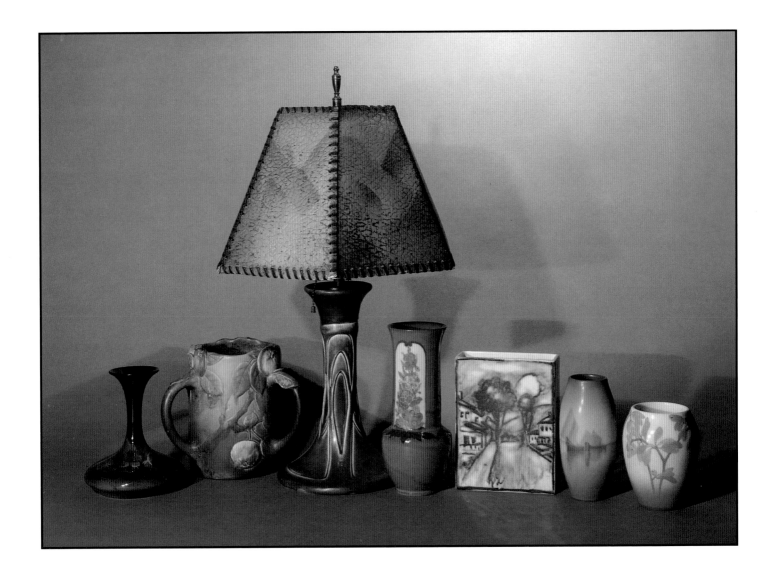

626 Standard glaze vase with flared rim and nasturtium decor, painted in 1898 by Carl Schmidt. Marks on the base include the Rookwood logo, the date, shape number 715 D and the artist's monogram. Height 6⅞ inches. $400-600

627 Fabulous ornately carved mat glaze three handled loving cup with bright apple decoration, done in 1904 by Kataro Shirayamadani. Marks on the base include the Rookwood logo, the date, shape number 790 BZ, V for Vellum glaze body and the artist's monogram. Height 7¾ inches. There are quite a few glaze blisters in several areas but the overall effect is spectacular. $2500-3500

628 Deeply carved and painted mat glaze lamp base done in 1906 in an Arts & Crafts manner most likely by Rose Fechheimer. A brownish green and a dark green glaze are used to enhance the carving. A cast in hole in the side of the base accepts an electrical cord and the electrical fittings are probably original to the piece. The parchment shade is old but not original. Marks on the base include the Rookwood logo, the date and shape number 822 A. Incised on the side of the base is the letter F inside a rectangle. Fechheimer is known to have done some carving and to have made lamp bases, so the attribution seems reasonable. Height of the ceramic portion only is 11⅜ inches. $1250-1500

629 Handsome high glaze vase having three panels, each enclosing lavishly colored floral bouquets, done in 1920 by Sara Sax. Marks on the base include the Rookwood logo, the date, shape number 690 C, two wheel ground x's and the artist's monogram. Height 9⅜ inches. There are several areas where the thick glaze has pooled or thinned. $700-800

630 Interesting high glaze scenic vase painted in 1946 by Jens Jensen. The scene consists of houses on either side of a tree lined street with a cloudy sky in the background. Marks on the base include the Rookwood logo, the date, shape number 6292 C, the number "8862" in black slip and the artist's monogram, also in black slip. Height 7⅝ inches. $1250-1500

631 Vellum glaze Venetian harbor scene vase painted in 1922 by Carl Schmidt. Marks on the base include the Rookwood logo, the date, shape number 551, V for Vellum glaze, P for porcelain body, a wheel ground x and the artist's monogram. Height 6¾ inches. There is a small glaze flaw at the rim and two dimples in the glaze but the piece is uncrazed. $1500-2000

632 Pretty Iris glaze vase with mistletoe decoration by Sara Sax, painted in 1906. Marks on the base include the Rookwood logo, the date, shape number 942 D, W for white (Iris) glaze and the artist's monogram. Height 5¼ inches. Very little crazing. $1250-1500

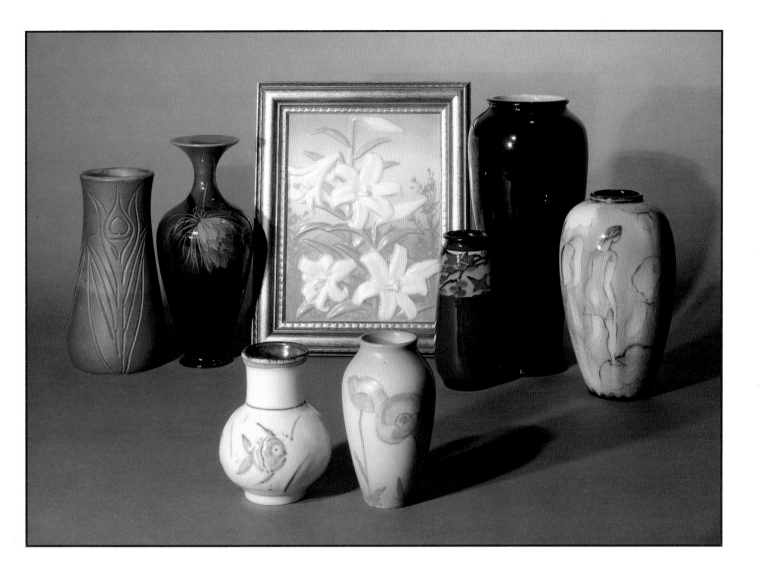

633 Tall Arts & Crafts style vase decorated with incised peacock feathers by Sallie Toohey in 1904 and covered with a leathery green mat glaze. Marks on the base include the Rookwood logo, the date, shape number 578 CZ and the artist's monogram. Height 10 inches. $700-900

634 Spectacular Sea Green glaze vase decorated in 1895 by Albert Valentien. The finely detailed flowers and stalks are a cactus variety known as nightblooming cereus and there are two large blooms and several twining stems under the very even and rich green glaze. The base is marked with the Rookwood logo, the date, shape number 216, a faint G for Sea Green glaze and the artist's full name. Height 11⅝ inches. Very little crazing. $4000-5000

635 Interesting Art Deco style vase with fish decor, done in heavy slip by Elizabeth Barrett in 1934 and covered with a semi-gloss glaze. The fish are alternately outlined in brown or white slip, the ones in white being somewhat hard to see on the cream ground. Marks on the base include the Rookwood logo, the date, S for Special shape and the artist's monogram. Height 5⅝ inches. Uncrazed. $700-900

636 Unusual and rare Vellum glaze plaque painted by Lenore Asbury in 1931. The basic shape is a Commercial blank with embossed Easter lilies decor which has been colored by Asbury and augmented with additional blue flowers in the background. We have seen one other Commercial plaque painted and signed by Asbury but this is the first we have seen to have the additional painting. The artist's initials appear on the lower right hand corner and marks on the back include the Rookwood logo, the date and shape number 6290. Affixed to the the frame is an original Rookwood paper logo. Size is 11⅛ x 8⅝ inches. Uncrazed and extremely clean. $3500-4500

637 Pretty mat glaze vase by Shirayamadani painted in 1943. Decoration consists of red poppies on a ground shading from blue to rose to cream to green. Marks on the base include the Rookwood logo, the date, shape number 913 E and the artist's initials. Height 6¼ inches. $1250-1500

638 Pleasant blue tinted high glaze vase by Lorinda Epply showing several finely detailed flying birds among oriental style foliage. Marks on the base includes the Rookwood logo, the date, shape number 2069, P for porcelain body and the artist's monogram. Height 7⅜ inches $1500-2000

639 Tall Commercial vase lined with a rich yellow and glazed on the outside in rich high glaze black. Marks on the base include the Rookwood logo, the date and shape number 2551. Height 13⅞ inches. Small glaze skip at the base. $400-600

640 Bizarre high glaze vase in the style of Jens Jensen showing a human figure and a bull walking through a cloudy sky dotted with a huge iris, a star and several unusual symbols. Made in 1944, the vase is marked with the Rookwood logo, the date and shape number 6868. Although not signed by anyone, the work is very much in keeping with Jensen's work and very exciting in scope and presentation. Height 9⅝ inches. $1500-2000

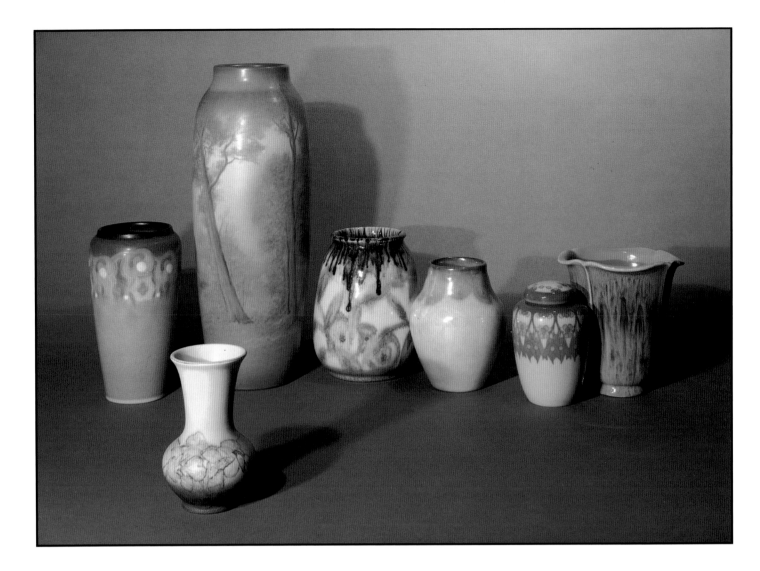

641 Vellum glaze vase with highly stylized floral decoration painted in 1916 by C.S. Todd. The base carries the Rookwood logo, the date, shape number 1369 D, V for Vellum glaze body, V for Vellum glaze and the artist's initials. Height 9¼ inches. There are two tight one inch lines descending from the rim. $300-400

642 Mat glaze vase in yellow with red and green nasturtium decor, done in 1933 by Sallie Coyne. The base carries the Rookwood logo, the date, S for Special shape and the artist's monogram. Height 6½ inches. $400-500

643 Large Vellum glaze landscape vase painted in 1917 by Ed Diers. The autumn scene features tall trees with turning leaves in a misty setting. Marks on the base include the Rookwood logo, the date, shape number 907 B, V for Vellum glaze body and the artist's monogram. Height 18 inches. $4000-6000

644 High glaze vase with colorful Art Deco floral decoration done in 1930 by Lorinda Epply. The interior is coated with a mottled gray-brown glaze which drips down over the sides of the rim. Marks on the base include the Rookwood logo, the date, shape number 6203 C, a fan shaped esoteric mark and the artist's monogram. Height 8⅛ inches. $700-900

645 Rare decorated Nacreous glaze vase done circa 1915 by an unknown artist. The simple decoration of red flowers on a blue-gray border contrast nicely with the creamy luster background. Rare in any form, Nacreous pieces with decoration are extremely unusual. The base is marked with the Rookwood logo but the date, shape number and artist's monogram are obscured by the glaze. Height 6⅞ inches. There are two small pits in the glaze. $1250-1500

646 High glaze lidded vase with stylized leaf and berry decoration in colorful repeating patterns, done in 1918 by Sara Sax. The interior of the vase and underside of the lid are done in the same yellow color used on some of the berries. Marks on the base include the Rookwood logo, the date, shape number 47 C, P for porcelain body and the artist's monogram. The artist's mark also appears inside the lid. Height 6⅜ inches. Uncrazed. $1750-2250

647 Fan shaped Commercial vase covered with Bengal Brown glaze at Rookwood in 1949. Marks on the base include the Rookwood logo, the date and shape number 6314. Height 7½ inches. Minor grinding chips on the base. $150-250

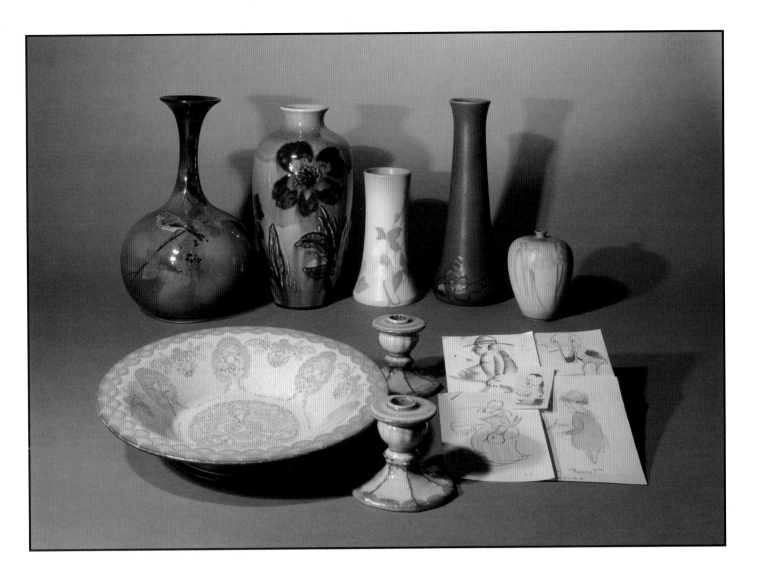

648	Bulbous Standard glaze vase with tall neck and flared rim, painted in 1897 by Kataro Shirayamadani. The finely detailed decoration is of a small sparrow perched on a limb amid leaves and berries. Marks on the base include the Rookwood logo, the date, shape number T 1105, a diamond shaped esoteric mark, a wheel ground x and the artist's cypher. Height 13¾ inches. There are some very minor underglaze spots on the surface which would probably account for the "x" and a small patch of loose glaze which is stable.	$1250-1500
649	Unusual high glaze console set consisting of a bowl and two candlesticks, painted in 1926 and 1928 by Sara Sax. The bowl has repeating floral and geometric patterns inside and a gunmetal black exterior. Marks on the base of the bowl include the Rookwood logo, the date (1926), shape number 2258 X and the artist's monogram. The candlesticks done in 1928 include the Rookwood logo, the date, shape number 2961 and the artist's monogram. Diameter of the bowl is 13¼ inches.	$1500-2000
650	Tall high glaze vase with floral decoration done in heavy slip by Wilhelmine Rehm in 1944. Marks on the base include the Rookwood logo, the date, shape number 6867, the notation "A 5/2508" in black slip and the artist's monogram. Height 13 inches. Some minor glaze pooling at the base.	$500-700
651	Pretty Vellum glaze vase with wild rose decoration, painted in 1908 by Ed Diers. The base carries the Rookwood logo, the date, shape number 1358 D, V for Vellum glaze body, V for Vellum glaze and the artist's monogram. Height 8⅝ inches.	$500-700
652	Tall mat glaze vase with carved and painted floral decoration, done in 1920 by C.S. Todd. Marks on the base include the Rookwood logo, the date, shape number 807, V for Vellum glaze body and the artist's initials. Height 13½ inches. The base has been drilled.	$400-500
653	Unusual group of 17 pencil drawings on paper done between 1929 and 1931 by Jens Jensen. Included are caricatures of several Rookwood decorators from the period including E.T, Hurley, John Dee Wareham and two sensitive views of Elizabeth Barrett, Jensen's future wife. There is also a cowboy, a golfer, a bathing beauty and several interesting but unidentified gentlemen. These are done on various sizes of paper, the largest being about 9 x 5 inches and most are in good original condition.	$200-300
654	Vellum glaze vase with pretty daisy decor, done in 1910 by Carrie Steinle. The base is marked with the Rookwood logo, the date, shape number 750 C, V for Vellum glaze body, a wheel ground x and the artist's monogram. Height 5½ inches. There is a small glaze bubble on the side.	$400-600

END OF SALE

NOTES

NOTES

NOTES

THE BOOKSTORE

Cincinnati Art Galleries is the largest Publisher of classic books about Rookwood Pottery in the world. We also have available many important books about American Art Pottery and American Arts and Crafts which are listed below. Orders can be placed by phone or mail with Visa or MasterCard and by mail with a check. If you need assistance in selecting a particular book, please feel free to call us for more information.

Please send me the following books:

_____ copies	"The **Glover Collection** of Rookwood Pottery" - Cincinnati Art Galleries - @ $45.00 each + $3.00 s/h	$ _____
_____ copies	"**Rookwood II**" Auction 1992 - Cincinnati Art Galleries - @ $35.00 each + $3.00 s/h	$ _____
_____ copies	"**Rookwood III**" - Auction 1993 - Cincinnati Art Galleries - @ $40.00 each + $3.00 s/h	$ _____
_____ copies	"**Rookwood IV & Keramics 1994**" Auction 1994 - Cincinnati Art Galleries - @ $35.00 each + $3.00 s/h	$ _____
_____ copies	**Special 4 auctions listed above Reg. $155** - @ $125.00 each + $7.00 s/h	$ _____
_____ copies	"**Keramics 1993**" - Auction 1993 - Cincinnati Art Galleries - @ $30.00 each + $3.00 s/h	$ _____
_____ copies	"The Book of **Rookwood** Pottery" - **Peck** (softbound) - @ $25.95 each + $2.00 s/h	$ _____
_____ copies	"**Rookwood Pottery Potpourri**" - Cummins - @ $26.00 each + $2.00 s/h	$ _____
_____ copies	"**Rookwood Pottery** - The Glorious Gamble" - **Cincinnati Art Museum** - Ellis - @ $40.00 each + $3.00 s/h	$ _____
_____ copies	"**American Artists at Auction**" 1/83 - 1/93- Franklin & James - @ $110.00 + $3.00 s/h	$ _____
_____ copies	"**American Art Pottery**" - Cooper - Hewitt Museum - @ $20.00 each + $2.00 s/h	$ _____
_____ copies	"**American Ceramics**" - The Collection of the Everson Museum of Art - @ $40.00 each + $2.00 s/h	$ _____
_____ copies	"**Art Pottery** of America" - Henzke - @ $45.00 each + $2.00 s/h	$ _____
_____ copies	"**Art Pottery** of the United States" - Evans (hardbound) - @ $45.00 each + $2.00 s/h	$ _____
_____ copies	"**Art Pottery** of the United States" - Evans (softbound) - @ $25.00 each + $2.00 s/h	$ _____
_____ copies	"From Our **Native Clay**" - Eidelberg - @ $40.00 each + $2.00 s/h	$ _____
_____ copies	"The **Newark Museum** Collection of American Art Pottery" - @ $35.00 each +2.00 s/h	$ _____
_____ copies	"**U.S. Marks on Pottery,** Porcelain & Clay" - Lehner - @ $24.95 each + $2.00 s/h	$ _____
_____ copies	"The Book of **Buffalo Pottery**" - Altman - @ $27.50 each + $2.00 s/h	$ _____
_____ copies	"The Collector's Encyclopedia of **California Pottery**" - Chipman - @ $24.95 each + $2.00 s/h	$ _____
_____ copies	"**Newcomb Pottery:** An enterprise for Southern Women" - Poesch - @ $14.95 each + $2.00 s/h	$ _____
_____ copies	"**Early Roseville** Pottery" - Huxford - @ $7.95 each + $2.00 s/h	$ _____
_____ copies	"The Collector's Encyclopedia of **Roseville Pottery I**" - Huxford - @ $19.95 each + $2.00 s/h	$ _____
_____ copies	"The Collector's Encyclopedia of **Roseville Pottery II**" - Huxford - @ $19.95 each + $2.00 s/h	$ _____
_____ copies	"A Collector's Guide to **Van Briggle Pottery**" - Nelson / prices - @ $40.00 each + $2.00 s/h	$ _____
_____ copies	"The Collector's Encyclopedia of **Van Briggle Pottery**" - Sasicki & Fania - @ $24.95 each + $2.00 s/h	$ _____
_____ copies	"All about **Weller**" - McDonald - @ $28.95 each + $2.00 s/h	$ _____
_____ copies	"The Collector's Encyclopedia of **Weller Pottery**" - Huxford - @$29.95 each + $2.00 s/h	$ _____
_____ copies	**Arts & Crafts** Movement in Western New York 1900-1920 - RIT - Austin - @ $16.00 each + $2.00 s/h	$ _____
_____ copies	Collected Works of **Gustav Stickley** - @ $20.00 each + $2.00 s/h	$ _____
_____ copies	The Early Work of **Gustav Stickley** - @ $20.00 each + $2.00 s/h	$ _____
_____ copies	**Gustav Stickley** After 1909 - @ $18.50 each + $2.00 s/h	$ _____
_____ copies	**The Mission Furniture of L. & J.G. Stickley** - @ $20.00 each $2.00 s/h	$ _____
_____ copies	**Stickley Brothers** of Grand Rapids - @ $16.50 each + $2.00 s/h	$ _____
_____ copies	**Quaint** Furniture - @ $6.95 each + $2.00 s/h	$ _____
_____ copies	What Is Wrought In The **Craftsman** Workshops - @ $15.00 each + $2.00 s/h	$ _____
_____ copies	**Limbert** Furniture - @ $20.00 each + $2.00 s/h	$ _____
_____ copies	**Roycroft** Furniture - @ $6.95 each + $2.00 s/h	$ _____
_____ copies	A Catalog of the **Roycrofters** - @ $11.95 each + $2.00 s/h	$ _____
_____ copies	**Shop of the Crafters** at Cincinnati - @ $7.95 each + $2.00 s/h	$ _____
_____ copies	**Lifetime** Furniture - @ $9.95 each + $2.00 s/h	$ _____

Sub Total ...$ _____

Shipping and Handling$ _____

Ohio Shipments add 5.5% Sales Tax$ _____

Total ...$ _____

Check, Visa or Master Card only please

Name _____

Address _____

City _____ State _____ Zip _____

Phone _____

☐ Visa ☐ Mastercard # _____ Exp. _____

Cincinnati Art Galleries

635 Main Street • Cincinnati, OH 45202 • (513) 381-2128 • FAX (513) 381-7527

ABSENTEE BID ORDER FORM

I wish to place the following bids with Cincinnati Art Galleries to be executed during its Rookwood IV and Keramics 1994 auction, June 11th, 1994.

I understand that Cincinnati Art Galleries will execute my absentee bids as a convenience and will not be held responsible for any errors or failure to execute bids. I also understand that my absentee bids are subject to all parts of the "Conditions of Sale" which appear in this catalog, and that I am responsible for the purchase price and 10% buyer's premium and the 5.5% Ohio State Sales Tax for all items purchased.

I understand that I am responsible for packing and shipping costs of my purchases. Cincinnati Art Galleries will ship my purchases in the best way possible as soon as full payment has been received, and I understand that four to six weeks should be allowed for delivery.

Lot #	Description	Bid Price
_____	_____	_____
_____	_____	_____
_____	_____	_____
_____	_____	_____
_____	_____	_____
_____	_____	_____
_____	_____	_____
_____	_____	_____
_____	_____	_____
_____	_____	_____
_____	_____	_____
_____	_____	_____
_____	_____	_____
_____	_____	_____
_____	_____	_____
_____	_____	_____
_____	_____	_____
_____	_____	_____
_____	_____	_____
_____	_____	_____

Cincinnati Art Galleries will always attempt to purchase designated lots for the lowest possible amount in competition with other bidders, but we cannot be held responsible for errors or failure to bid. All terms of "Conditions of Sale" apply to absentee bidders as well as those present.

Name _____ Bidder # _____

Address _____

Phone Number _____

Ohio Resale Number _____

Signature _____ Date _____

Cincinnati Art Galleries
635 Main Street
Cincinnati, OH 45202
513-381-2128
FAX 513-381-7527